SUSAN POINT WORKS ON PAPER

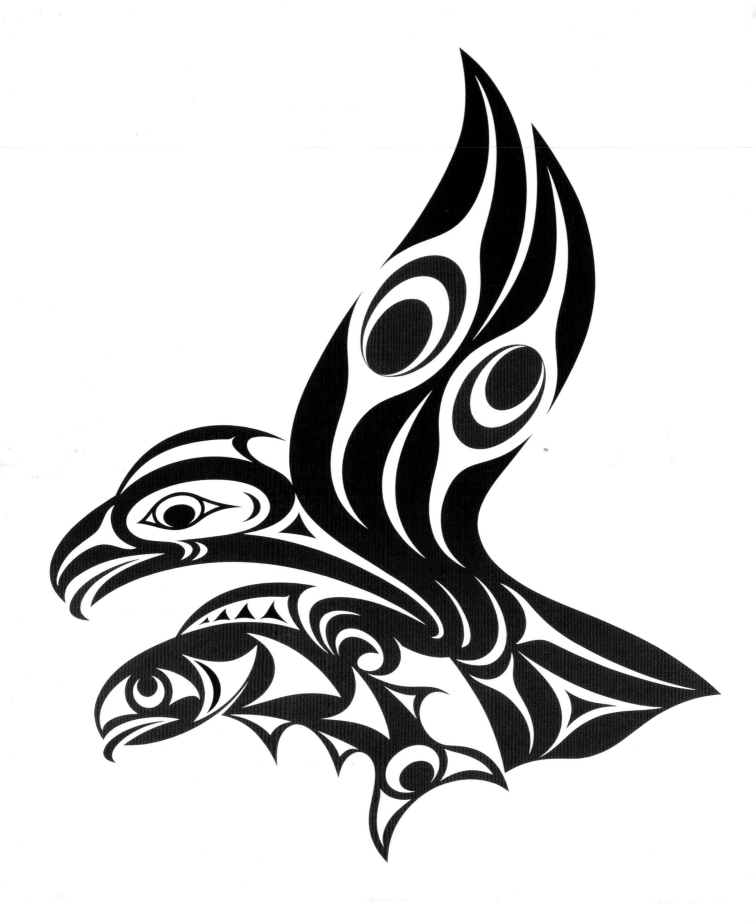

DALE CROES | SUSAN POINT | GARY WYATT

SUSAN POINT
WORKS ON PAPER

FIGURE 1 PUBLISHING

VANCOUVER | WWW.FIGURE1PUB.COM

Cataloguing data available from Library and Archives Canada
ISBN 978-0-9918588-9-7 (pbk.)
ISBN 978-1-927958-19-3 (cloth in slipcase, limited edition)

Editing by Scott Steedman
Cover and interior design by Peter Cocking
Cover and interior photography by Kenji Nagai
Printed and bound in China by C&C Offset Ltd.
Distributed in the U.S. by Publishers Group West

Figure 1 Publishing Inc.
Vancouver BC Canada
www.figure1pub.com

ACKNOWLEDGEMENTS
Susan would like to express her gratitude to all those who have
contributed to her printmaking career, especially Walter De Jong of
Prism Graphics, Peter Braune of New Leaf Editions and Eric Bourquin
of Seacoast Screen Printing.

Measurements of artworks are given as height × width

TITLE PAGE IMAGE
Protector
2006 · Edition size: 100
Serigraph · 30 × 25 inches

This book is dedicated to the memory of George (Bud) Mintz of Potlatch Arts Ltd., a man passionately committed to the recognition, appreciation and collectability of Northwest Coast art. Bud was one of the earliest collectors to consider Northwest Coast art as beautiful and culturally significant. He possessed a keen intellect and sharp wit and interacted with unabashed honesty and integrity with artist, customer and collector alike. Most significantly, Bud contributed to the marketing viability of not just Northwest Coast art but also the artists themselves. One such artist was Susan Point, one of the first female Coast Salish artists. Her entry into a male-dominated art community was not without its challenges, but Bud saw in her an artist with the talent and drive to revitalize the Coast Salish art form in the 1980s, when it did not have the degree of success it now enjoys. Bud collaborated with Susan on many commissions through the years and undertook local, national and international exhibitions of her serigraphs. This exposure undoubtedly helped bring Susan Point to the forefront, both as an artist and as a conveyor of Coast Salish culture. We continue to enjoy Susan's prolific artistic life and remember the passion for the art form that was the driving force behind Bud's contribution to Northwest Coast art.

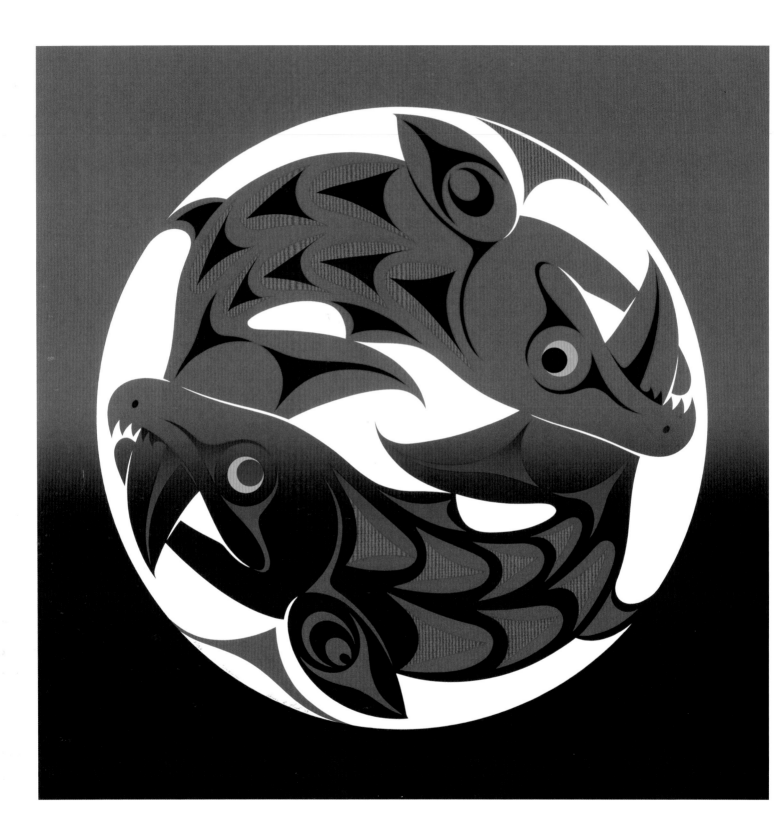

Sockeye

January 2003 · Edition size: 52
Serigraph · 22¼ × 22 inches

Contents

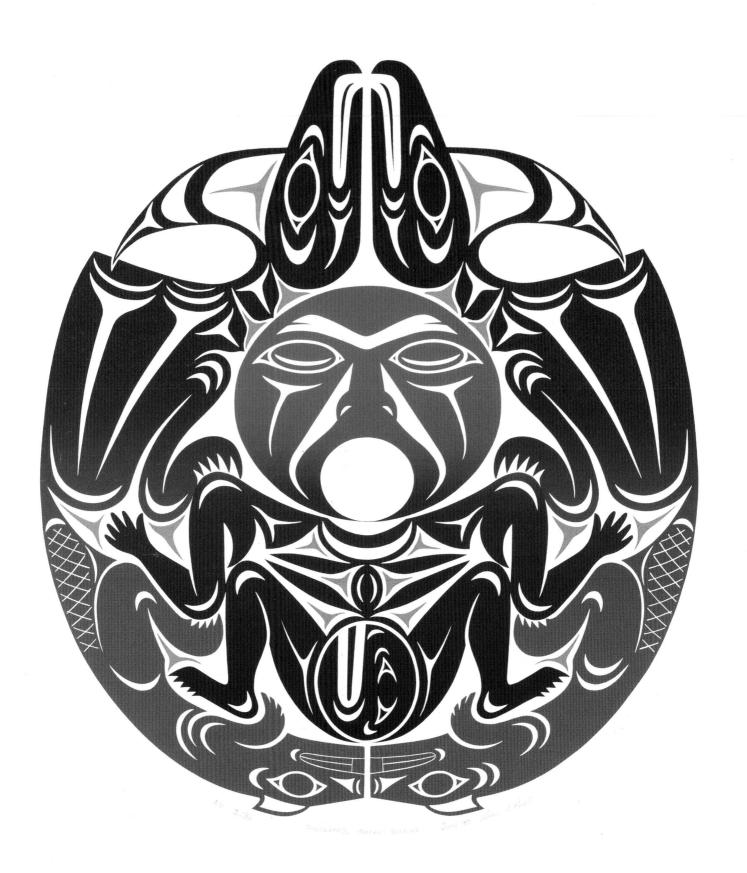

Artist's Statement

To PUT INTO words what my art means to me would be like trying to count the facets on each grain of a handful of sand ... each with its own story. I am briefly going to talk about my printmaking.

Firstly, prints are my life! I have made many works of art other than prints, and I am baffled when I see what I have done. That being said, what I consider to be my real body of work is my limited-edition prints.

All the work I have realized, in one form or another, is connected to a common foundation: making prints. The works I have made from wood, stone, glass, bronze, copper, aluminium, bone, horn, ceramic, steel, polymer, concrete, cast iron, silver, gold and canvas, for me, are equally as important as my works on paper.

In fact, I print just about every day—in my mind, that is. I love making prints and I love to teach others different techniques that I have learned over the years.

Digital technology is gaining prominence in the art world and can result in real works of art, to be sure. But I believe that making prints by hand has a direct simplicity. The knowledge and skill of pulling each print is the process I would like to pass on to my children and grandchildren, and other artisans as well.

My approach to drawing has a definitive link to my experience as a printmaker. While making prints, I have learned that there is much to be gained through Murphy's Law. My imagery evolves through understanding process and practice. Experimenting can always provide new possibilities. My need to find answers opens new doors to more inspired questions about the possibilities of printmaking.

One of the things I like about printmaking is that it gives me a chance to reach a greater audience. For me, my prints are my fingerprints; they reveal my thoughts and feelings on paper.

FACING

Thunderbird Man and Beavers
July 1989 · Edition size: 120
Serigraph · 25¾ × 19¾ inches

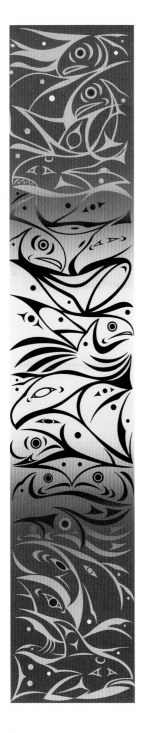

My early works are very important to me, as during those years I was discovering the stories and legends that had been passed on orally by my Salish ancestors. The prints all have their own story and, in some cases, multiple stories.

To try to summarize what this all means to me is very difficult. There is so much that I would like to share but struggle to put into words.

I would like to share one story about a print I produced in 2007 entitled *Missing Pieces*. I drew this image on a hilltop in Yelapa, Mexico. *Missing Pieces* originated from a commission from B.C. Ferries via satellite phone. My assistant and friend Linda Gillan gave my husband the dimensions for the artwork. He wrote down the dimensions but inadvertently reversed them. The artwork was to have been for a vertical space…not a horizontal one. The colour and beauty of my surroundings was infused into the overall design. At the time, I was thinking about how much nature is being lost—thus the title *Missing Pieces*. To make a long story short, I finished the artwork only to discover it was for a vertical stairwell, so I drew a new design, *Visual Perception,* for the commission. Regardless, I produced *Missing Pieces* (a limited edition of 26) anyway, because it was an image I loved and had created based on where it was conceived, and why.

Many of my images are based on nature, where one can see colour in constant transition in the changing light. Everyone has their own memories and experiences with nature, and I hope that my images can evoke these. I have made many prints about the cause and effect of losing our natural world, and hope my work communicates the value of nature and the absolute need to protect what remains.

As every print begins with a black-and-white drawing, I often see the power of that stark contrast. Sometimes the power of the black and white allows me to see images in the negative space that inevitably become part of the design.

FACING
Visual Perception
May 2005· Edition size: 82
Serigraph · 44 × 11½ inches

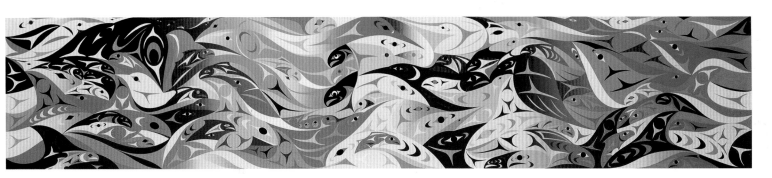

Missing Pieces
November 2007
Edition size: 26
Serigraph · 44 × 11½ inches

I have used printmaking to create images of educational value, giving historical insight into the roots of my culture, the environment and current social issues. With each theme, my primary objective has always been to create an image that challenges the viewer to use their own imagination, with the hope that they see more than what is obvious.

Overall, I hope that through my artwork I have used a visual language to help carry the torch, a torch that was lit by my ancestors. A value of tradition and originality. Most importantly, what I have gained by researching and studying the surviving examples of my ancestral legacy is a personal respect for the individual innovations and expressions that were nurtured by generations of my people tied to this land. Printmaking has been the flame of my torch. I am so happy to see printmaking continued by my children, my grandchildren and other Salish artisans, and hope that a unique Salish legacy will continue for generations.

I would like to express my gratitude to all, for their appreciation and support of my artwork. Their interest in my work is truly inspiring to me. I would also like to thank Dale Croes and Gary Wyatt for this publication—their words add a new perspective and foundation to my prints.

SUSAN POINT

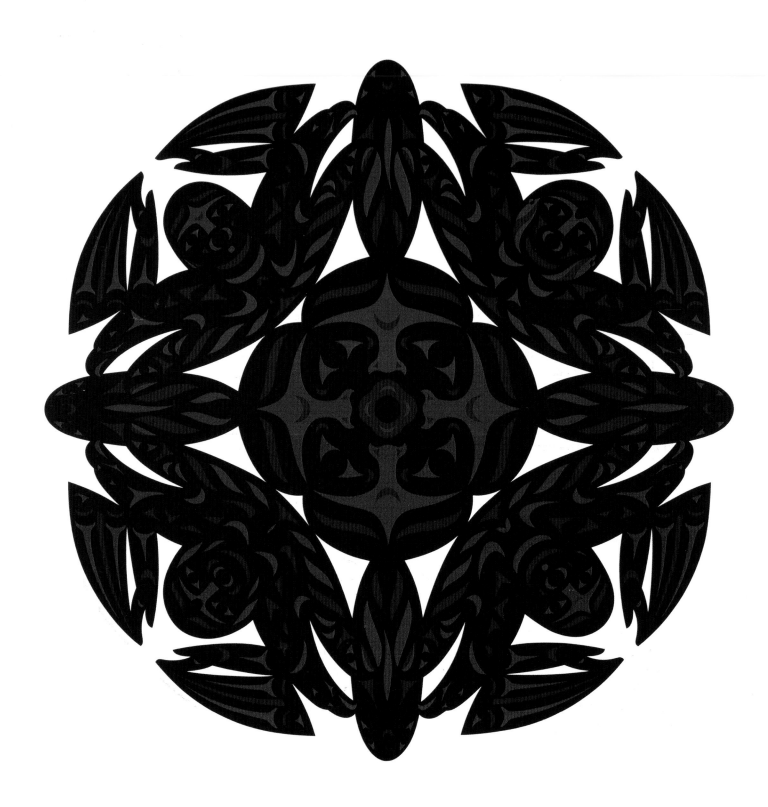

Introduction

GARY WYATT

SUSAN POINT IS from Musqueam, a Coast Salish village situated near the mouth of the Fraser River that is now incorporated into the city of Vancouver, British Columbia. Her family has lived at Musqueam for countless generations. The word *Musqueam* means "People of the Grass," a reference to the grassy marshes of the river's edge, which offered plentiful materials for weaving. Susan has a row of intricately woven baskets created by her mother, grandmother and great-grandmother on display in her home today. She often references the design forms of Coast Salish woven arts in both her sculpture and graphics, weaving together literal woven patterns and metaphors of ideas. The river's edge and the great Pacific Ocean also offered a wealth of salmon, sea life, plants, berries and animals. These sustained the village and were the subject of thousands of stories that defined the relationship between the people and their environment—and provided Susan with endless inspiration for her prints and sculptural artworks.

Susan Agnes Martha Point was born in 1952 and has lived surrounded by Coast Salish art and culture ever since. She began making prints on her kitchen table in 1981, completing her first one, *Salmon* (page 18), in April. Her earliest works were interpretations of the unique designs carved on historic spindle whorls, definitive Coast Salish objects. The spindle whorl was a flat disk, approximately 8 to 10 inches in diameter, carved from wood or stone. It was elaborately carved on one or both sides, with a central hole where a long spindle was inserted for spinning wool.

The Salish nation is the largest Northwest Coast nation. Stretching north–south from the mid coast of British Columbia deep into Oregon and east–west from the eastern coast of Vancouver Island into the central interior of British Columbia, the Salish's traditional territory covers a landscape of extraordinary diversity, including coastal mountains, rivers, forests, desert plains and the jagged coastline of the Pacific Ocean.

FACING
Behind Four Winds
February 2012 · Edition size: 50
Serigraph · 33½ × 33 inches

Early in her career Susan was offered several prestigious commissions, and as her reputation as an artist began to grow, public art became a dominant part of her artistic production. Public art offered her unlimited possibilities for exploring Salish art as fine art by playing with scale, new materials and mixed media. Susan quickly earned a reputation for large-scale private and public art commissions in wood, glass, stone and, particularly, mixed-media sculpture. She has remained dedicated to the print medium and has released a few limited-edition prints every year throughout her career. Her husband, Jeff Cannell, and their children, Brent, Rhea, Thomas and Kelly (all four of whom are established artists themselves), assist Susan on larger projects.

The majority of Northwest Coast prints, including Susan's, are serigraphs, but she has mastered most printmaking techniques and has frequently played with a variety of techniques in creating a single print. This collection includes prints produced using woodblock, reduction woodblock, plate woodblock, intaglio, chine-collé, lithography, aquatint and embossing, as well as a variety of mono prints and handcrafted papers. To date she has produced more than 320 limited-edition prints, of which only 169 could be included in this book as a cross-section of her techniques and subjects. Prints have allowed her to support numerous charities and causes with particular emphasis on education, culture, environmental protection and women's issues.

"I have been fortunate to work with the best printmakers over my career," Susan explains. "It is this accumulated knowledge and expertise that they shared with me that inspired me to love the various processes as much as I love creating my imagery. This has pushed me to find original ways of using the printmaking media."

This collection is compiled from a privately held collection that includes every print Susan has ever produced. This very early recognition of her potential as an artist has led to a long-term friendship and the opportunity to share in an extraordinary career over the past thirty-plus years. Every year a few prints were added to the collection, each one revealing Susan Point's unique ability to design, tell stories and describe cultural histories.

FACING
Spirit World
December 2005 · Edition size: 75
Serigraph · 30 × 24 inches

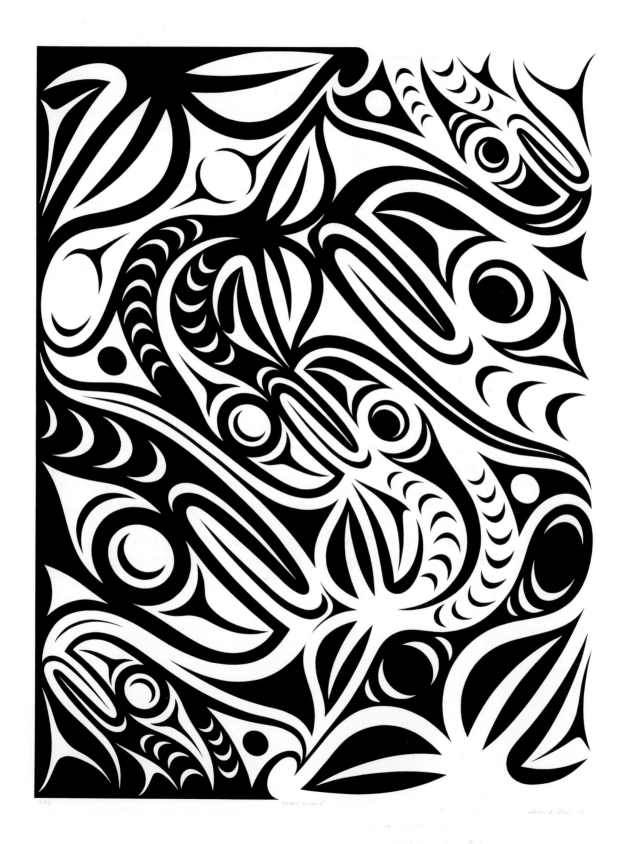

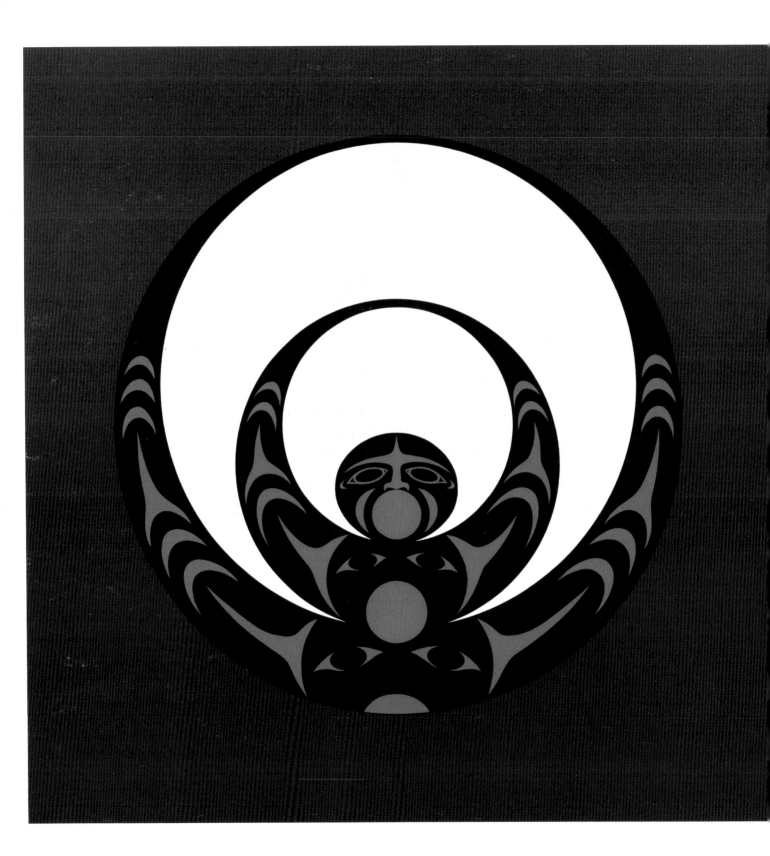

Showing the Wealth on Paper, Echoing the Archaeological Past

DALE R. CROES

JEFF CANNELL, SUSAN Point's husband, contacted me a number of years back and asked me if I could show the couple a waterlogged archaeological site we were excavating with the Squaxin Island Tribe. The site, in Puget Sound, Washington, is known as Qʷuʔgʷes, a Lushootseed Salish name meaning "a place to come together," a reference to the fact that archaeological scientists and indigenous cultural experts were working in partnership on it; it had been excavated in this collaborative fashion for eleven summers. I was a big fan of Susan's work and was thrilled to be asked. I was also amazed when she told me later that it was the first archaeological site she had ever visited.

As an archaeologist I was just as surprised to be asked to help introduce *Susan Point: Works on Paper*. All my forty-plus-year career I have specialized in waterlogged or wet sites, which preserve wood and fiber artifacts excellently—typically up to 90 percent of the artifacts and material culture of ancient Northwest Coast peoples come from such sites. As in the title of one of her prints, *Echoing the Past*, Susan possibly felt that my exposure to the wealth of this ancient cultural art tradition might help describe some of her efforts to transmit it into our future.

Many of Susan's prints show this rich wood and fiber material culture. *Sacred Weave*, rich in symbolism, reflects the beauty of woven basketry thousands of years old, recovered from Northwest Coast wet archaeological sites. Musqueam Northeast, a three-thousand-year-old wet site in Susan's own cultural territory on the Fraser River, revealed more than 125 examples of carefully woven basketry items—including pack baskets, 33 constructed with the checker weave shown in Susan's print.[1] Also recovered were cedar bark string gill nets and three-strand twisted cedar bough ropes. The ropes were probably used as harpoon lines for hunting seals attracted to salmon caught in the ancient gill net. The cordage was

FACING
Echoing the Past
May 1994 · Edition size: 88
Serigraph · 23¼ × 22 inches

1 Croes 1975, Archer and Bernick 1990

twisted in a Z direction, just like Susan's *Salmon Cedar Rope—State 1* print here (which I proudly own). These are just a few examples of Susan *Echoing* [her Musqueam cultural] *Past* into the present and future.

The Salish Implement: Sculpture Series I nicely shows two important items we see for millennia in the archaeological past—an ornate comb and mat creaser, the latter used in making sewn tule/cattail mats. As we know from the ancient Ozette wet site, a village on the Olympic Peninsula where entire houses were encased and preserved under a massive clay mudslide three hundred years ago, many utilitarian wooden items were beautifully sculpted as a matter of course.

Over fifty carved combs, mostly wooden, were found in the ancient Ozette houses.[2] These were typically worn as necklaces by Salish women, who would (and still do) use them both as hair combs and as scratchers. Touching one's skin is/was considered improper (low class), so a comb serves/served that purpose. The Ozette examples, as in Susan's print, often had elaborately carved figures on the handles and comb teeth either on one or both ends. One had separately carved teeth bound together in a fan; it may have been used for grooming wool dogs or for carding wool to create the roving used in yarn production.

The oldest known wooden comb, discovered in a three-thousand-year-old wet site on the Hoko River in Washington State, has 13 intricately carved wood teeth twined together at one end.[3] Also found at the Hoko wet site, at the western end of the Strait of Juan de Fuca, was a beautifully sculpted wooden mat creaser, with two beak-to-beak belted kingfishers forming the handle. Susan's print *The Salish Implement, Sculpture Series I* shows another water animal, a duck with the handle hole cut through its wing. The beak-to-beak kingfishers on the ancient creaser were of opposite genders, one with belt ruffles on its neck (female) and one without (male). Not only is the Hoko wet site mat creaser one of the oldest wooden sculptural art pieces ever found, having been made and used at the time Tutankhamen ruled Egypt, but it was also painted, with the eyes and the head tufts of the kingfishers painted in black.[4]

One of the most important Central Northwest Coast—Coast Salish and Makah—"machines" was undoubtedly the elaborately carved wooden spindle whorl, which generated most of the people's wealth or "currency"—the blankets. In the excavated Ozette plank houses, 23 were found, averaging an amazing nine spinners per household.[5] Some were still on their wooden shaft, which had a slight knob on one end to hold in one's palm and spin the loose roving of wool into tight spun yarn. The side facing the spinner or weaver was carved with an ornate design that she viewed as she made the yarn. Of the 169 Susan Point prints in this volume, about

2 Kent 1975

3 Croes 1995:176–77

4 Croes 1995:174–76

5 Croes 2005:171–73, Draper 1989:6

FACING
Salish Implement:
Sculpture Series I
March 1988 · Edition size: 18
Serigraph · 14⅞ × 10½ inches

COMB DESIGN IN THE FORM OF A DEER

MAT CREASER IN THE FORM OF A DUCK

A/P II/VI MARCH '88 SALISH IMPLEMENT SCULPTURE SERIES I Susan A. Point

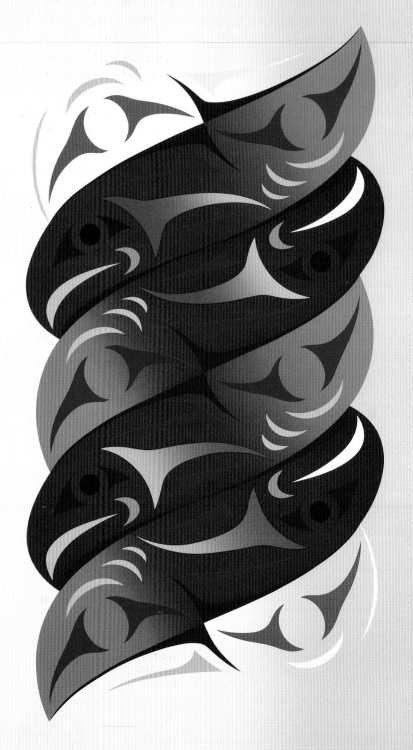

70—almost half—are based on this critical implement, the tool that produced the wealth, the yarn to weave the blankets—the Western equivalent of currency.

Since ancient and contemporary Central Northwest Coast peoples emphasize carved art in implements for making blankets, as Susan Point does here in spindle whorl forms in her print work (and elsewhere in her monumental sculptural work),[6] this focus on blanket production equipment, past, present and future, needs to be explored. Archaeologists see spindle whorls, usually of bone or stone in dry sites and sometimes elaborately carved, in sites going back at least a thousand years, giving us some idea when the Central Northwest Coast spinning industry may have begun.[7] The sites with ancient spinners from this time period are concentrated in what is now called the Salish Sea, in archaeological sites of the southern Kwakwaka'wakw; Coast Salish in the Gulf, straits, and Puget Sound; and Makah/southern Nuu-chah-nulth on the west end of the Strait of Juan de Fuca (also suggesting a cultural time dimension for this inland sea, characterized as a single functioning estuarine ecosystem). Interestingly, the Nuu-chah-nulth archaeological sites north of the mouth of the Strait of Juan de Fuca do not have spindle whorls in their ancient or contemporary communities,[8] meaning this blanket-weaving complex was limited to Salish Sea traditions over at least the past millennium.

To better understand Susan's 70 spindle whorl–based print designs, we should see how they fit into the complex blanket-weaving industry developed along the Northwest Coast. Along with the ancient and contemporary Central North-west Coast spinners, the region developed true double-bar looms (the northern Tlingit [Chilkat] and Haida use single-bar hanging looms woven like baskets), weaver swords/batons, yarn spools and a domesticated source for yarn to make the wealth—wool dogs. Through husbandry and intentional breeding practices developed in the past millennium, a wool or hair dog was domesticated as a controlled source for the production of blanket yarn. Archaeological examples of these dogs (distinct from village dogs) are well documented and they were often reported by early Western explorers in the Makah and Coast Salish territories.[9] In the entire American continent only two Native peoples domesticated an animal for its hair for spinning wool to make their textiles: the ancient Peruvians (Inca) bred alpaca from llamas and the ancient Salish Sea peoples bred wool dogs from the common dog to establish control over the production of the yarn they needed for blanket weaving. The Northern Northwest Coast peoples collected mountain goat wool, but on the Central Northwest Coast, where mountain goats are not native to the Olympic Peninsula, and possibly Vancouver Island, the Salish Sea people domesticated and used active husbandry to control this critical aspect of their yarn production.

6 Wyatt 2000

7 Mitchell 1990:346–47, Carlson 1983:29–31

8 Drucker 1950:194–95, McMillan 1999, personal communications 2013

9 Barsh, Jones and Suttles 2002:1–11, Gleeson 1970, Crockford 1997

FACING
Salmon Cedar Rope—State 1
July 2004 · Edition size: 99
Serigraph · 36 × 21 inches

10 Suttles 1983:86

11 Ibid:86

12 Ibid:86

13 Daugherty and Friedman
1983:192–93

14 Ibid:192

15 Gustafson 1980:16–17

16 best illustrated in
Gustafson 1980:16

17 Croes 1997:609–11,
Croes 2001:164–66

Wayne Suttles, an anthropologist who specialized in Central Northwest Coast traditions, notes in *Coast Salish Art* that objects made by men and used by men were "usually undecorated or decorated sparsely." In contrast, "implements made by men but used by women, such as mat creasers, spindle whorls, swords for beating wool, the posts of weaving frames ('looms'), etc. were often, though not always, decorated with carving and/or painting."[10] He then wondered, "why should they use what appears to be the most structured style on one article, the *spindle whorl?*" (emphasis mine).[11] We could ask the same question here: why are half of Susan's prints focused on the wool spinners? Suttles and I have the same suggestion—"the answers lie in the use to which these implements were put, producing that other, essential source of power and prestige—*wealth*" (emphasis mine).[12] And visible wealth—blankets one could produce—has been a primary medium of exchange along the Northwest Coast, from archaeological evidence of whorls, for at least a thousand years.

The Ozette village wet site again demonstrates the emphasis on wealth production in ancient households. Besides the 23 elaborately carved wooden spindle whorls, six wooden yarn spools, some with sculpted human heads on end knobs, were found.[13] Fourteen decorated and slotted wooden loom uprights and loom roller bars were also uncovered, meaning that an average of three true looms were found per household—again emphasizing the industry of blanket weaving on complex shuttle looms, and not hanging looms as seen to the north. Ten wooden weavers' swords/batons, possibly used as shuttle sticks, were also recorded, some with wolf-like carvings on their handles.[14]

Since soft organic materials such as hair, wool, hide, flesh and sinew do not normally preserve in wet sites, only one example of a multi-layer folded ancient blanket was found at Ozette, probably because it was in a concentrated pile and in a crushed wooden box.[15] This blanket was woven in the true-loom plaited twill weave with mostly white (likely dog) wool with dark elements added to create a distinct plaid design.[16]

Having conducted decades of archaeological work on the Northwest Coast, notably with the well-preserved wood and fiber artifacts from ancient wet sites, I have proposed that the cultural economies and arts seem to have evolved first in the Central Northwest Coast and then influenced the cultural directions of the arts and economies in the Northern (and possibly Southern) Northwest Coast. The archaeological evidence shows that some of the art forms and subsistence equipment, including ancient wooden fishhooks types, developed earliest in the Central Northwest Coast sites, around two thousand years ago in what is known as the Marpole Phase.[17] With time this technology appears to have diffused from the Central to the

Northern Northwest Coast, where it blended into the development and use of these cultural techniques and styles in later periods, including into the contact period. In a sense this is proposing that some of the evolving technologies and art styles of the Northern Northwest Coast reflect a diffusion or "spin-off" of cultural ideas developed at least two millennia earlier amongst the Central Northwest Coast populations.

For the arts, this would seem counter to the general anthropological perspective that the "center for the development of Northwest Coast Indian art" was the Northern Northwest Coast.[18] Squaxin Island Tribe master artist Andrea Wilbur-Sigo, a close associate and student of Susan Point, showed me how easy it was to transform Northern art elements into Coast Salish art elements, which may in turn have been a transformation from ancient Central Coast styles: the ovoids become circles, the U-forms become crescents and the split-Us become trigons.[19] In a sense she sees how part of this earlier cultural style shift could have taken place—simply evolving in a different direction on the Central Coast using the core elements developed earlier. This transition does not show a lessening of complexity in design, but rather a shift in focus by connecting the art to song, dance, vision and religion in a new trajectory for the Central Coast arts. Suttles states it well in *Coast Salish Art*: it "may have been the result of shifts in importance, back and forth, between the power of the vision and the power of the ritual word or shifts in the concentrations of wealth and authority"[20]—a dynamic part of Central Northwest Coast cultures that endures today.

Susan Point takes her Salish cultural training, including echoes from the ancient past, and transmits the crucial elements into the future through her visions. This is a Salish tradition that has always influenced cultures around it, especially those to the north, but now also a Western culture residing in the nation's traditional Salish Sea territories. This transmission moves the culture forwards into new generations of Salish youth and continues to educate outside cultures about the considerable wealth of the Coast Salish. A focus on the spindle whorl reflects the making of Salish wealth—blankets—in spinning yarn from indigenous domesticated wool dogs, weaving on true looms and using ornate weavers' swords/batons. Explaining the actual meaning of the spindle whorl designs is best done by cultural experts, such as by Susan Point in her discussions of her work here. Her work enriches our world community, becomes part of the world's wealth and is now compiled on paper here...

DALE R. CROES, PH.D.
President, Pacific Northwest Archaeological Services
Adjunct Faculty, Department of Anthropology, Washington State University

18 Holm 1965:20

19 Andrea Wilbur-Sigo, personal communications 2013

20 Suttles 1983:86

REFERENCES

Archer, David J.W., and Kathryn Bernick, 1990. "Perishable Artifacts from the Musqueam Northeast Site." Manuscript on file, British Columbia Archaeology Branch, Victoria, B.C.

Barsh, Russel L., Joan Megan Jones, and Wayne Suttles, 2002. "History, Ethnography, and Archaeology of the Coast Salish Woolly-Dog." In Snyder, L.M. and E.A. Moore, eds., *Dogs and People in Social, Working, Economic or Symbolic Interaction. Proceedings of the 9th Conference of the International Council of Archaeozoology 1–11.* Oxbow Books, Durham, UK.

Carlson, Roy L., ed., 1983. *Indian Art Traditions of the Northwest Coast.* Archaeology Press, Burnaby, B.C.

Crockford, Susan J., 1997. *Osteometry of Makah and Coast Salish Dogs.* Archaeology Press, Burnaby, B.C.

Croes, Dale R., 1975. "Musqueam Northeast Basketry and Cordage." Manuscript prepared for Charles Borden, Musqueam Northeast report, on file at the National Museum of Civilization, Ottawa.

Croes, Dale R., 1995. *The Hoko River Archaeological Site Complex, The Wet/Dry Site (45CA213), 3,000–1,700 B.P.* Washington State University Press, Pullman, WA.

Croes, Dale R., 1997. "The North-Central Cultural Dichotomy on the Northwest Coast of North America: Its Evolution as Suggested by Wet-Site Basketry and Wooden Fish-Hooks." *Antiquity* 71:594–615. Cambridge, England.

Croes, Dale R., 2001. "North Coast Prehistory—Reflections from Northwest Coast Wet Site Research." In Jerome S. Cybulski, ed., *Perspectives on Northern Northwest Coast Prehistory,* Canadian Museum of Civilization, *Mercury Series* Paper 160:145–71, Hull, Quebec.

Croes, Dale R., 2005. *The Hoko River Archaeological Site Complex, The Rockshelter (45CA213), 1,000–100 B.P.* Washington State University Press, Pullman, WA.

Daugherty, Richard, and Janet Friedman, 1983. "An Introduction to Ozette Art." In R.L. Carlson, ed., *Indian Art Traditions of the Northwest Coast,* pp. 183–95, Archaeology Press, Burnaby, B.C.

Draper, John A., 1989. "Ozette Lithic Analysis." Department of Anthropology, Washington State University, Pullman, WA.

Drucker, Philip, 1950. "Culture Element Distributions, XXVI: Northwest Coast." University of California Anthropological Records 9(3):157–294. Berkeley, CA.

Gleeson, Paul, 1970. "Dog Remains from the Ozette Village Archaeological Site." M.A. thesis, Washington State University, Pullman, WA.

Gustafson, Paula, 1980. *Salish Weaving.* Douglas & McIntyre, Vancouver, B.C., and University of Washington Press, Seattle, WA.

Holm, Bill, 1965. *Northwest Coast Indian Art: An Analysis of Form.* University of Washington Press, Seattle, WA.

Kent, Susan, 1975. "An Analysis of Northwest Coast Combs with Special Emphasis on those from Ozette." M.A. thesis, Washington State University, Pullman, WA.

McMillan, Alan D., 1999. *Since the Time of the Transformers: The Ancient Heritage of the Nuu-chah-nulth, Ditidaht, and Makah.* UBC Press, Vancouver, BC, Pacific Rim Archaeology series.

Mitchell, Donald H., 1990. "Prehistory of the Coasts of Southern British Columbia and Northern Washington." In Wayne Suttles, ed., *Handbook of North American Indians, Vol. 7: Northwest Coast,* 340–58. Smithsonian Institution, Washington, D.C.

Suttles, Wayne, 1983. "Productivity and Its Constraints: A Coast Salish Case." In R.L. Carlson, ed., *Indian Art Traditions of the Northwest Coast,* pp. 67–87, Archaeology Press, Burnaby, B.C.

Wyatt, Gary, ed., 2000. *Susan Point, Coast Salish Artist.* Douglas & McIntyre, Vancouver, B.C., and University of Washington Press, Seattle, WA.

FACING
**British Columbia
Welcomes the World**
July 1994 · Edition size: 20
Serigraph · 22 × 21⅞ inches

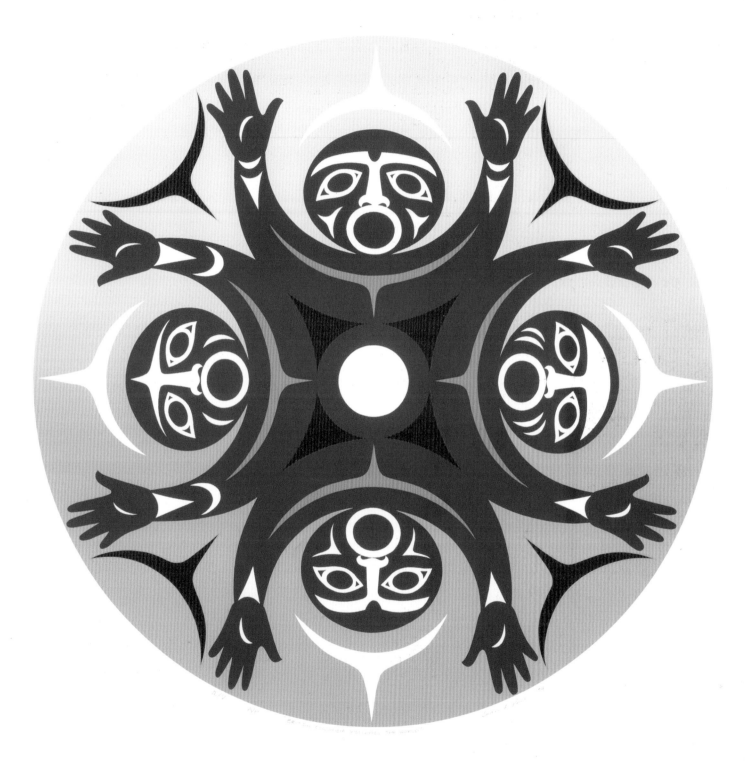

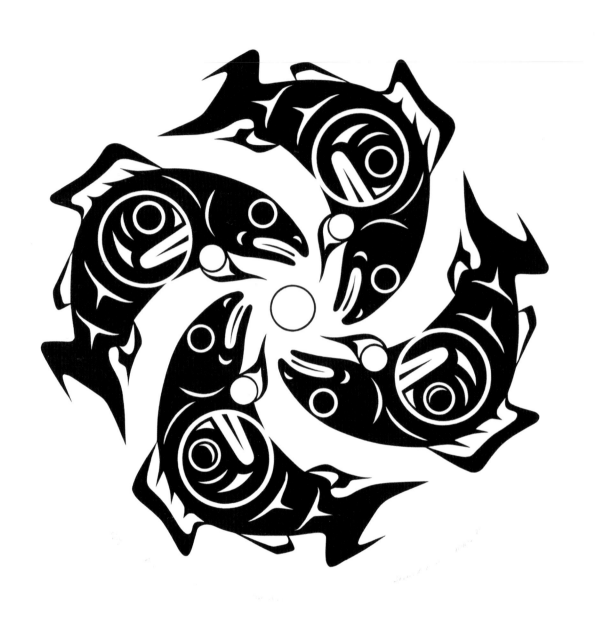

Salmon

April 1981 · Edition size: 45

Serigraph · 19⅞ × 19⅞ inches

Kwantlen
August 1983 · Edition size: 100
Serigraph · 22¼ × 30⅛ inches

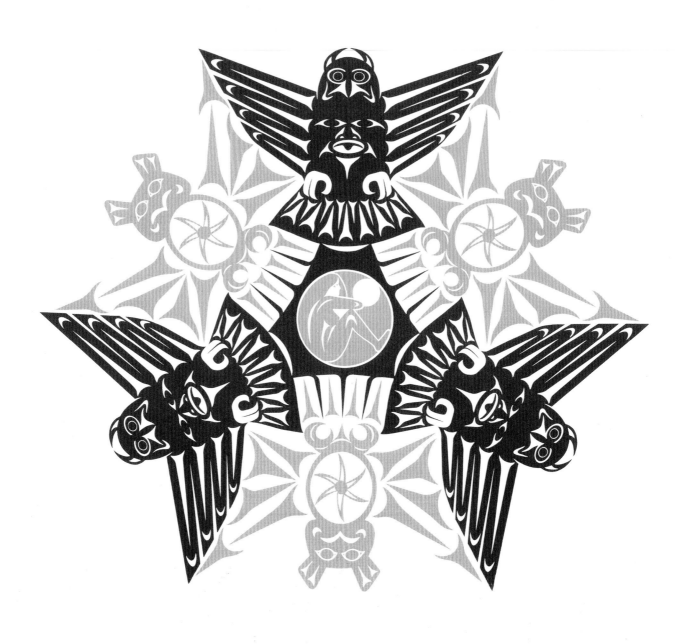

Captive Maiden

December 1983 · Edition size: 90
Serigraph · 23 × 20⅞ inches

FACING

Coast Salish Design

November 1984 · Edition size: 80
Serigraph · 33 × 20 inches

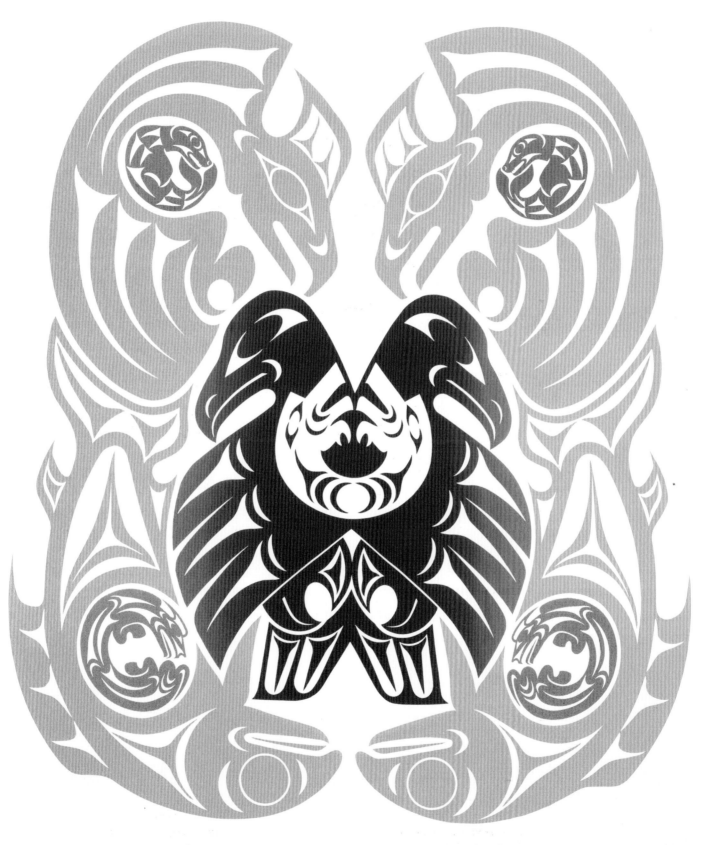

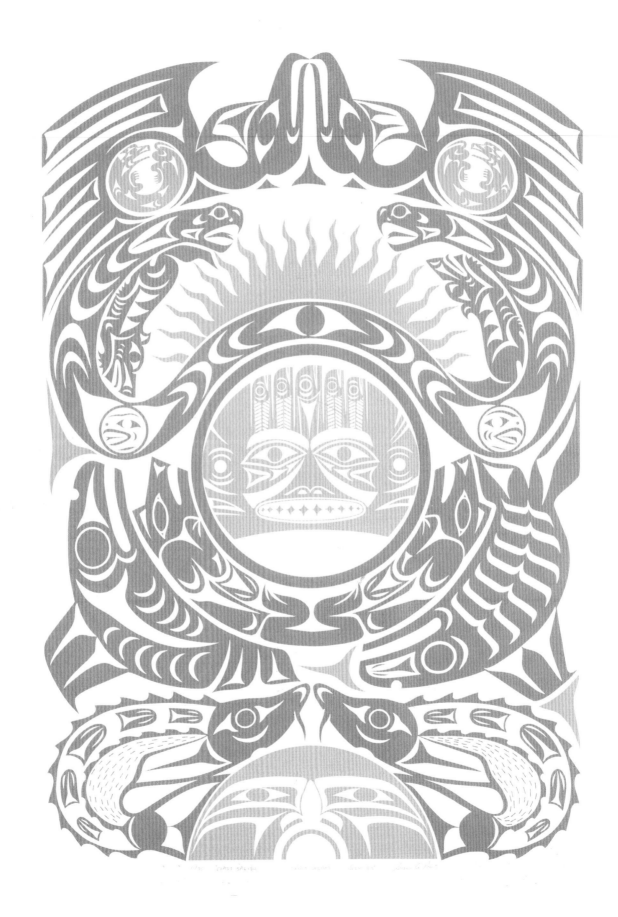

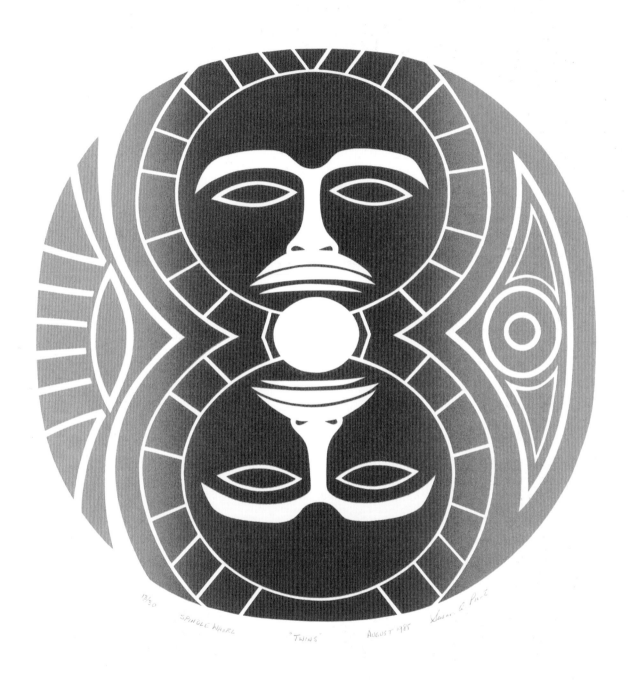

13/30 SPINDLE WHORL "TWINS" AUGUST 1985 Susan A. Point

FACING
Spirit Dreams
July 1985 · Edition size: 35
Serigraph · 30⅛ × 22⅛ inches

Twins
August 1985 · Edition size: 30
Serigraph · 14⅞ × 12¾ inches

23

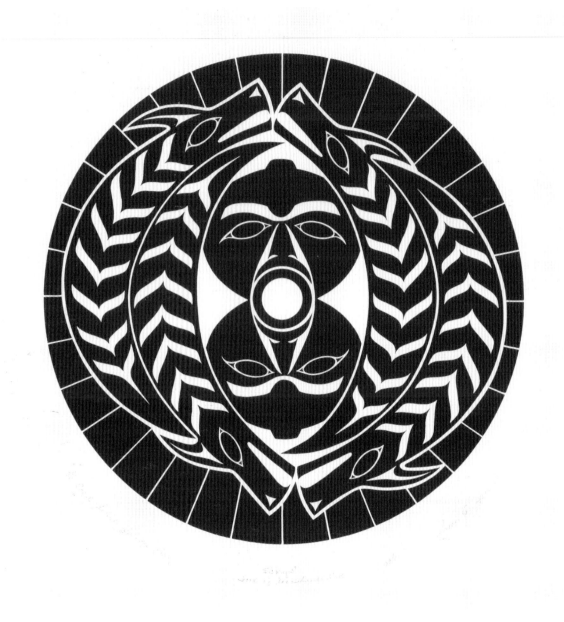

**Scinqua—Food of
the Thunderbids**

May 1986 · Edition size: 70
Serigraph · 17⅞ × 13 inches

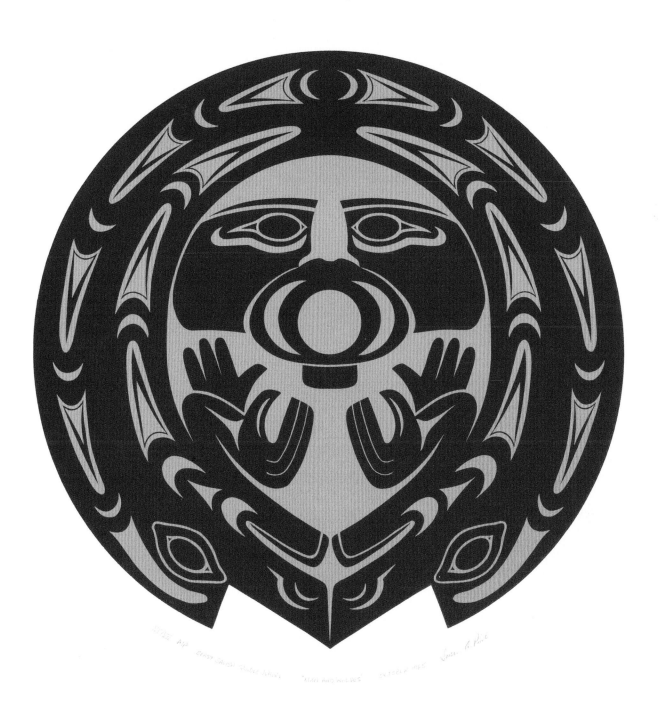

Man and Wolves

October 1985 · Edition size: 55
Serigraph · 19⅝ × 19½ inches

ABOVE ALL ELSE, sly and cunning Raven loved to play tricks on humans. Perched high atop a tree, he spied the village women with berry baskets walk into the woods. A glint appeared in his eye as trickery formed in his mind. Darting silently from tree to tree, he watched as the women filled their baskets with the sweet and succulent bounty of the forest.

Then, in a magic instant, Raven descended and took on a human form. He charged through the underbrush and shouted: "The enemy's war canoes are attacking the village. Run for your lives." Mortified, the women dropped their baskets and scattered in all directions.

When the commotion had subsided into a faint and distant rustle, Raven stopped, pleased with his trickery as he surveyed the treasure laying at his feet. He fell to his knees and gorged himself as only a raven in human form could.

Sated with berries and half delirious and intoxicated, he rolled along the ground, crushing the remaining berries and gradually transforming himself into a horrid and bloody apparition. With some difficulty, he raised himself and loudly proclaimed victory over the enemy.

One by one the women returned, uttering words of praise and gratitude to their bloody hero. As they approached, however, a tiny snail who had watched the entire affair from the safety of a nearby log, told the women how they had been cheated.

Stunned and bewildered, their gratitude turned to rage. And as one body they threw themselves at Raven. But the smart and wily Raven instantly changed into his true form and escaped their wrath with a few strokes of his powerful wings, cawing gleefully as he disappeared into the trees.

SUSAN POINT

FACING
Raven
February 1985 · Edition size: 30
Serigraph · 19¾ × 12¾ inches

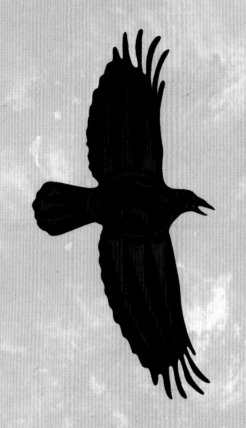

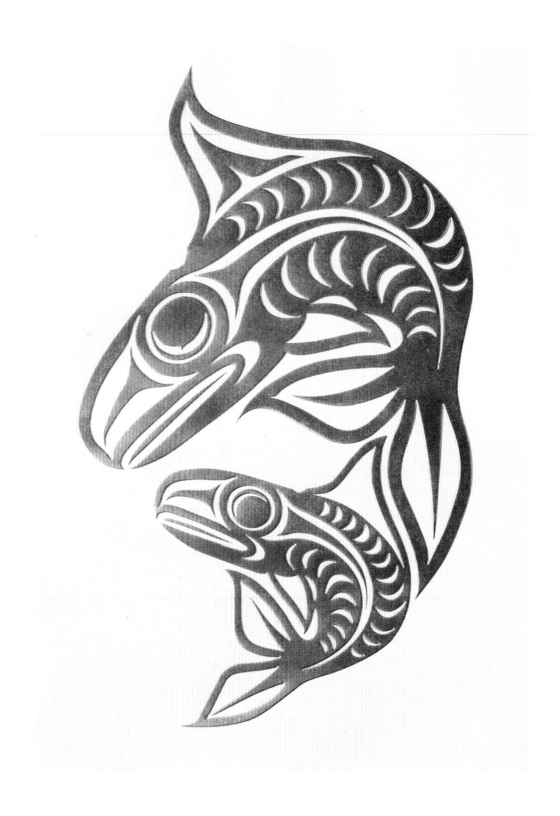

Killer Whale and Calf

April 1988 · Edition size: 1000

23-karat gold embossing

14 × 10½ inches

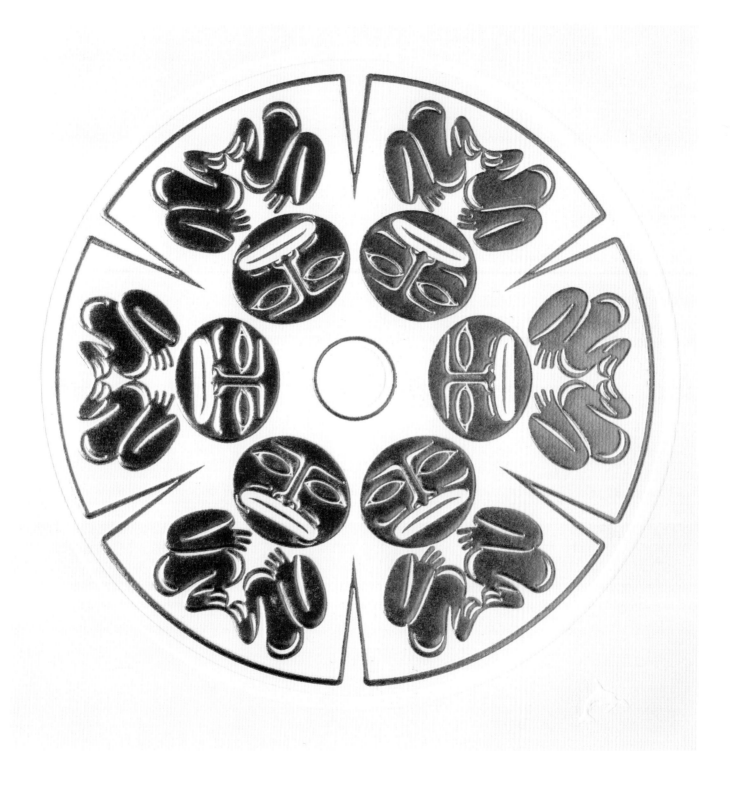

Tribal Council

June 1986 · Edition size: 1000

23-karat gold embossing

14 × 12⅛ inches

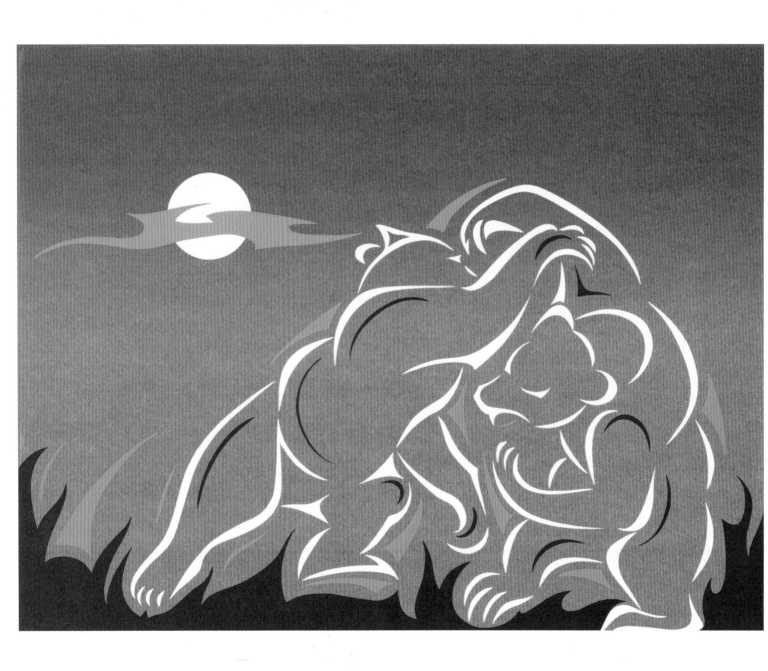

Moonlight Battle

August 1987 · Edition size: 30

Serigraph · 12⅝ × 15 inches

FACING

Spirit of a Warrior

June 1986 · Edition size: 65

Serigraph · 20⅜ × 15¼ inches

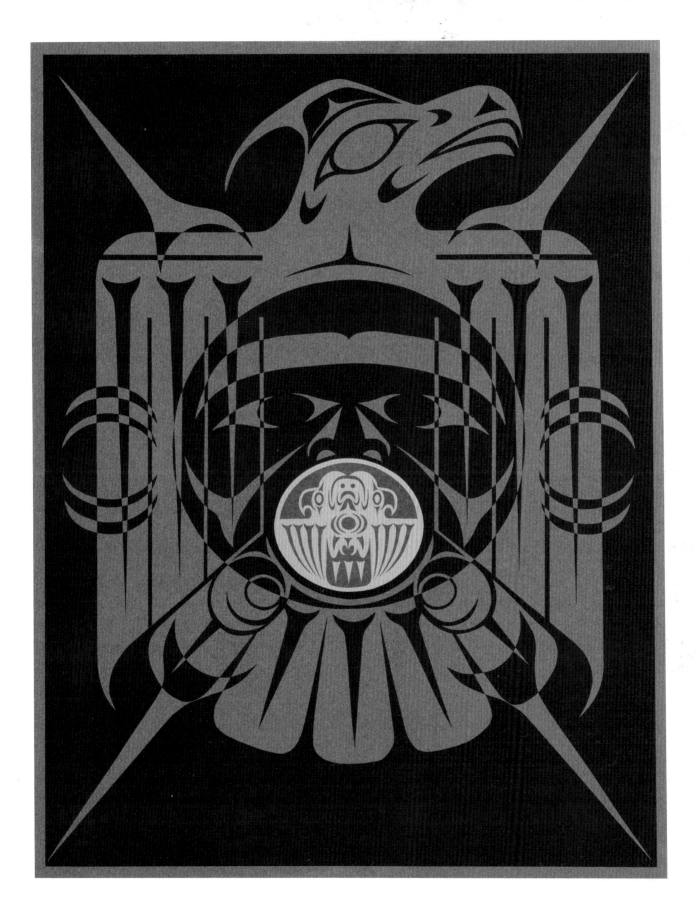

Qulqulil

January 1986 · Edition size: 25

Serigraph · 29½ × 29 inches

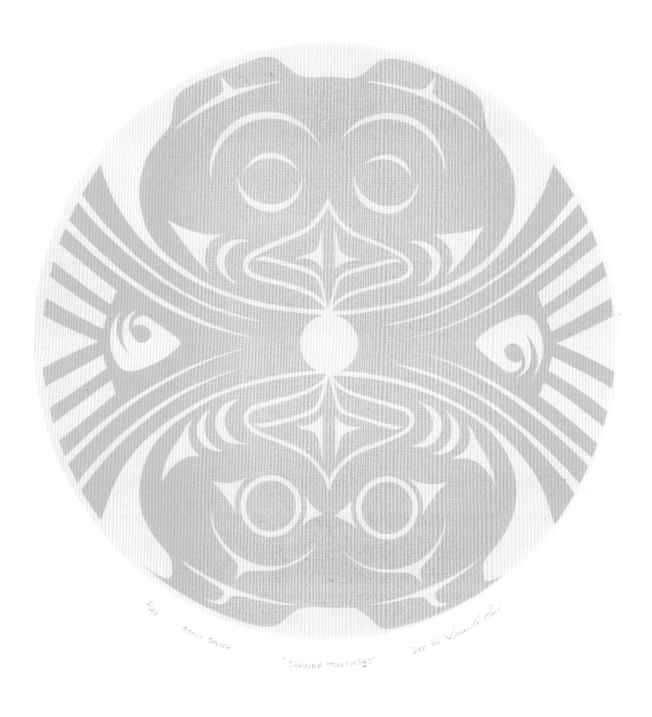

Skakala Tseetmoks

December 1986 · Edition size: 40

Serigraph · 13⅛ × 12¾ inches

33

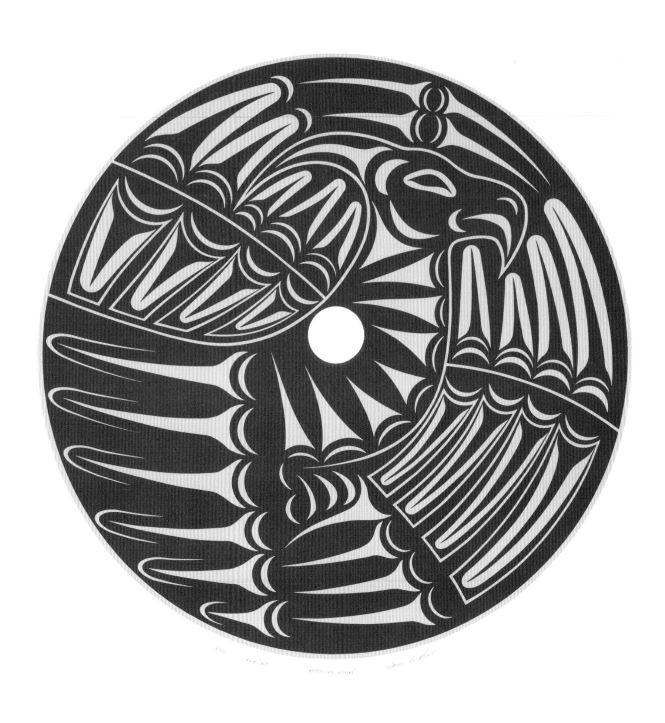

Mystical Whorl

February 1987 · Edition size: 40

Serigraph · 19 × 18⅓ inches

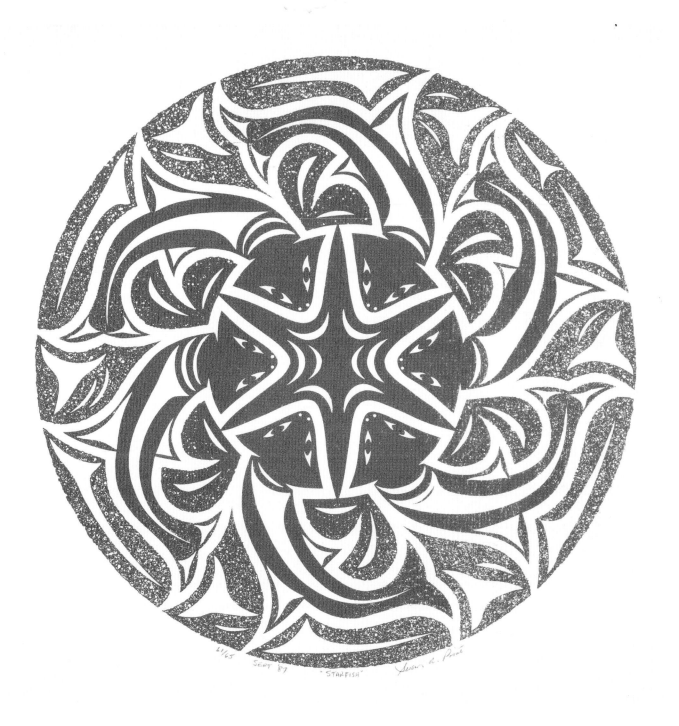

Starfish

September 1987 · Edition size: 65

Serigraph · 13¾ × 13 inches

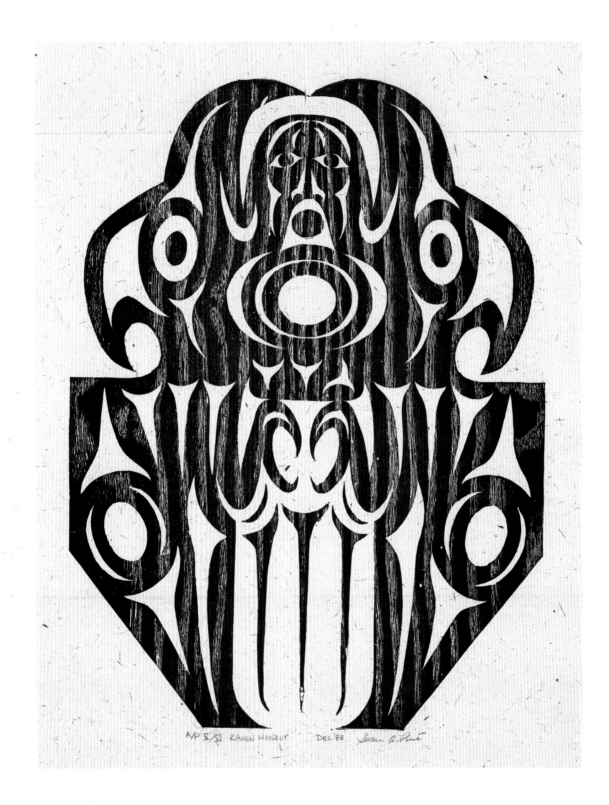

Raven Woodcut

December 1988 · Edition size: 60

Woodcut block print · 15 × 10⅞ inches

Handmade paper of cedar bark

FACING

Slahal Drum and Kingpin

April 1988 · Edition size: 30

Woodcut block print

18 × 15⅛ inches

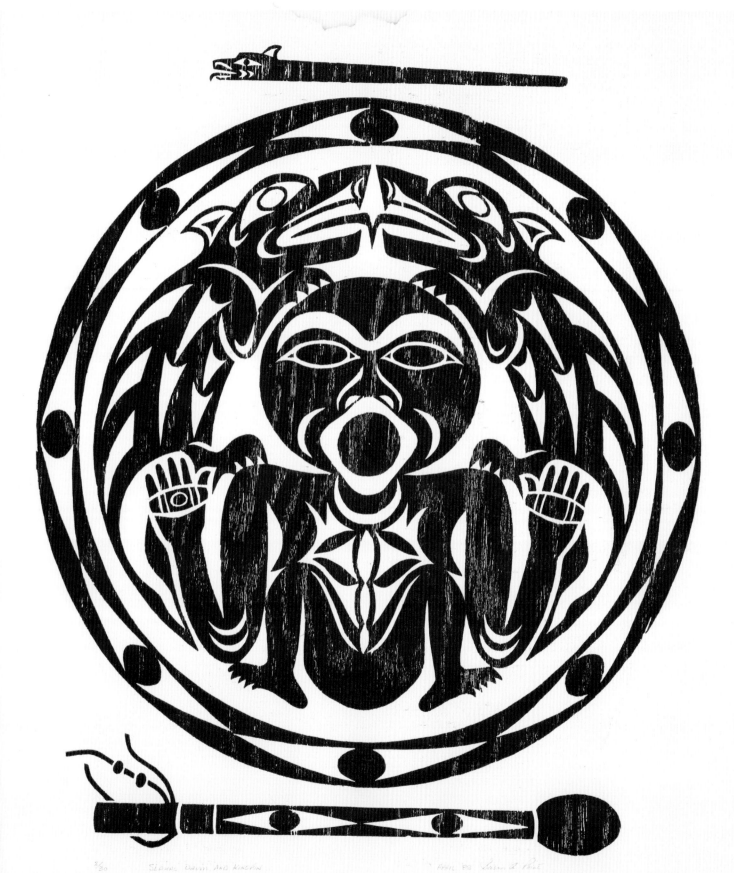

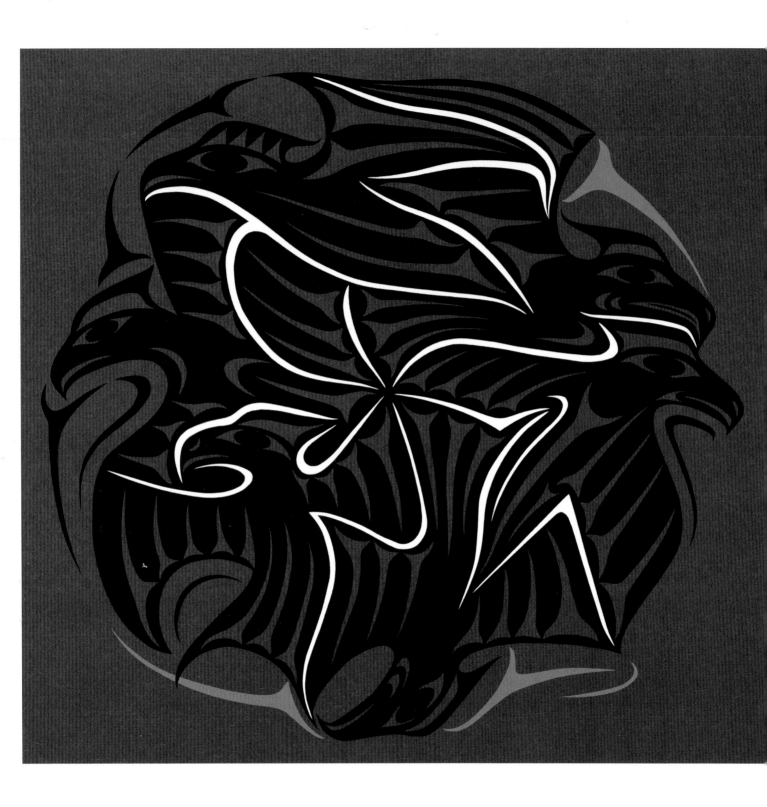

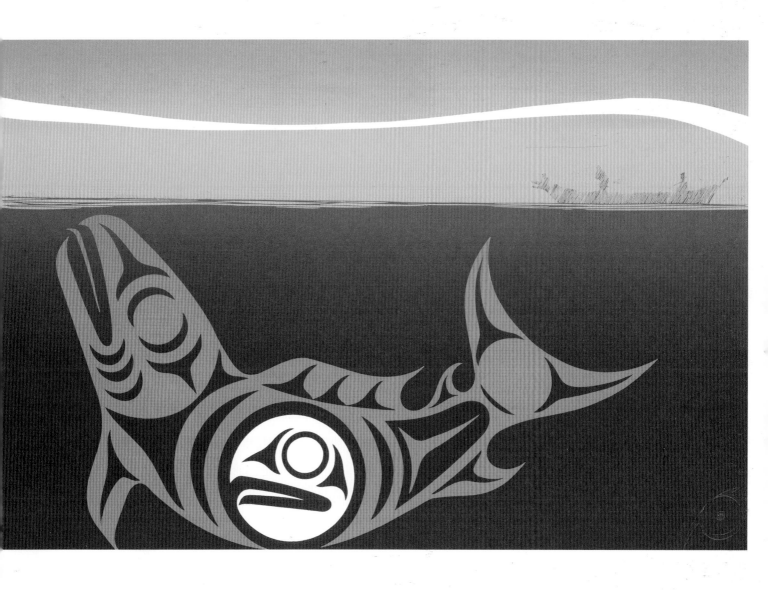

FACING
Northern Watch
November 1988 · Edition size: 40
Serigraph · 14 × 14 inches

Fishing
November 1988 · Edition size: 45
Serigraph · 9¾ × 14 inches

39

MANY YEARS AGO there was a woman and her children who lived by the beach. One morning the woman dressed her children and sent them out to play. While the children played on the beach amongst the logs, they came across a nest of snakes. The snakes were startled and began attacking the children, who screamed and cried out. The woman heard the screams and went to investigate. Seeing the snakes attacking her children, she picked up a big stick and began clubbing the snakes to death, except for the mother snake, who was only wounded. The woman brought her children home to safety.

That night when she fell asleep, she dreamed of a beautiful lady who was crying for help. The beautiful lady told the woman that in the fight she had killed all of the beautiful lady's children and wounded her seriously too. Then the beautiful lady explained that since the woman had killed all of her children, her own children would also perish; if she had spared at least the youngest of the snake children, her own children would have been spared. As time passed, the beautiful lady's prediction came true and the woman lost all of her children one by one. After all those happenings, the woman and the beautiful lady became the best of friends. When the woman became a Spirit Dancer her powers were those of the snake song. The beautiful lady also blessed her with good luck, and anything she did because of that good luck, she did well.

SUSAN POINT

FACING
Snake Lady
April 1990 · Edition size: 90
Serigraph · 17 × 17 inches

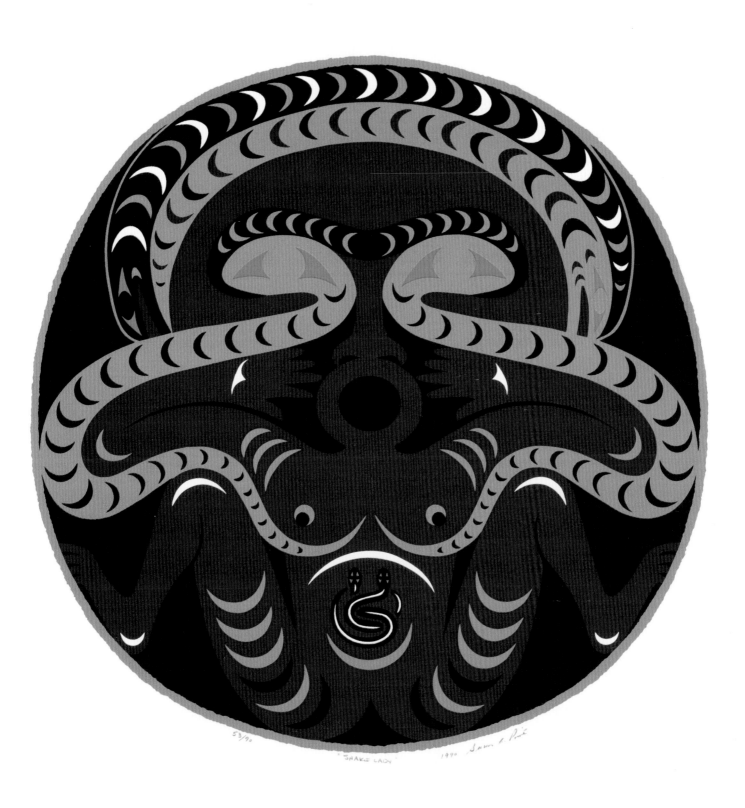

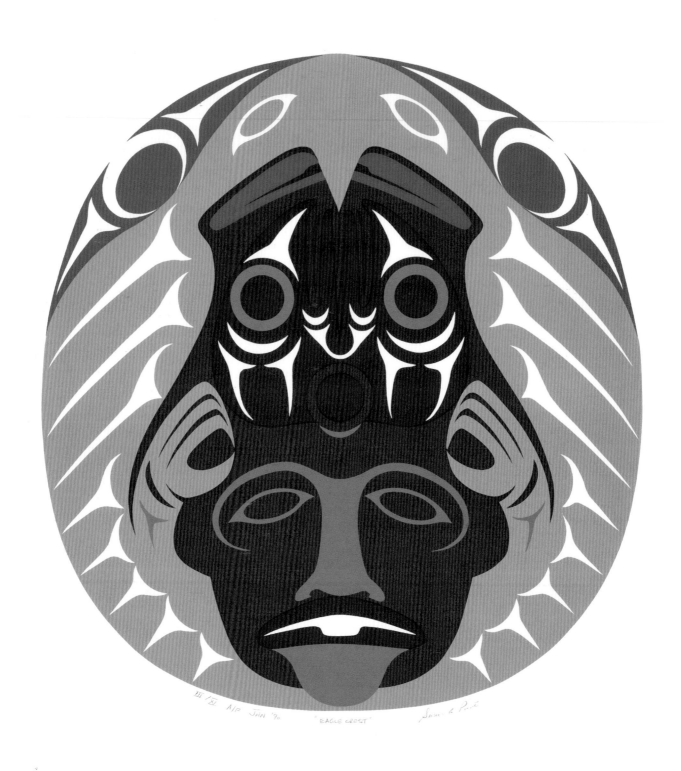

Eagle Crest

January 1990 · Edition size: 110

Serigraph · 16¾ × 15¼ inches

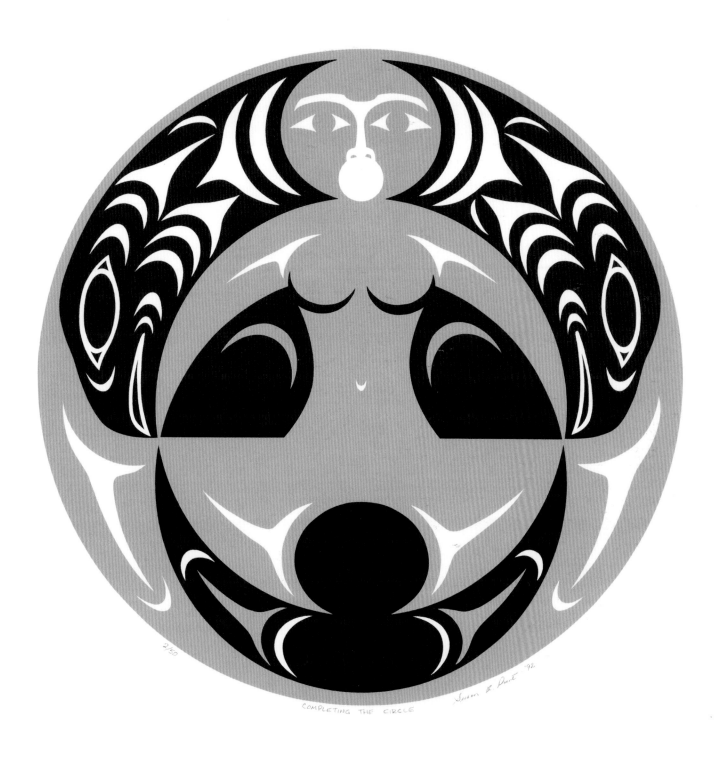

2/50 COMPLETING THE CIRCLE Susan A. Point '92

Completing the Circle
April 1992 · Edition size: 50
Serigraph · 16¼ × 16¼ inches 43

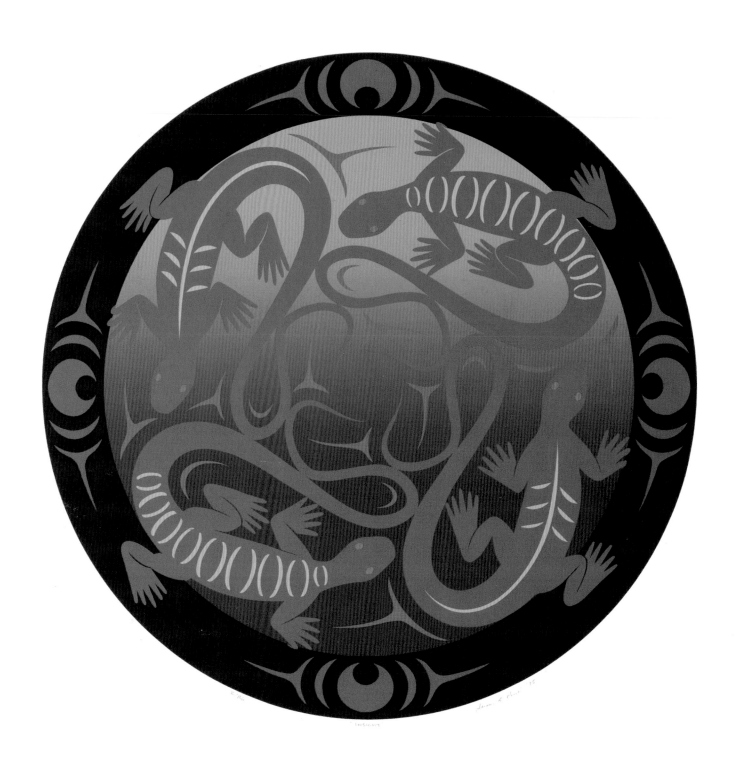

Insight (Thunder Lizards)

September 1995 · Edition size: 86

Serigraph · 22 × 21¼ inches

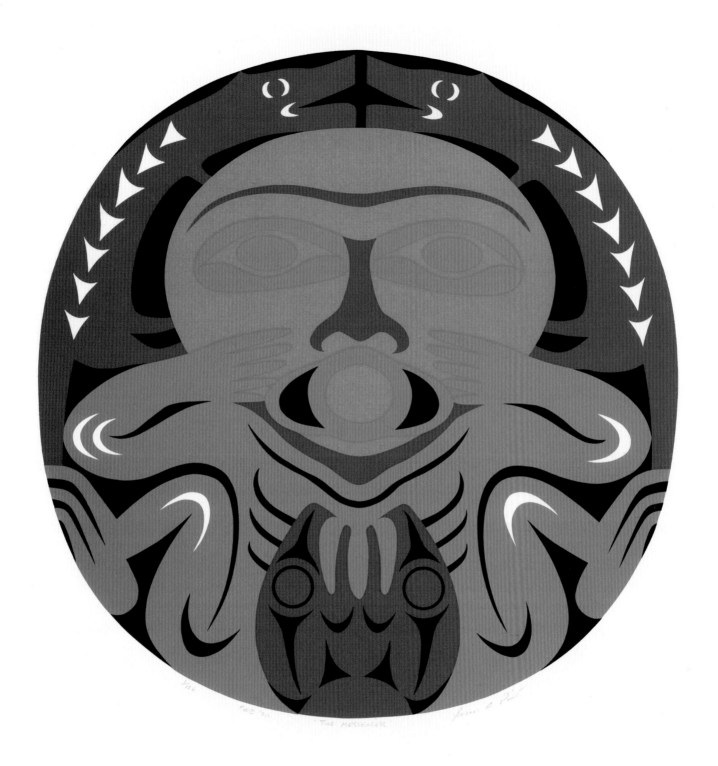

The Messenger

February 1990 · Edition size: 126

Serigraph · 16 × 15 inches

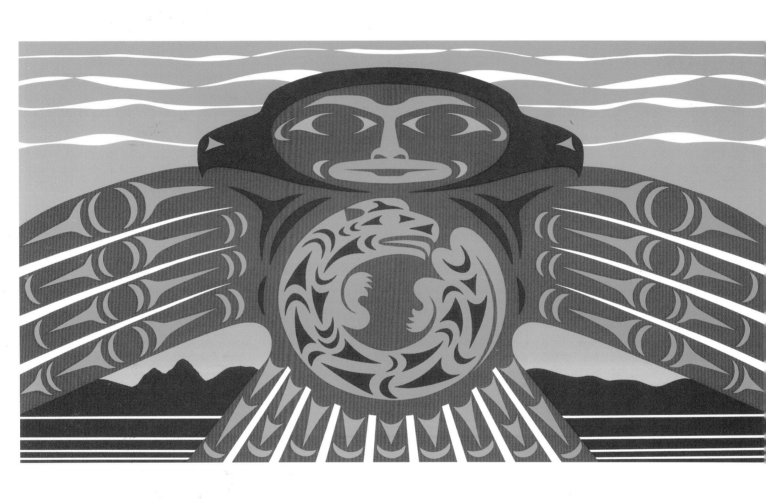

Pacific Spirit '91
November 1990 · Edition size: 200
Serigraph · 13¼ × 22⅜ inches

FACING
Spirit of an Eagle
May 1991 · Edition size: 105
Serigraph · 27¾ × 19¼ inches

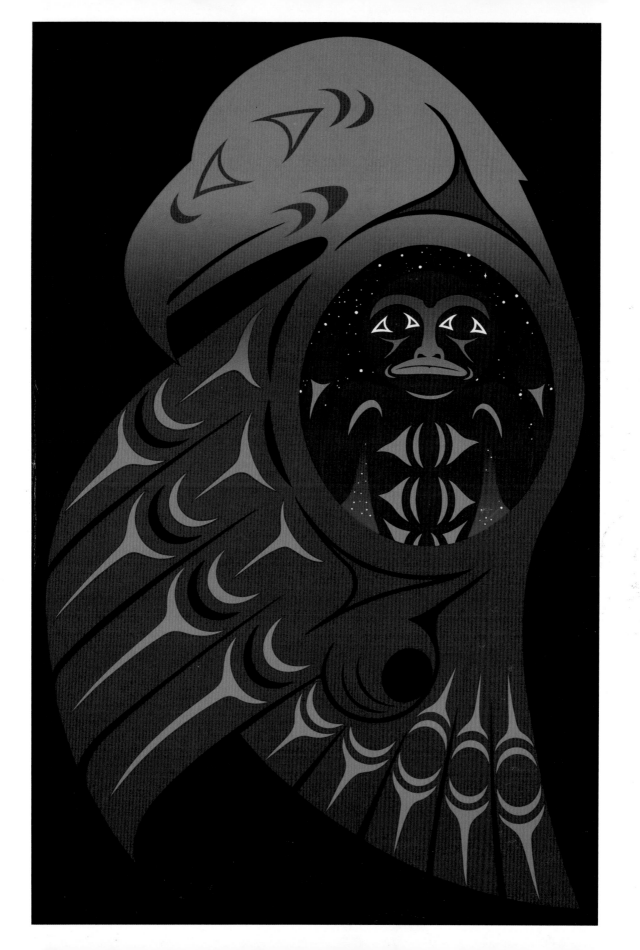

THE FROG IS very important to my people. In the area of our village we have numerous varieties of frogs. Most abundant are the small green tree frogs. In the spring, thousands sing in harmony during the early dusk. The song symbolizes the change of seasons. The song tells us the winter ceremonies and longhouse season is over and that it is time to prepare for the fishing and gathering to come.

SUSAN POINT

FACING
Frog and Butterfly
May 1990 · Edition size: 90
Serigraph · 16 x 15⅛ inches

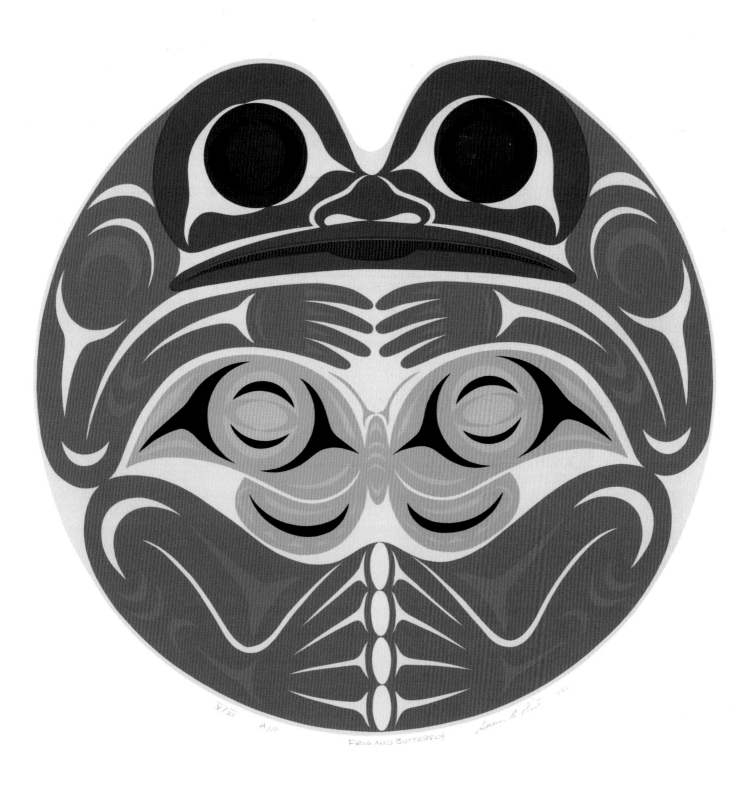

FROG AND BUTTERFLY

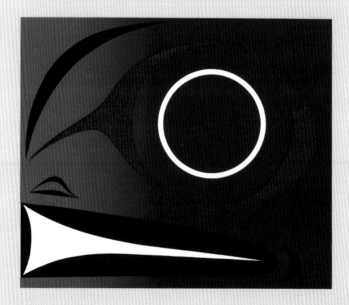

Survivor
June 1992 · Edition size: 44
Serigraph · 7½ × 7½ inches

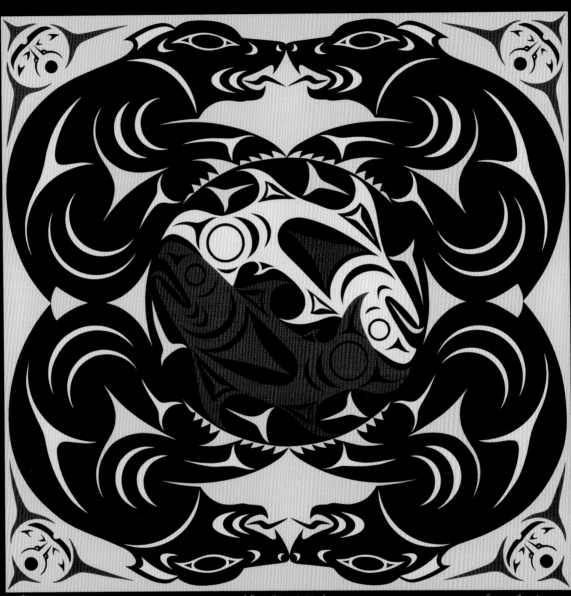

2/45 · "BLACK BEAR CHILDREN" · Susan A. Point '92

Black Bear Children

May 1992 · Edition size: 45

Serigraph · 20⅞ × 20⅞ inches

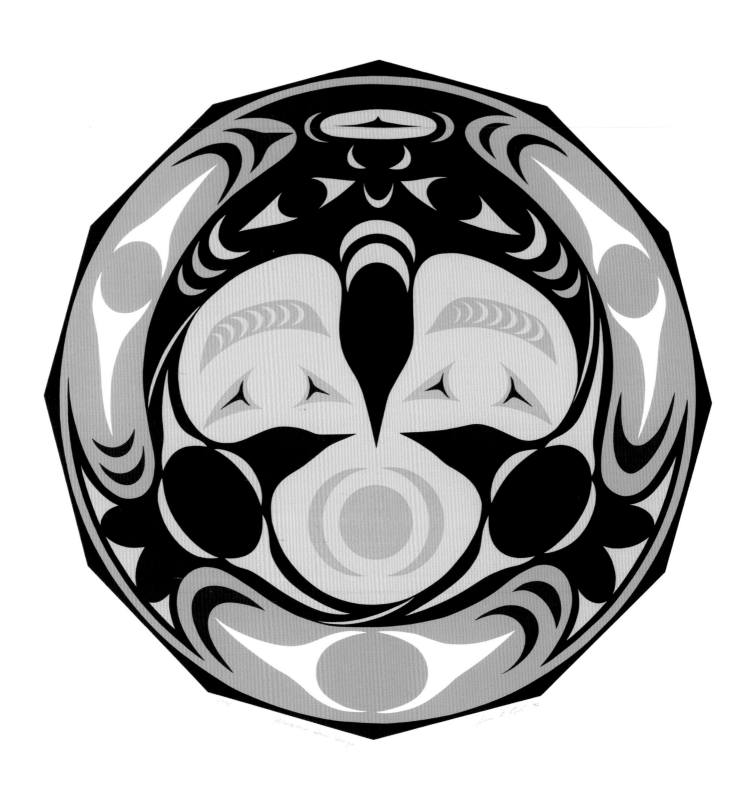

Blackbird Drum Design

February 1992 · Edition size: 75

Serigraph · 22 × 22 inches

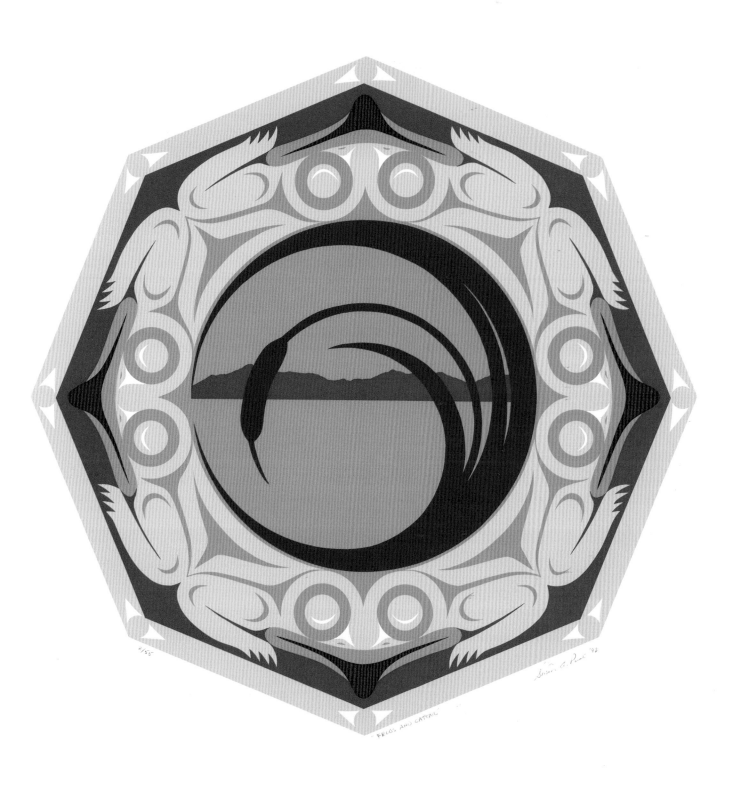

Frogs and Cattail

October 1992 · Edition size: 55

Serigraph · 17 × 17 inches

53

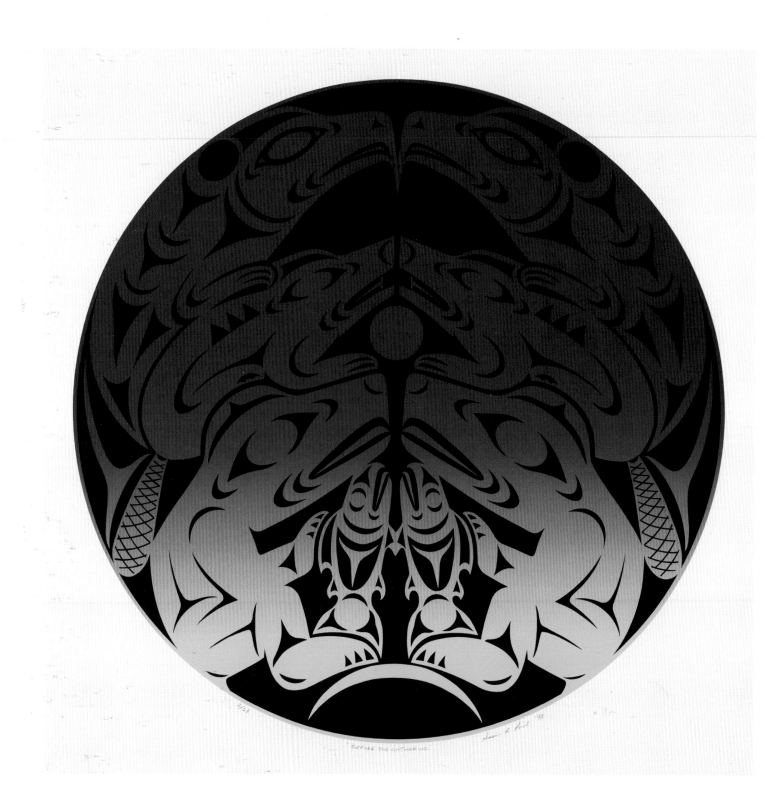

Before the Gathering State I

January 1993 · Edition size: 28

Serigraph · 22¼ × 20⅝ inches

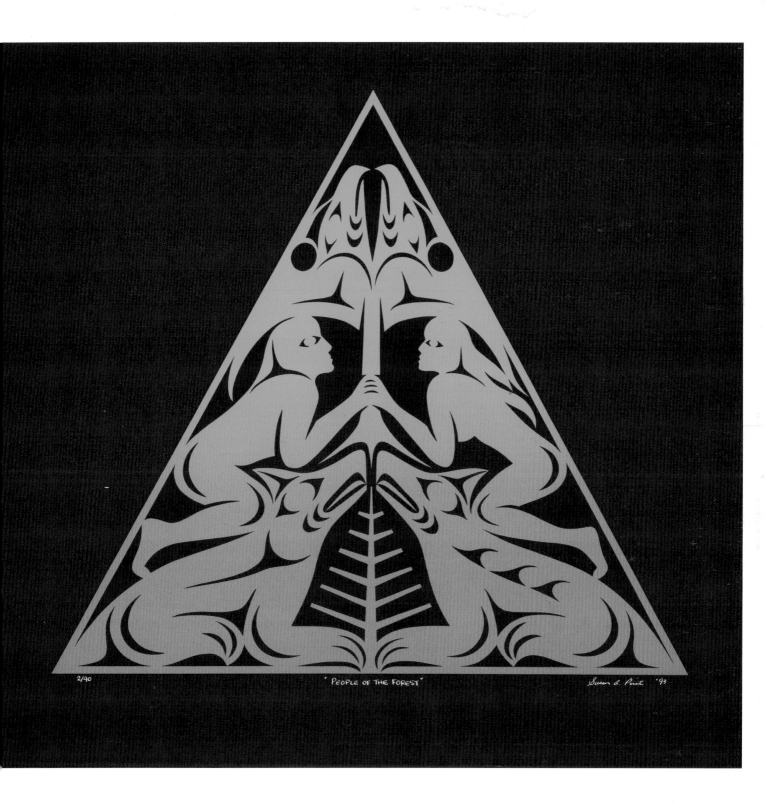

People of the Forest

June 1993 · Edition size: 90
Serigraph · 17¾ × 16½ inches

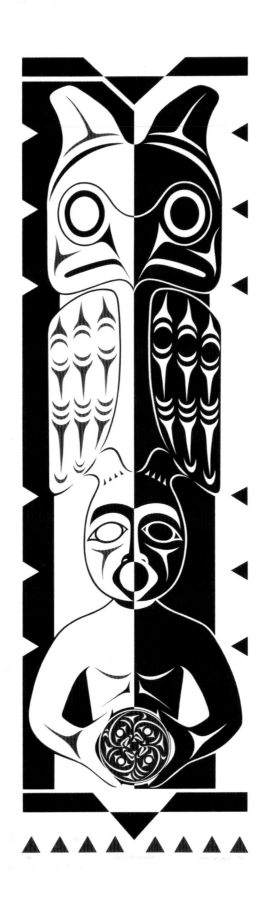

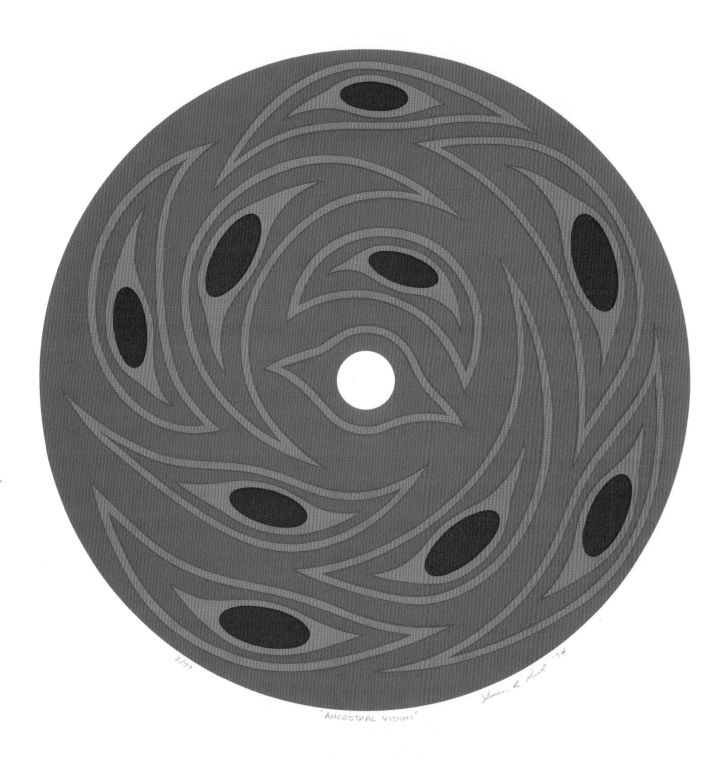

2/77

"ANCESTRAL VISION"

FACING
Salish Housepost
February 1993 · Edition size: 80
Serigraph · 30 × 11¼ inches

Ancestral Vision
March 1994 · Edition size: 77
Serigraph · 15 × 15 inches

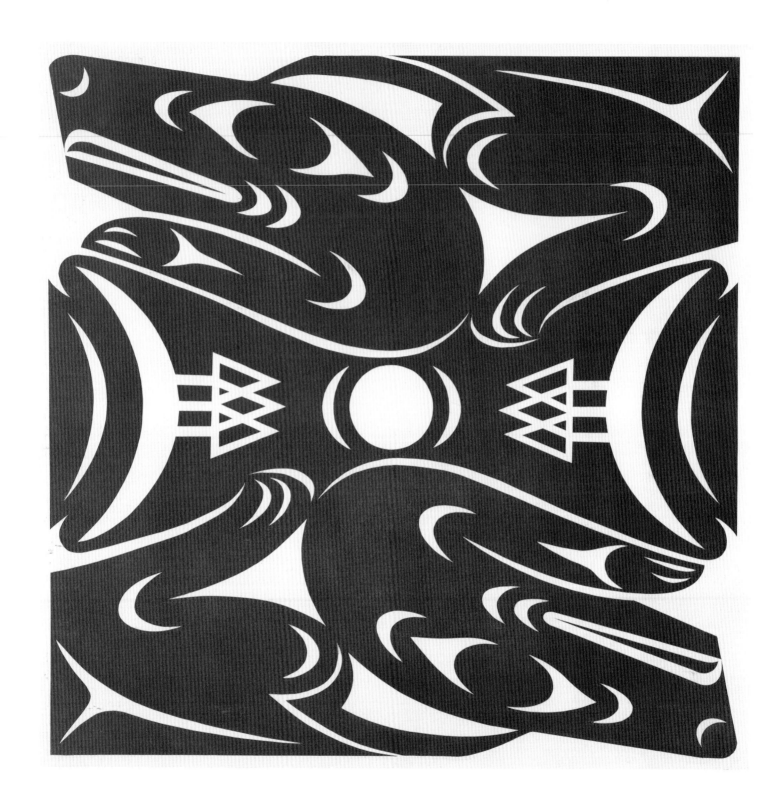

Land

November 1993 · Edition size: 30

Intaglio aquatint etching · 30 × 30 inches

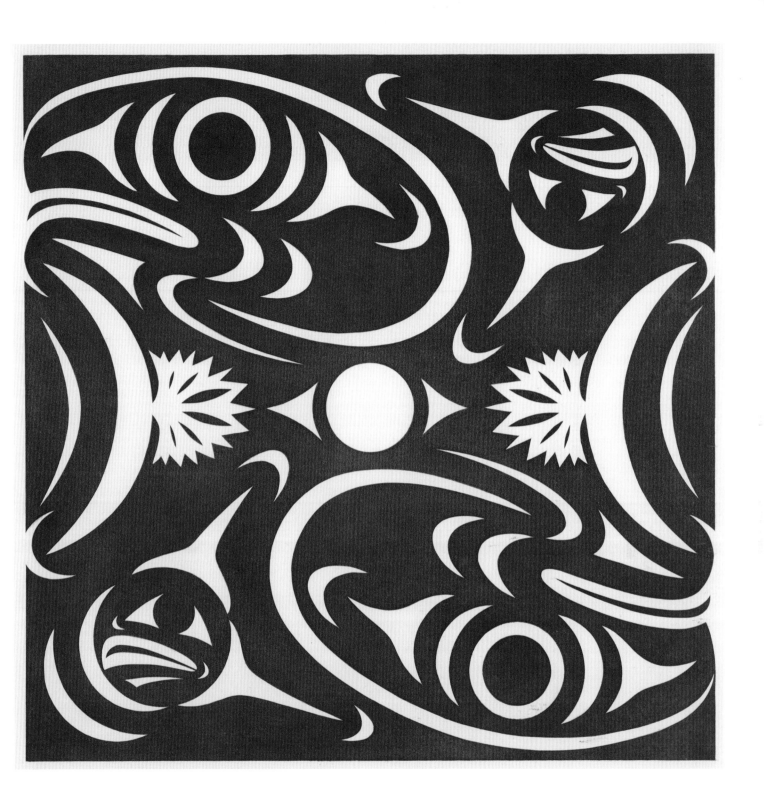

Sea

November 1993 · Edition size: 30

Intaglio aquatint etching · 30 × 30 inches

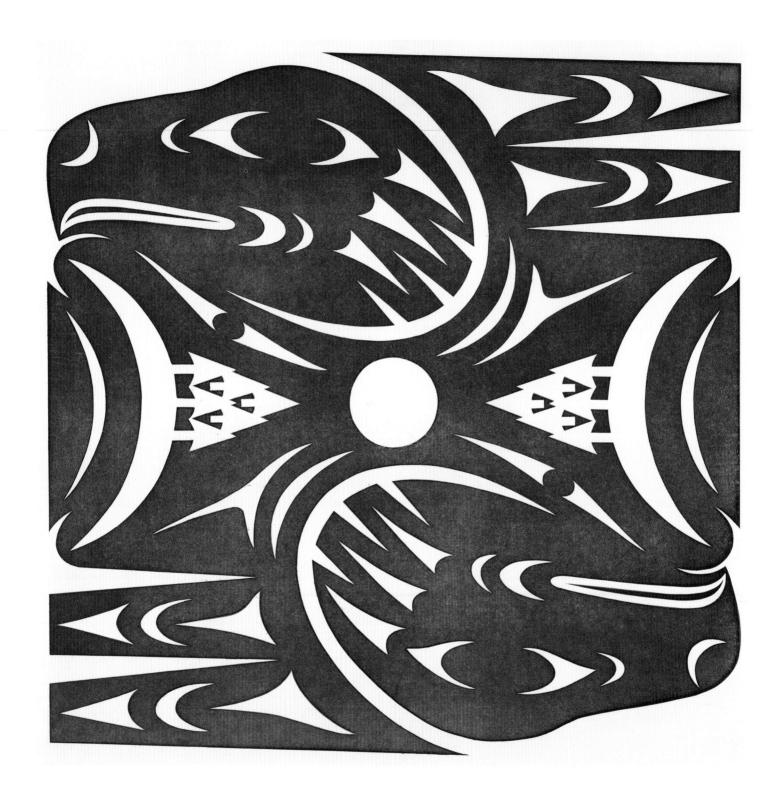

Sky

November 1993 · Edition size: 30

Intaglio aquatint etching · 30 × 30 inches

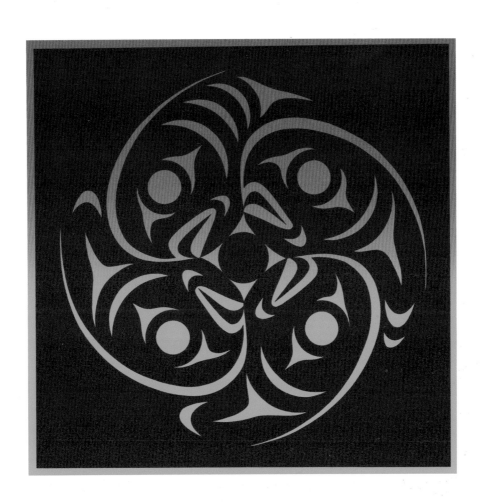

Awakening

March 1993 · Edition size: 50
Serigraph · 13 × 13 inches

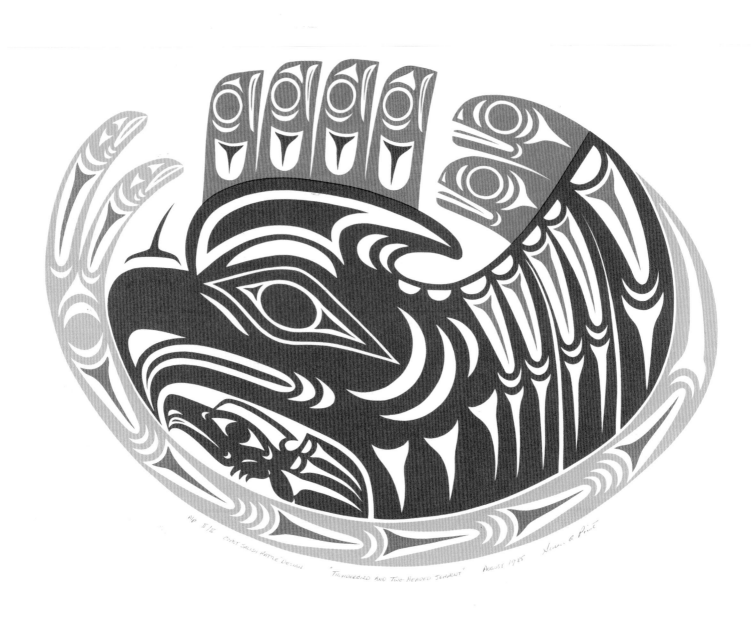

**Thunderbird and
Two-Headed Serpent**

August 1985 · Edition size: 60

Serigraph · 15 × 22¼ inches

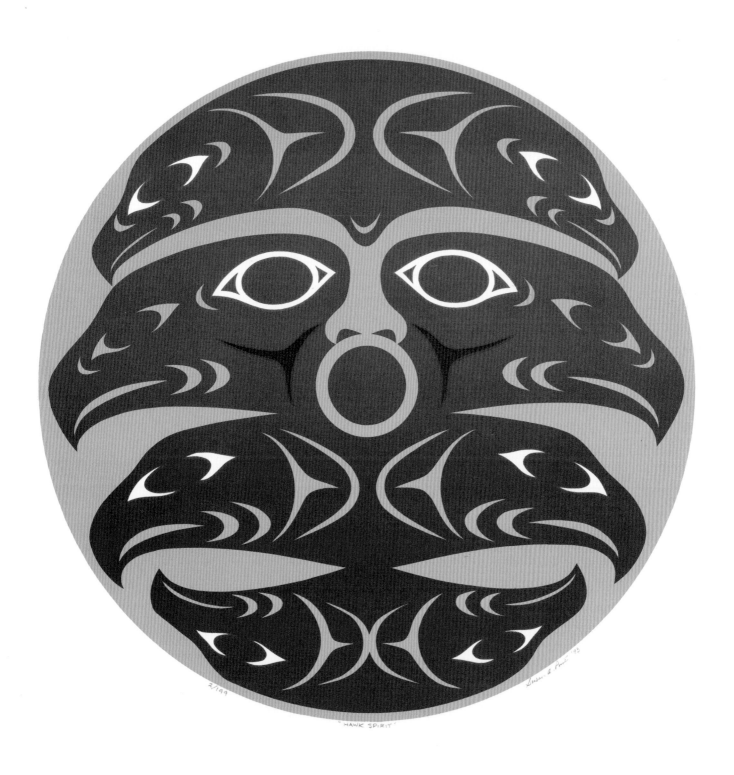

2/199

"HAWK SPIRIT"

Hawk Spirit

May 1993 · Edition size: 199

Serigraph · 11¾ × 11 inches

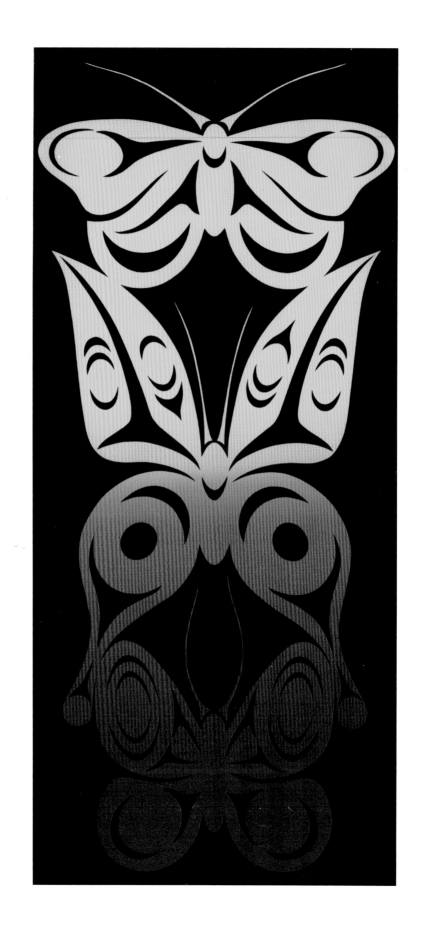

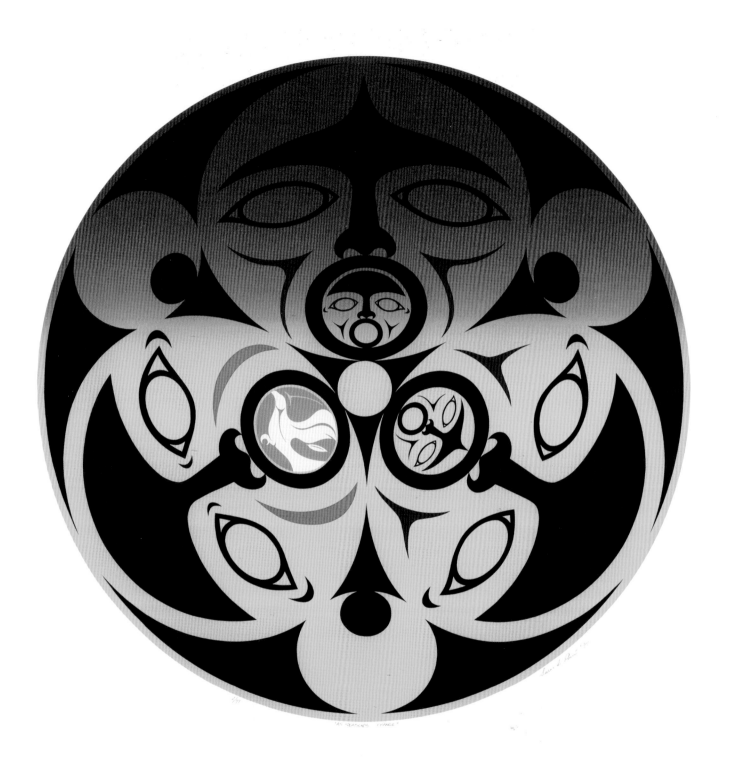

Butterfly II

July 1993 · Edition size: 80

Serigraph · 22 × 10⅝ inches

As Seasons Change

October 1994 · Edition size: 99

Serigraph · 26⅜ × 26 inches

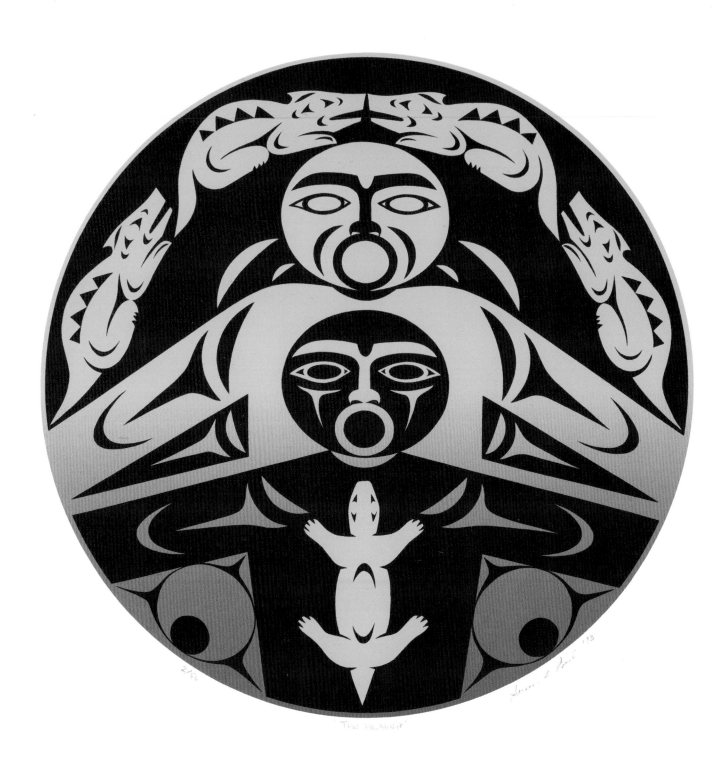

The Healer

September 1993 · Edition size: 80

Serigraph · 11 × 11 inches

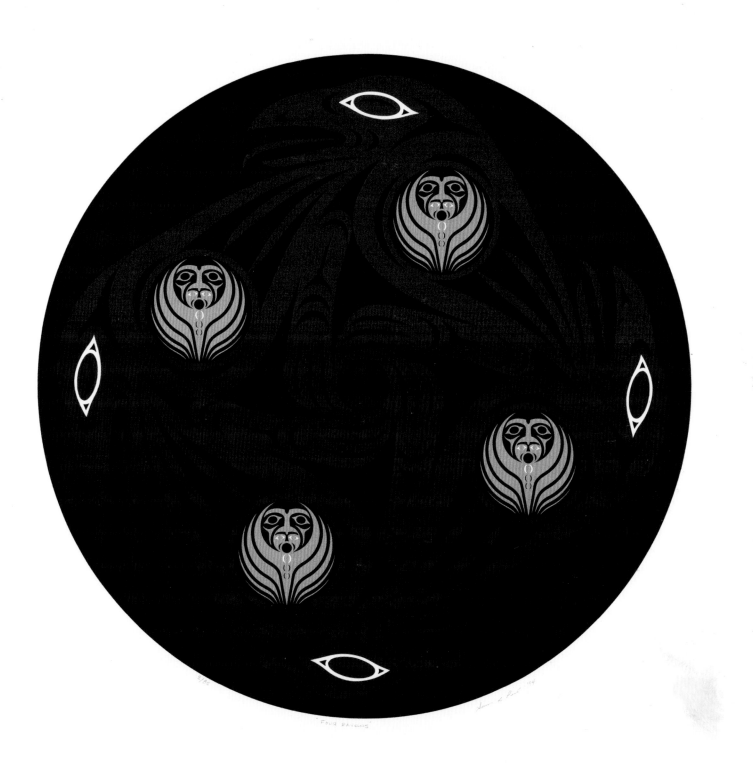

Four Ravens

December 1994 · Edition size: 85
Serigraph · 21⅝ × 19¾ inches

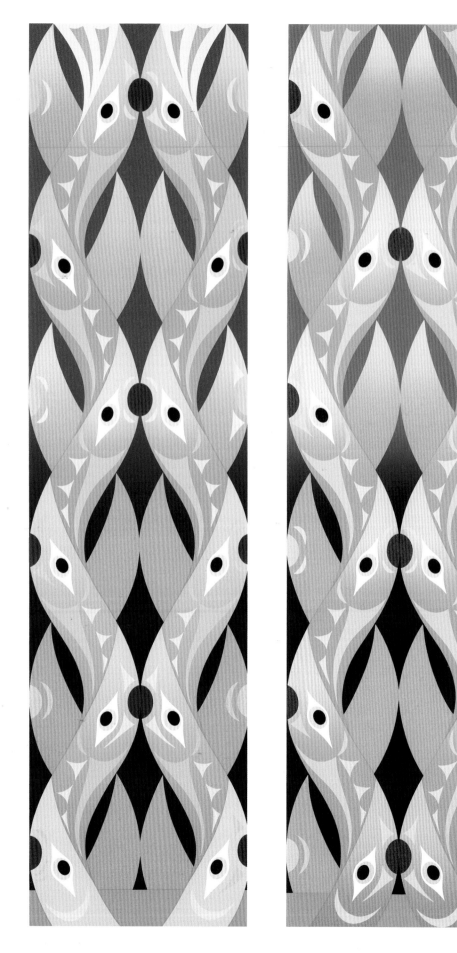

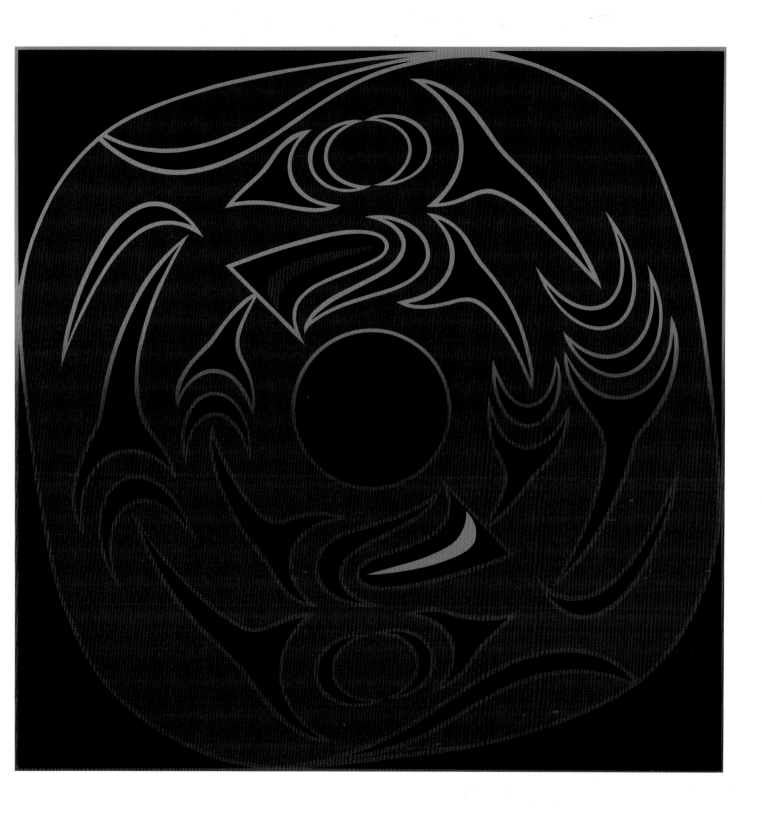

FACING LEFT
The River Woven by Time
March 2002 · Edition size: 100
Serigraph · 32¾ × 11¼ inches

FACING RIGHT
The River Rewoven by Time
January 2003 · Edition size: 100
Serigraph · 32¾ × 11¼ inches

Transition
February 1993 · Edition size: 90
Serigraph · 23 × 23 inches

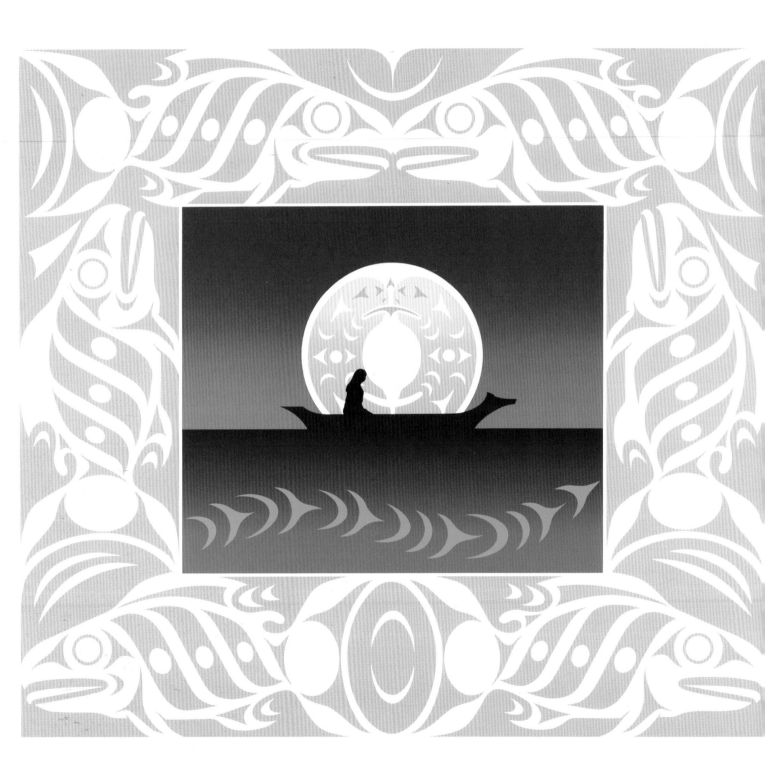

Vision Quest

with Kelly Cannell

December 1994 · Edition size: 99

Serigraph · 28⅓ × 30⅓ inches

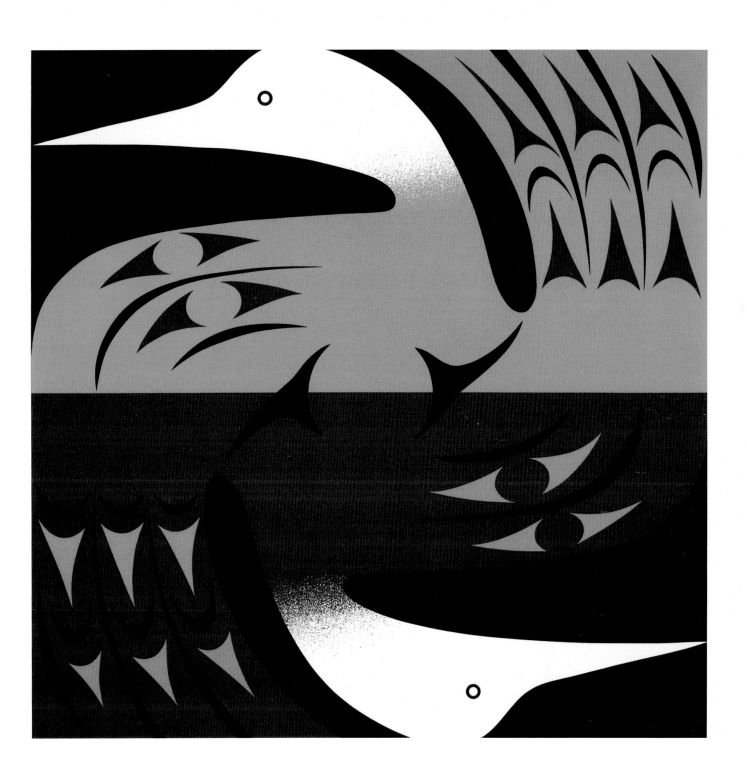

Arctic Loons

January 1994 · Edition size: 88

Serigraph · 22 × 22 inches

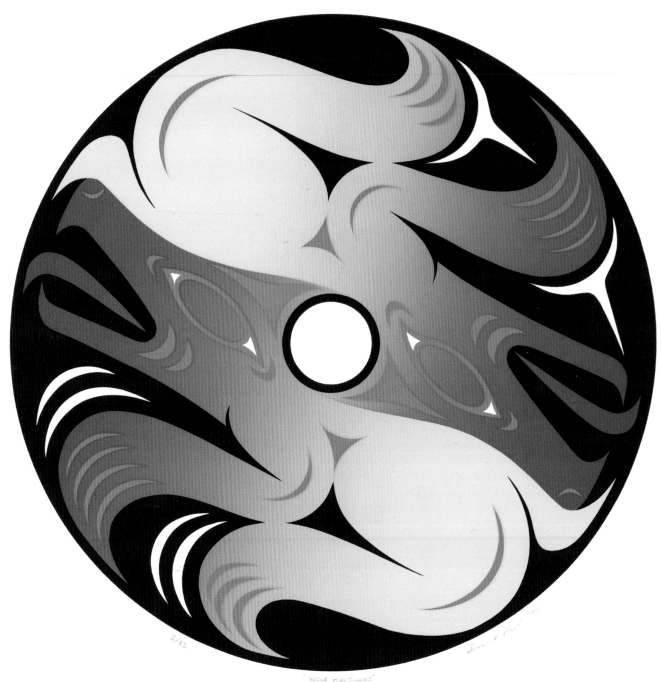

2/82 "WOLF BROTHERS"

Wolf Brothers

August 1994 · Edition size: 82

Serigraph · 16⅛ x 15 inches

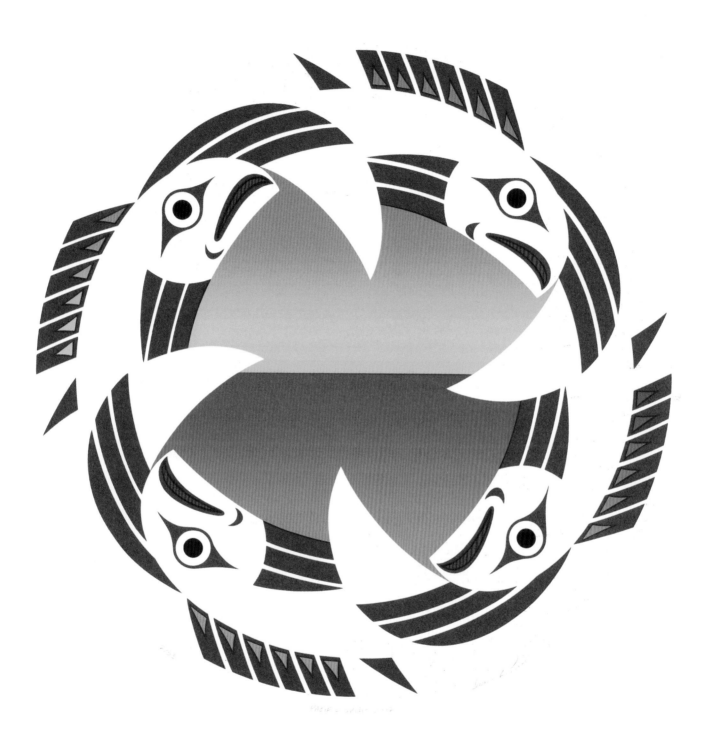

Pacific Spirit 2002

August 2001 · Edition size: 53
Serigraph · 16¼ x 16¼ inches

THIS LIMITED EDITION is a combination of chine-collé and intaglio printing. Chine-collé is a method of adhering thin pieces of coloured paper to the larger printing paper at the same time that the inked image is printed. Intaglio is a method of printing in which ink is forced into incised lines or recessions on a plate, the surface wiped clean, dampened paper placed on top, and paper and plate run through an etching press to transfer the ink to the paper. It encompasses etching, engraving, aquatint, collagraph and other techniques. This particular image is an aquatint (an intaglio method on zinc or copper plates, in which tones are obtained by powdered rosin or paint spray. Acid bites these tones into the plate to various depths, deeper bites yielding darker tones.) *Insignia of Pride* depicts an eagle, a symbol of power that is next in line to the thunderbird. Eagle down is a symbol of peace and friendship. Suggested in this image are two women's faces protected by an eagle (and a salmon head is suggested within the body).

SUSAN POINT

FACING
Insignia of Pride
November 1995 · Edition size: 60
Chine-collé and intaglio etching
8½ × 10 inches

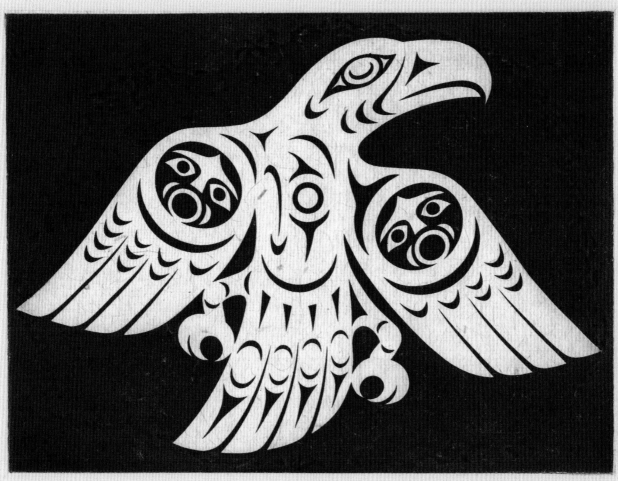

2/60 " INSIGNIA OF PRIDE" Susan A. Point '95

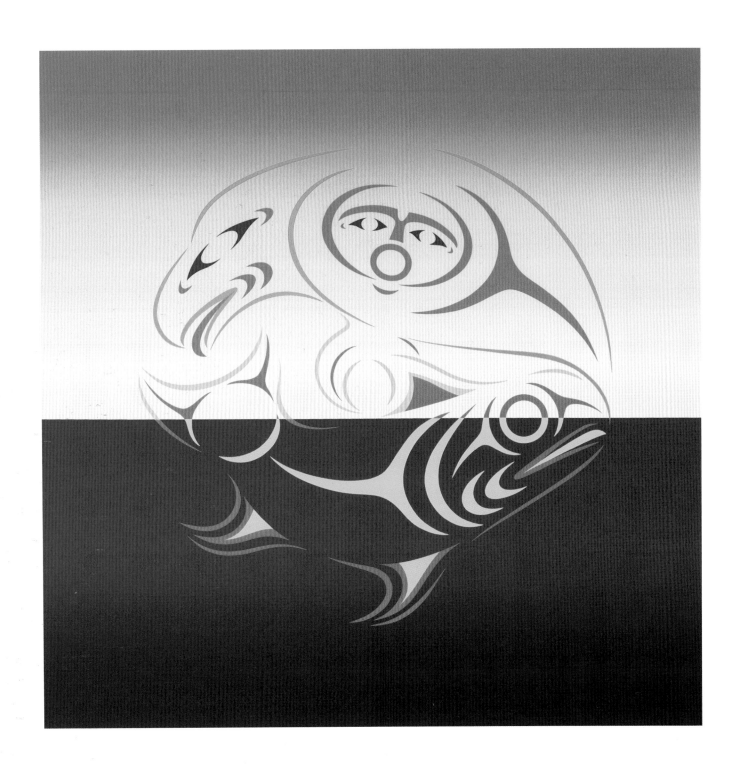

Preservation

September 1996 · Edition size: 152

Serigraph · 23 × 23 inches

FACING

Arrival

July 1996 · Edition size: 10

Serigraph · 23½ × 22 inches

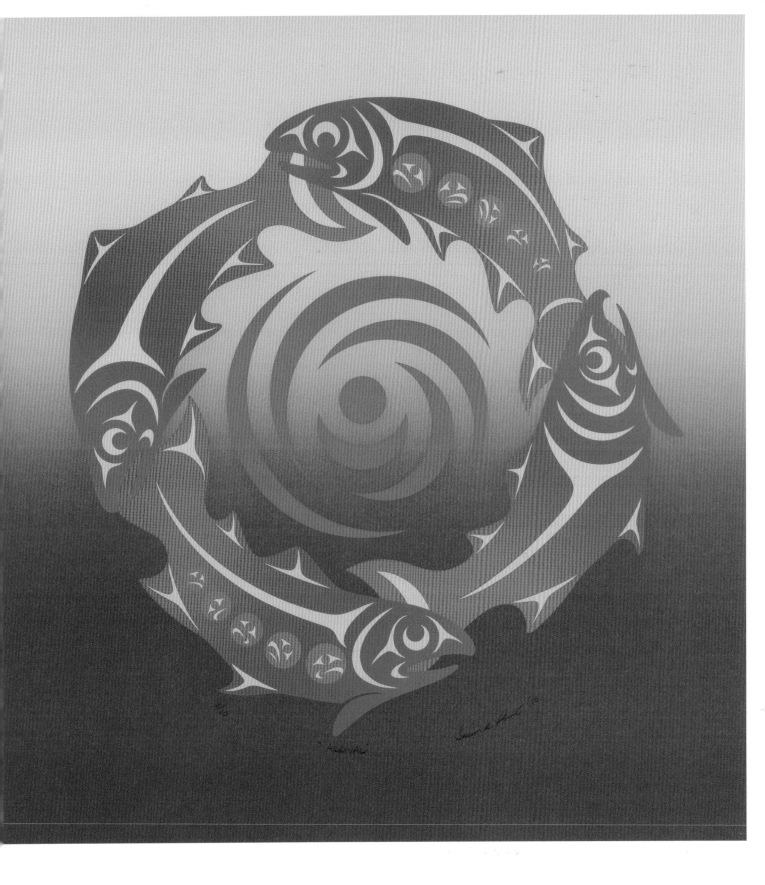

THIS LIMITED EDITION is a combination of chine-collé, intaglio printing and serigraphy. Serigraphy is a stencil process using a mesh stretched over a frame. Ink is forced through openings in the mesh, which can be blocked by a variety of methods.

Free Spirit depicts a thunderbird (the most powerful of all spirits) with a woman's face incorporated within its body. Within each of us is a power and ability to become what we are meant to be—for some of us this power comes easily, while others have to be careful not to be distracted or misled towards an unfulfilling destiny. This print is a reminder as to the choices we can make and the chances we must take.

SUSAN POINT

FACING
Free Spirit
October 1995 · Edition size: 52
Mixed medium chine-collé,
intaglio etching and serigraphy
20⅞ × 22½ inches

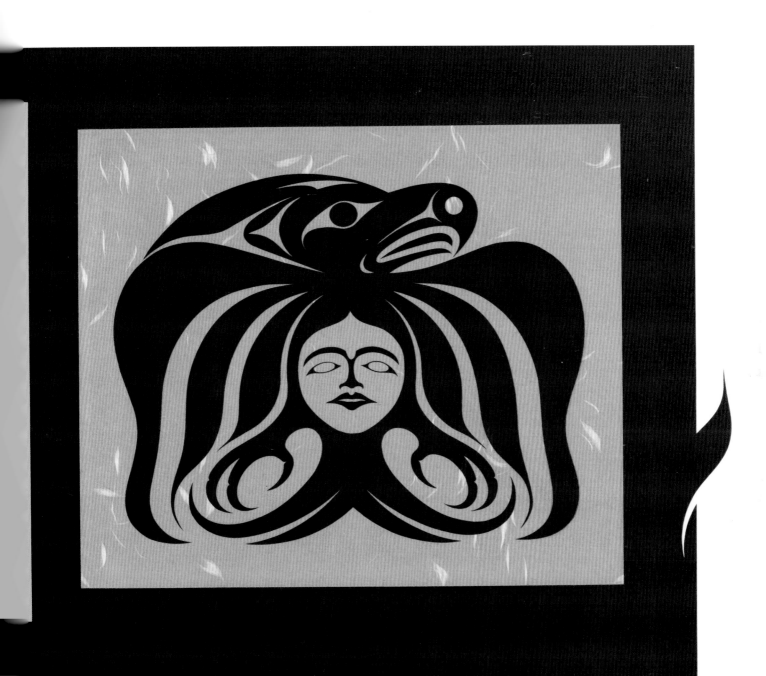

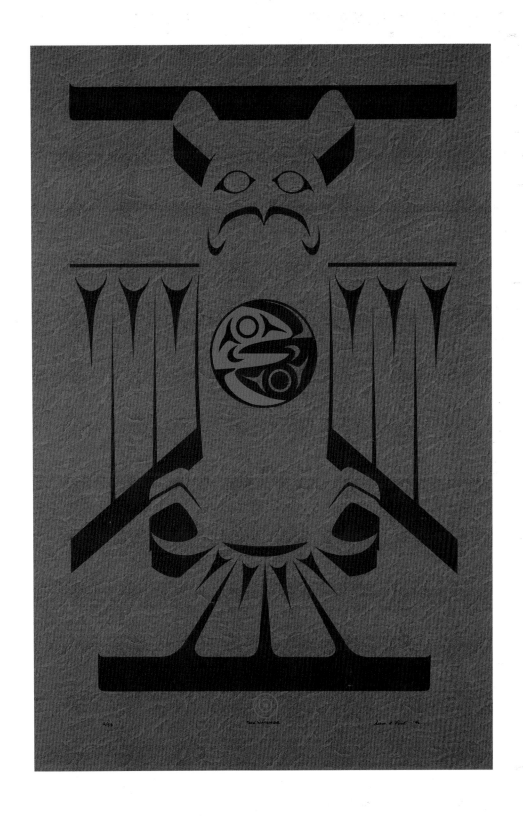

FACING
Song of the Wild
April 1997 · Edition size: 97
Serigraph · 27 × 17¾ inches

The Watcher
February 1996 · Edition size: 52
Serigraph · 27 × 17½ inches

THIS IMAGE WAS also carved as a monumental 16-foot spindle whorl commissioned by the Vancouver International Airport Authority in the fall of 1994 for its new terminal building. The imagery in this spindle whorl refers to flight, reflecting the spirit of the Pacific Northwest Coast as well as traditional Coast Salish art by using design elements such as crescents, U-forms and wedges or V-forms. As birds, animals and human forms as well as other images were often represented on traditional Coast Salish spindle whorls, I felt that it was important this design represent not only the theme of "flight" relating to the airport but also the human element—peoples between places.

Flight depicts two eagles, two human forms, salmon motifs, and the Moon, Sun and Earth. The eagle, which is a symbol of great power, is designed around the image of a man whose arms are raised, welcoming visitors and in a gesture of flight. The upper torsos of the human figures represent the Coast Salish people, whose traditional lands include the airport and the city of Vancouver. On their chests are salmon motifs that represent the fact that the Coast Salish still live and fish along the shores of the Fraser River. Salmon is the sustenance of life and a symbol of wealth for our people.

SUSAN POINT

FACING
Flight
July 1995 · Edition size: 230
Serigraph · 22 × 22 inches

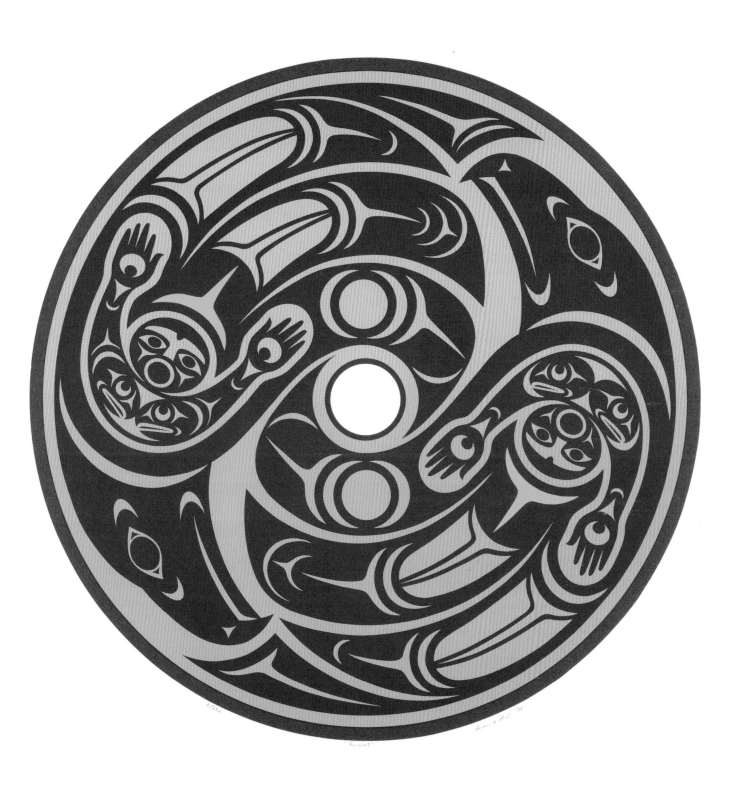

"FLIGHT"

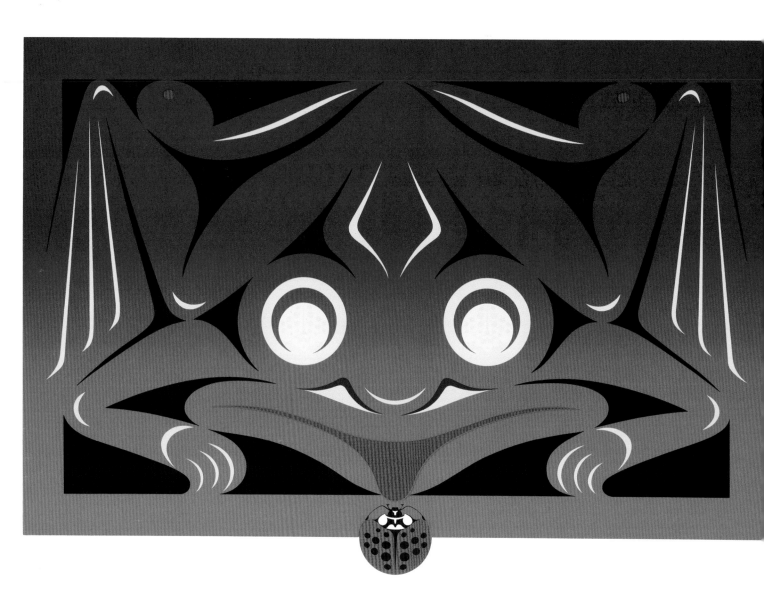

Frog Box Design
August 1996 · Edition size: 152
Serigraph · 22 × 28 inches

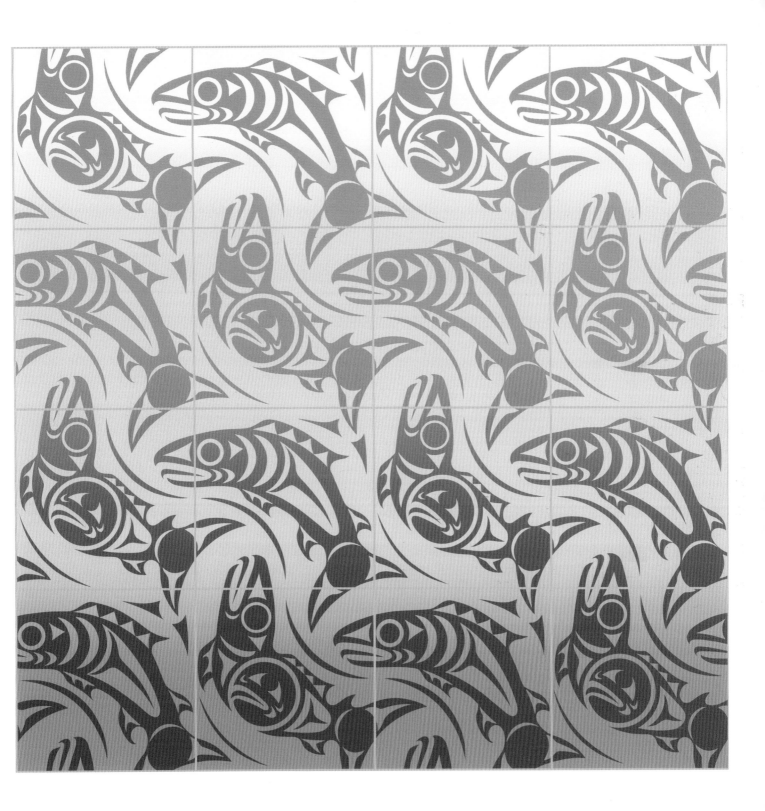

Sechelt Spawning Salmon Wall

April 1996 · Edition size: 111

Serigraph · 25⅝ × 25⅝ inches

IN FEBRUARY 1995, the University of British Columbia Museum of Anthropology commissioned Susan Point to recreate a number of Coast Salish artifacts from available prehistoric fragments made of antler, bone and wood. Susan recreated these pieces in the form of pen and ink illustrations and some in actual antler and bone for an exhibition entitled *Written in the Earth: Coast Salish Prehistoric Art.* This exhibition explores the art from prehistoric sites such as Musqueam, Saanich and Kwantlen Coast Salish territories dating back some three to four thousand years.

One of the unique features of prehistoric society in the Marpole Period is the abundance of personal ornaments. There is evidence that people born into upper-class families marked their status with bead, shell and copper necklaces, headdresses and other ornaments.

This print, *Salish Woman,* shows a woman wearing a few of these ornaments. On her forehead she wears a curvilinear design brow band made from antler, known as *Smiling Frog*; she also wears a nose ornament made of bone, a stone labret that pierces her lower lip and a finely engraved pendant that hangs around her neck. The brow band is one of the prehistoric fragments that Susan recreated in pen and ink; she also did a pen and ink illustration of the engraved lignite pendant, known as *Smiling Man,* for the *Written in the Earth: Coast Salish Prehistoric Art* exhibition.

FACING
Salish Woman
July 1996 · Edition size: 44
Intaglio aquatint · 18⅛ × 14 inches

2/22 "SALISH WOMAN" Susan L. Point '96

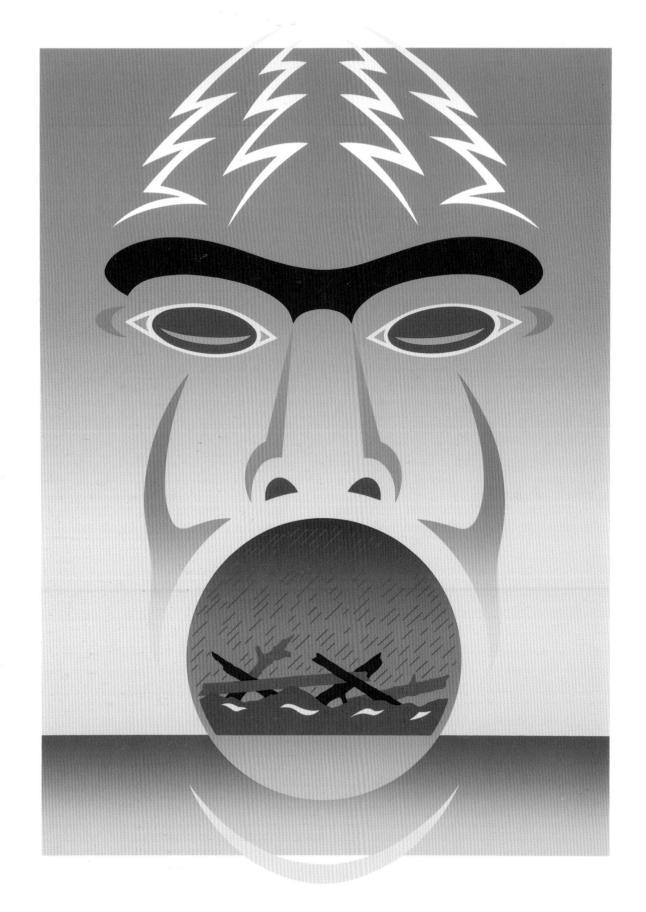

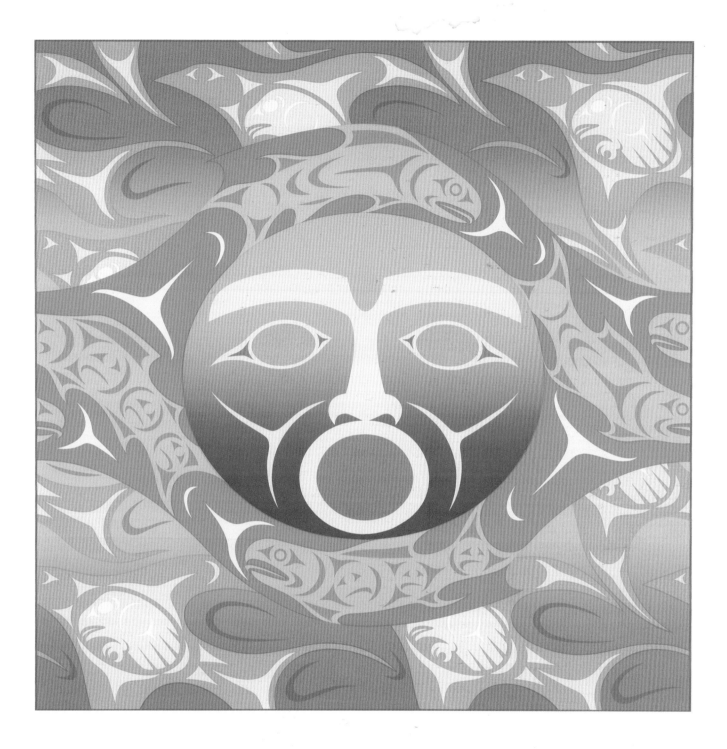

FACING
Storm Wind
From North Wind Fishing Weir
series of 6 prints
February 2004 · Edition size: 30
Serigraph · 22⅛ × 18 inches

Water—The Essence of Life
April 1996 · Edition size: 166
Serigraph · 22 × 23¼ inches

THIS DESIGN IS a continuation of *Water—The Essence of Life* and can be framed and placed either above or below this print to create a wall mural of any size. It was created using two grids (of the original 14) for the West Seattle Pump Station. The overall original design for *Water—The Essence of Life* was created by using 14 grids to create a large repeat wall mural, in concrete, for integration into the upper facade and wing walls of the pump station, on the north side of Harbor Avenue in the Alki Point area. This project was commissioned by the city of Seattle, Washington, in 1993.

To precast the intricate, low-relief, multi-level imagery into concrete wall units, each of the fourteen grids, 24 × 25 inches in size, had to be hand carved out of laminated red cedar. The 14 patterns were then rubber molded along with plaster mother molds. The complete wall mural covers approximately one thousand square feet.

In producing this design, I worked with the Coast Salish art style, to pay tribute to the aboriginal peoples who once lived in the Alki Point area. As this particular site was a historical gathering site when the fishing was good, I incorporated human faces and salmon into the design; the human faces also represent the present-day community who now live in this area. I incorporated eggs within some of the salmon, and baby birds inside the birds, to represent the continuing cycle of life and the new beginnings and renewals of these essential resources.

The motifs also represent the land, sea and sky; the human face symbolizes the land; the salmon, the sea; and the birds, the sky. As water is the function of this building, and because water is the essence of all life—and life basically entails land, sea and sky—I felt it appropriate to use this imagery. This design is also intended to show the integration between man and nature, which are inter-connected in one way or another in the unity of life. In the overall design I also tried to create a look of energy and fluidity.

SUSAN POINT

FACING
The Essence of Life Continued
April 1996 · Edition size: 111
Serigraph · 22 × 23¼ inches

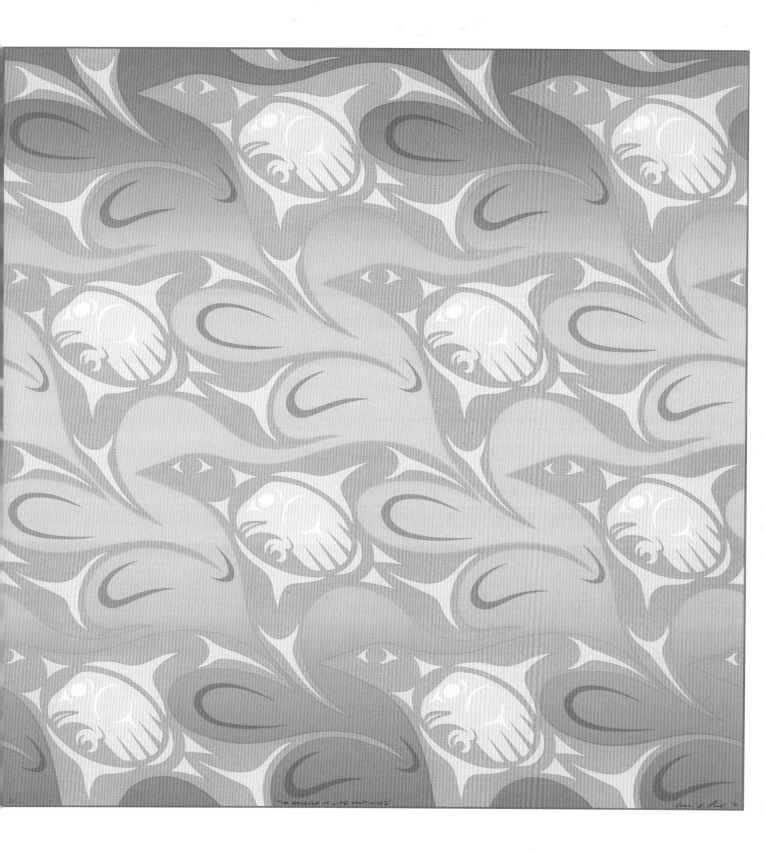

"THE ESSENCE OF LIFE CONTINUED"

THIS ORIGINAL WHORL image is one of my contemporary works. Although it is in a whorl format, I do not consider it traditional. I have used the format more like a window to view a stormy plot of ocean. While the waves are rolling, we catch a glimpse of an orca travelling along. Within the dorsal of the orca is the reflection of a man's face, which pays tribute to the Coast Salish stories about the Whale People.

SUSAN POINT

FACING
Storm Wind
May 1997 · Edition size: 152
Serigraph · 22 × 22 inches

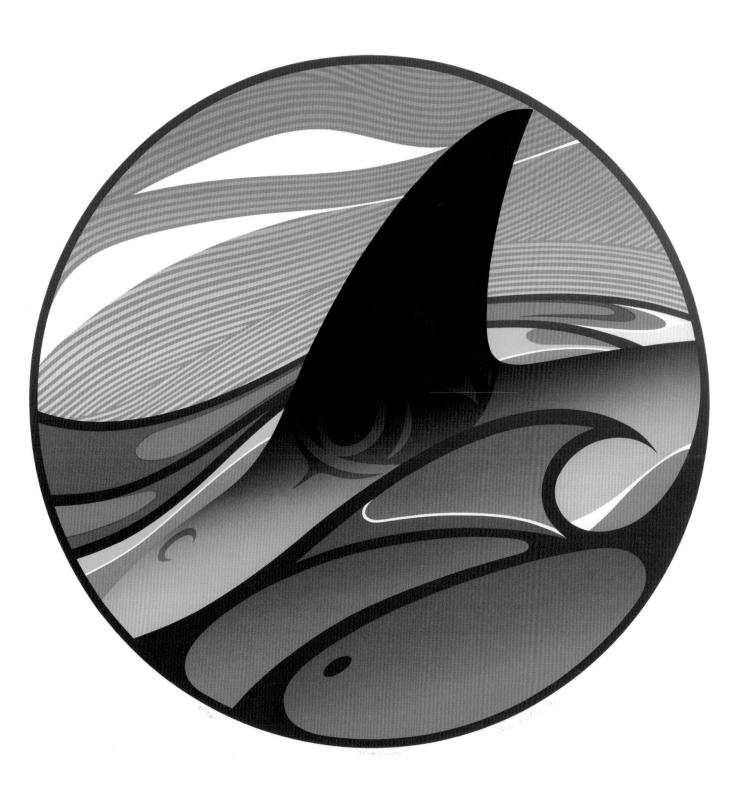

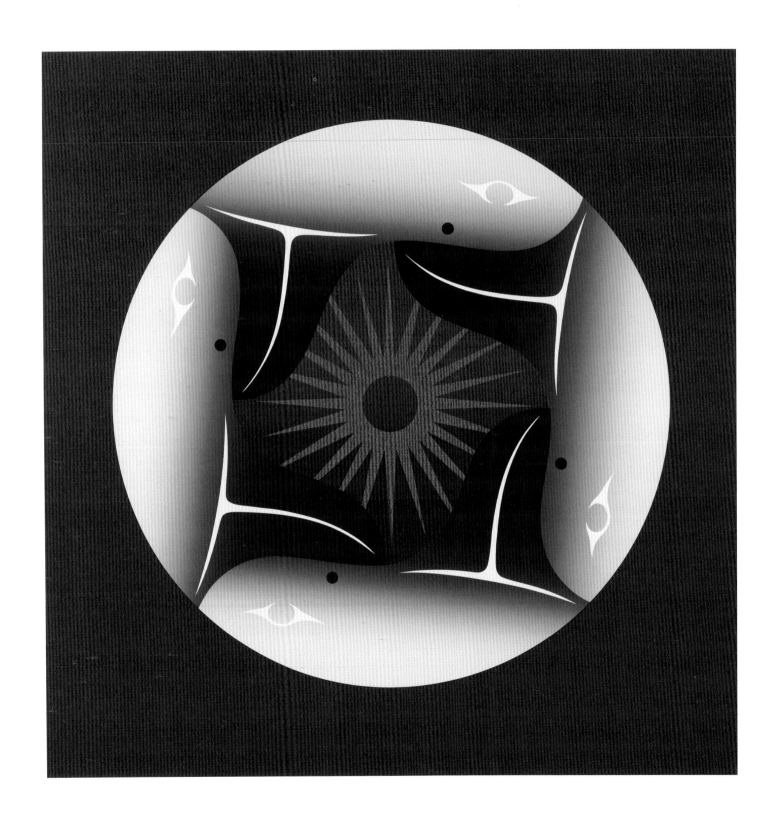

From the Sea Four Orcas

April 1997 · Edition size: 60

Serigraph · 23½ × 22 inches

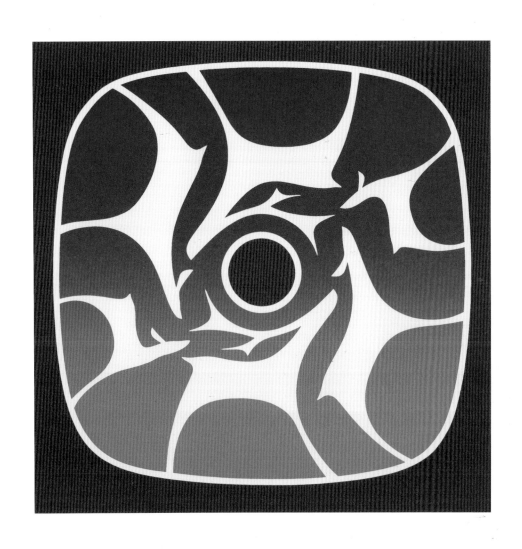

Of this Land

December 1998 · Edition size: 197
Serigraph · 10⅞ × 10⅓ inches

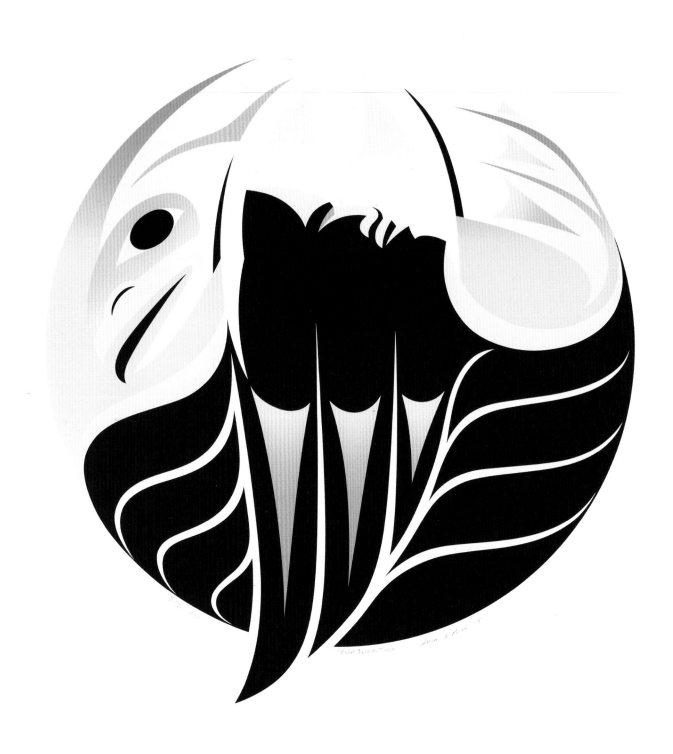

Over Black Tusk

October 2005 · Edition size: 50

Serigraph · 22 × 22 inches

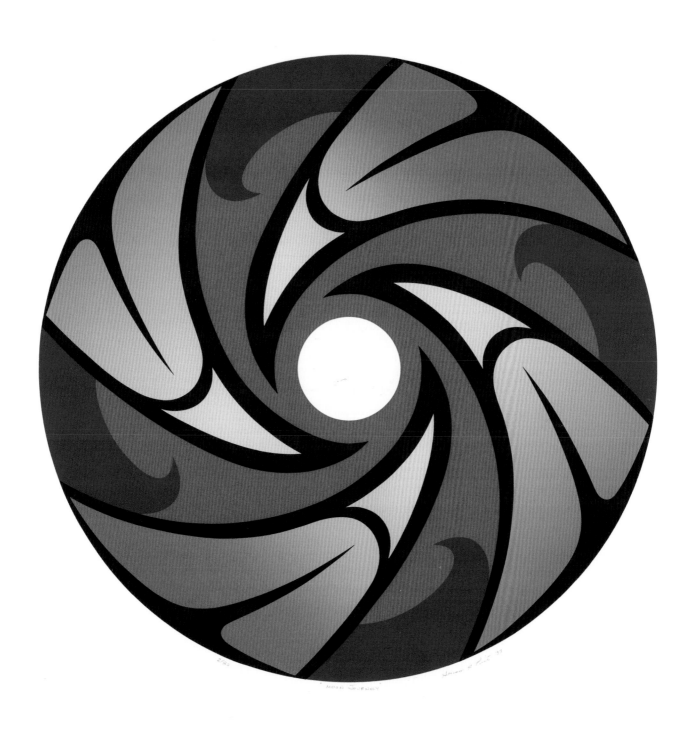

Moon Journey

April 1997 · Edition size: 80
Serigraph · 21 × 20 inches

THIS IMAGE IS meant to reflect communication, working together and energy. Of the images and symbols traditionally used by the Coast Salish, I felt that the Raven would best symbolize these qualities. The Raven is known for its creative powers, communication and transforming abilities, and is considered by many to be the most important creature, a symbol of prestige and knowledge. This particular print depicts four Ravens coming together with the dawn of a new era in the background. The position of the Ravens gives one the impression they are negotiating. There is a feeling of resolution and acceptance. Their posture is meant to suggest that they are compatible and participating equally in consultation, affecting understanding and the creation of new objectives. The lines within the wings of the Raven and the movement created by these lines symbolize fluidity and energy.

SUSAN POINT

FACING
Relationship of Dependency
December 1997 · Edition size: 77
Serigraph · 18¾ × 18⅛ inches

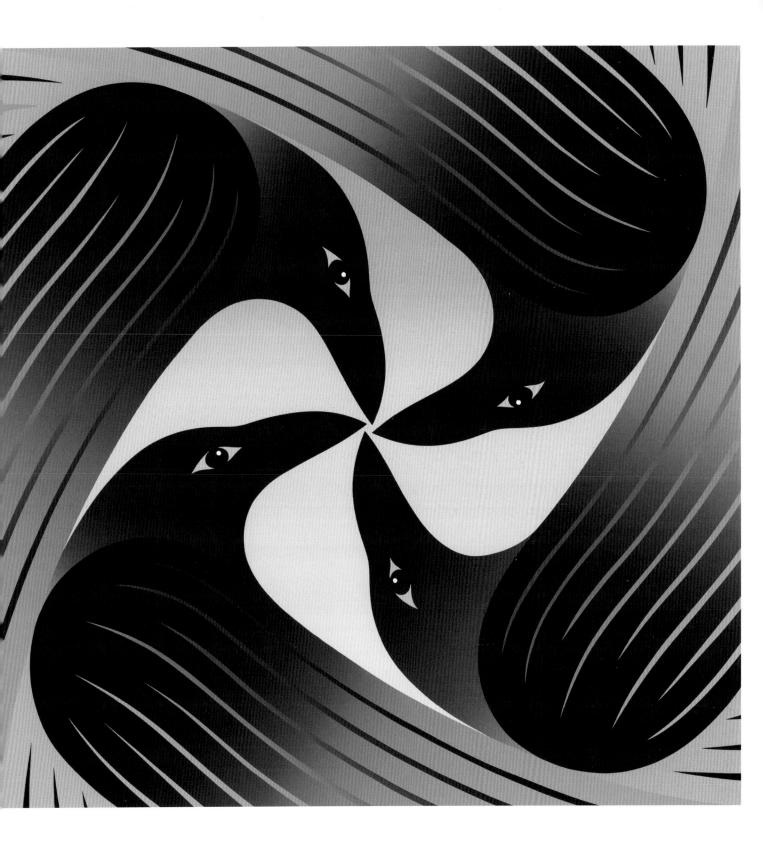

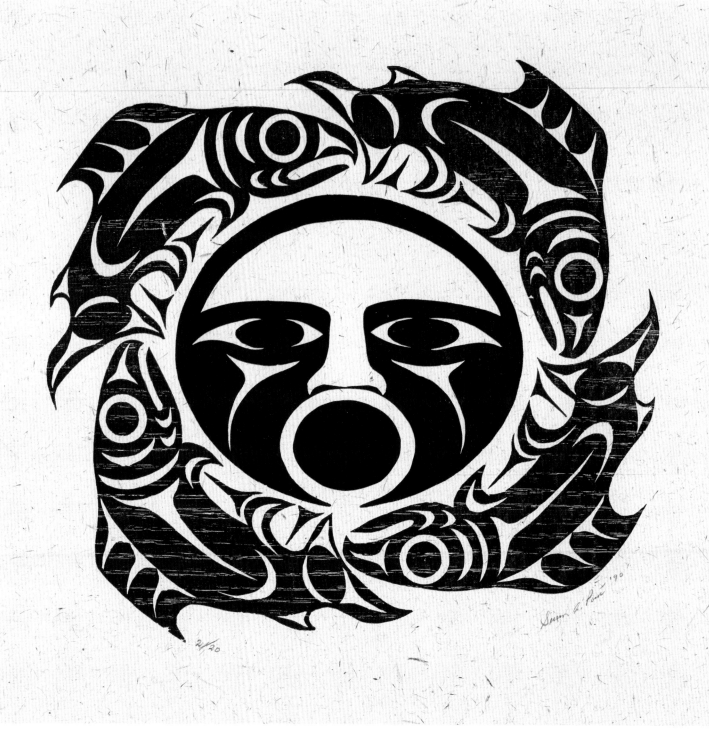

Salmon Run

January 1990 · Edition size: 20

Woodcut and linocut

on handmade paper

14¼ × 15 inches

FACING

Empowerment

July 1997 · Edition size: 44

Chine-collé and intaglio etching

18 × 13½ inches

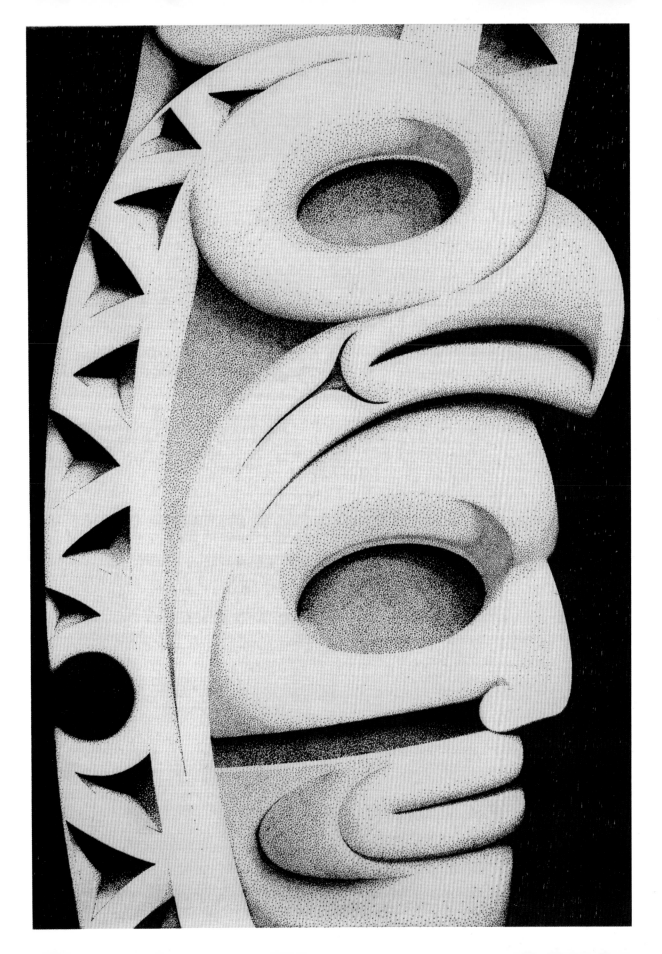

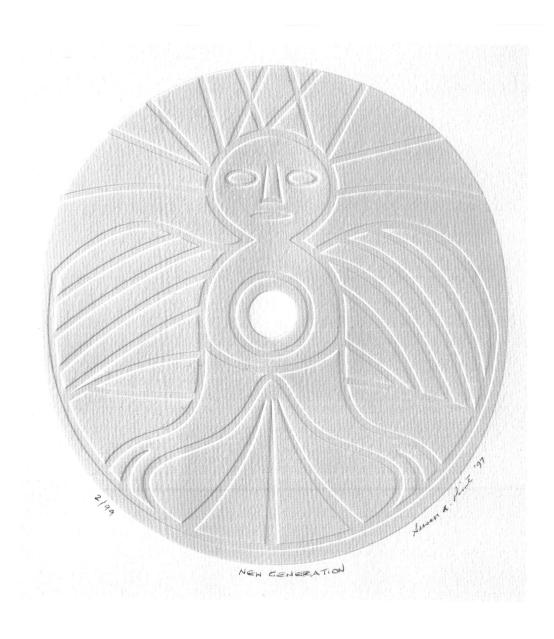

2/99

New Generation

Xavier A. Point '97

NEW GENERATION

New Generation

November 1997 · Edition size: 99

Embossed tint · 8⅝ × 8½ inches

FACING

Becoming One

January 1997 · Edition size: 115

Serigraph · 26 × 22 inches

I AM VERY PROUD of my Coast Salish heritage and was recently honoured when the White Rock Royal Canadian Mounted Police asked me to design a Coast Salish housepost to be carved by resident artists of the Semiahmoo tribe, another Salish village. Robert Davidson, one of the most renowned Haida artists, oversaw the project and assisted with the carving. This is a detail drawing of the top of the housepost I designed. The post represented a guardian figure with an eagle above his head. The wings of the eagle also form the man's hair.

SUSAN POINT

FACING
Coast Salish Legacy
January 1998 · Edition size: 45
Intaglio etching · 17⅝ × 14⅞ inches

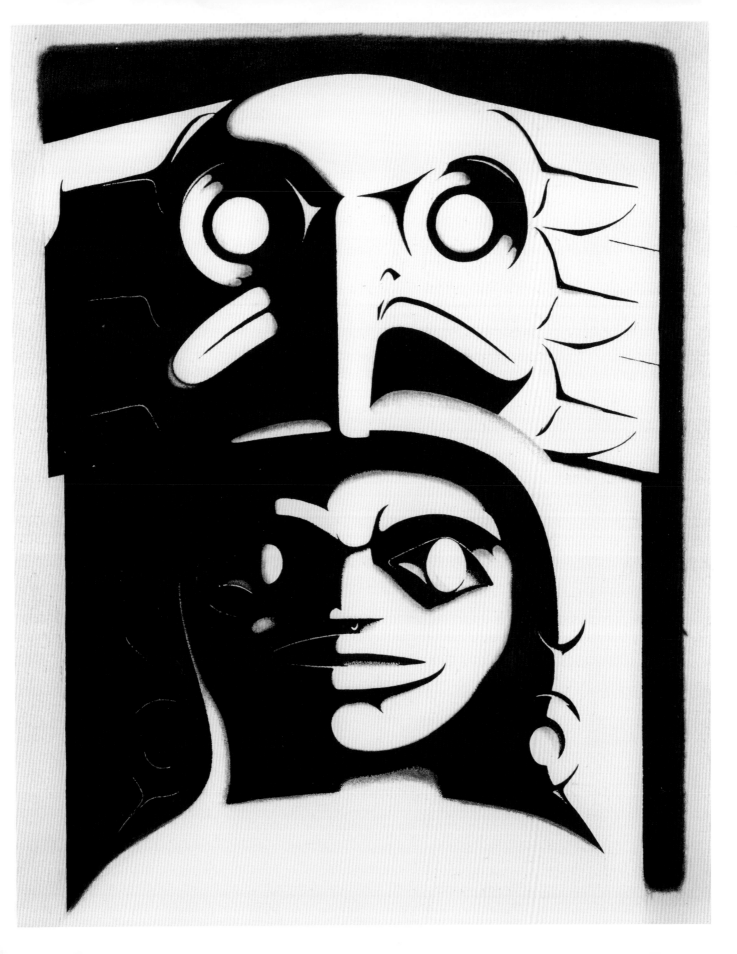

I WAS FORTUNATE ENOUGH to view 26 grizzly bears in the wild while driving through western Canada. The experience sparked my interest in their situation within our ever-changing environment. Where once grizzlies roamed freely over large territories, now in some cases only their memory remains. Not only is their space becoming an urgent issue, but illegal poaching and over-hunting also threaten their population. Hunters insist the bears are abundant and that they need to be harvested whereas government censuses paint a much bleaker picture. This print shows the grizzlies' fading presence upon the landscape.

SUSAN POINT

FACING
Spirits of the Wild
January 1998 · Edition size: 115
Serigraph · 22 × 28 inches

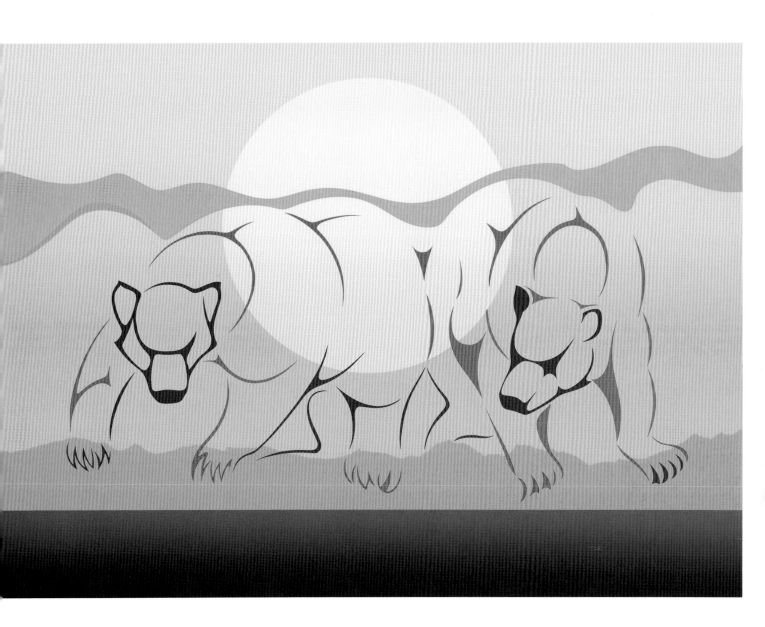

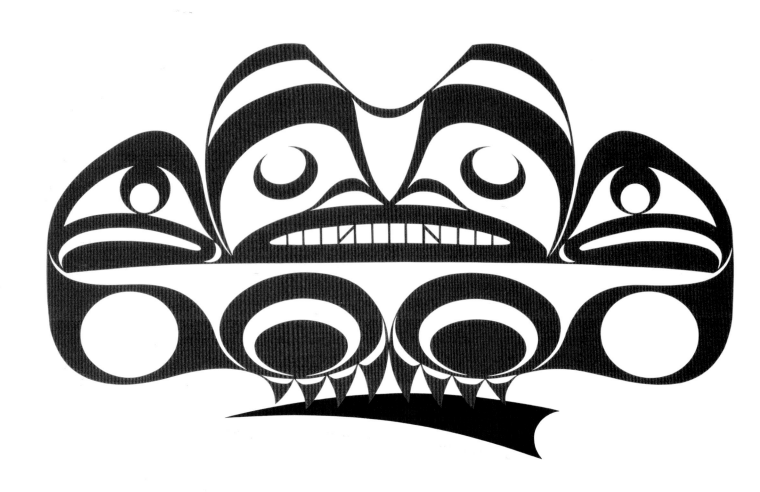

Overexposure

January 1998 · Edition size: 28
Serigraph · 18⅞ × 27⅛ inches

FACING
Native Sun

January 1998 · Edition size: 45
Serigraph · 31¼ × 31⅜ inches

THE SPINDLE WHORL is a disk which acted as a flywheel on the spinning device used for making wool yarn. Many spindle whorls, which could be oval, soft-squared or circular, had very complex designs on one or both sides. The circular spindle whorl format is representative of the circle of life. Many of the ancient spindle whorl motifs that originally inspired me to practice Coast Salish artistry were very graphic and, in some cases, geometric in nature. Although I initially started studying and drawing the old whorls with human and animal forms on them, I have always admired the ones with simple geometric and floral imagery.

This set of four prints, three serigraphs and one reduction woodblock, is my own adaptation of some of these early pieces by my ancestors.

SUSAN POINT

FACING
Circles in Time I, II, III, IV
January 1998 · Edition size: 101
Serigraph and woodblock print
8⅝ × 8⅝ inches

110

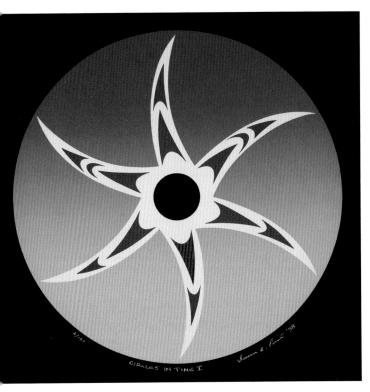

CIRCLES IN TIME I

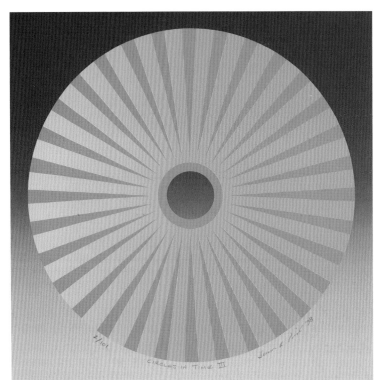

CIRCLES IN TIME III

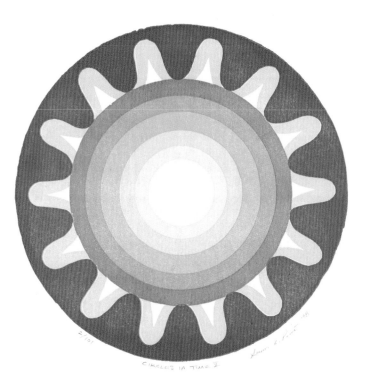

CIRCLES IN TIME II

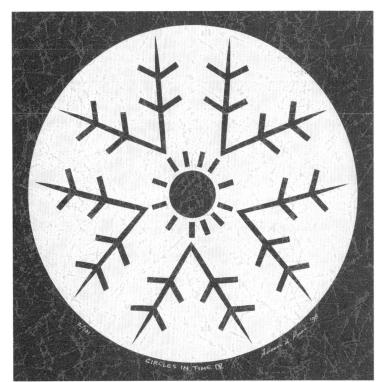

CIRCLES IN TIME IV

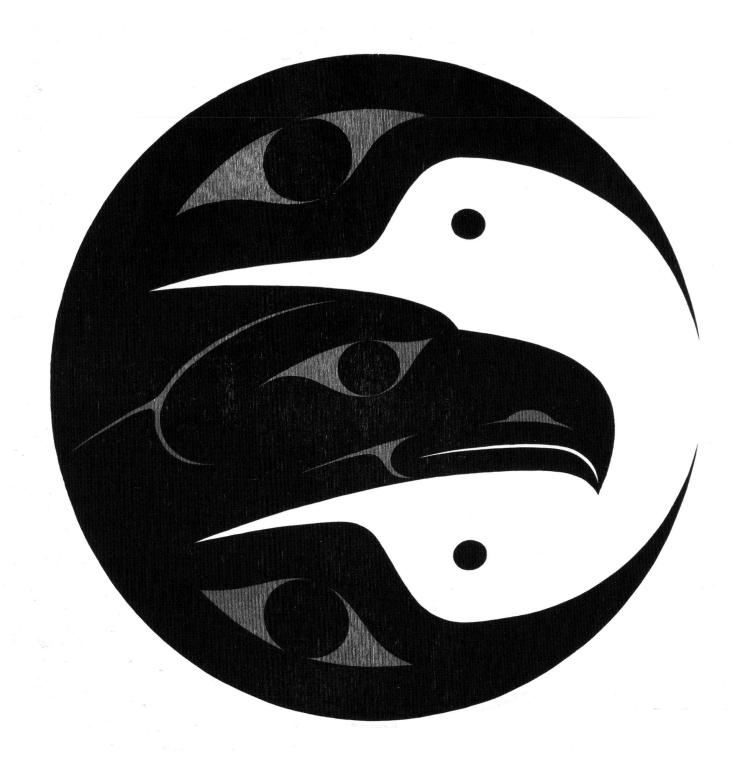

Pacific Spirit '98

March 1998 · Edition size: 33

Woodblock · 31½ × 31½ inches

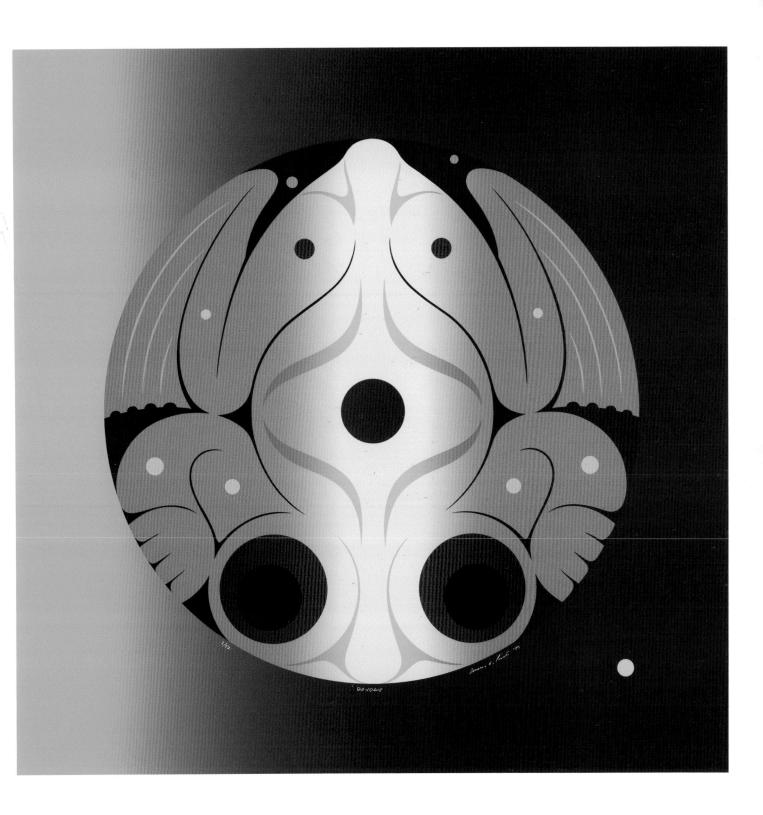

Dewdrop

July 1999 · Edition size: 52

Serigraph · 30 × 30 inches

Sacred Land
October 1999 · Edition size: 40
Serigraph · 9 × 24 inches

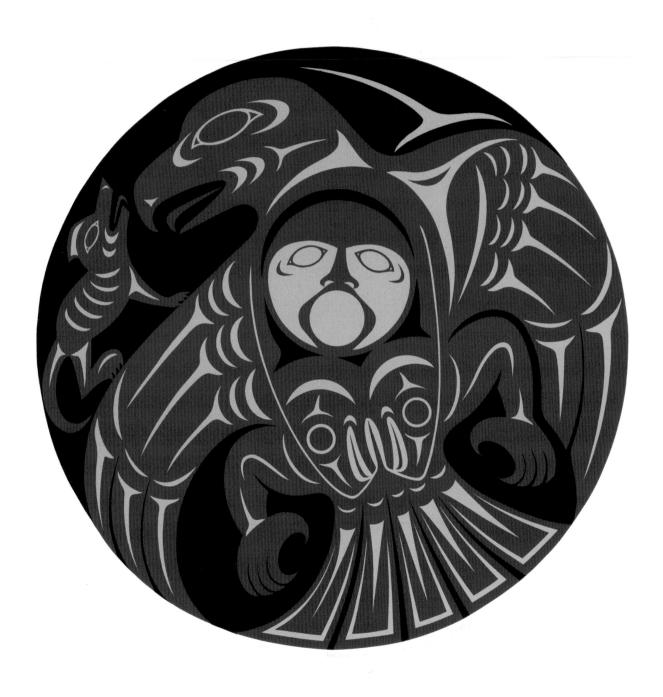

Pacific Spirit 1990
May 1990 · Edition size: 40
Serigraph · 18 × 18 inches

FACING LEFT
Raven's Sky
October 1999 · Edition size: 40
Serigraph · 24 × 9 inches

FACING RIGHT
**Where the Ocean
Meets the Sky**
October 2006 · Edition size: 98
Serigraph · 36½ × 12¼ inches

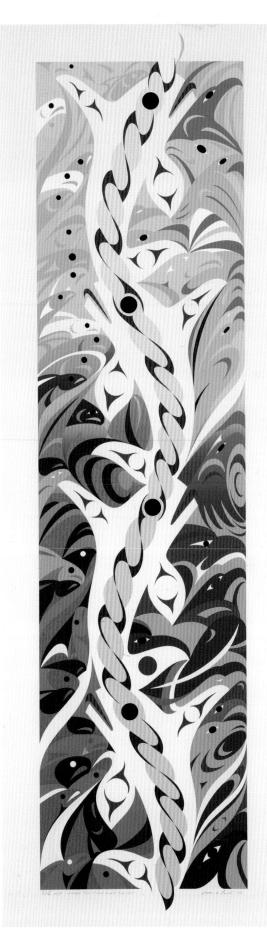

Timeless Light

December 1999 · Edition size: 99
Serigraph · 10 × 8½ inches

Communications Bird Images

November 2000 · Edition size: 15
Intaglio and chine-collé
28¾ × 27½ inches

T HIS IMAGE WAS inspired by a story I read about an albino or white raven that became resident in a small town in northern British Columbia. There are a few recorded cases of albinos in different animal groups such as bear, bison and raven. This print honours nature's way of surprising us with its exciting phenomenon.

SUSAN POINT

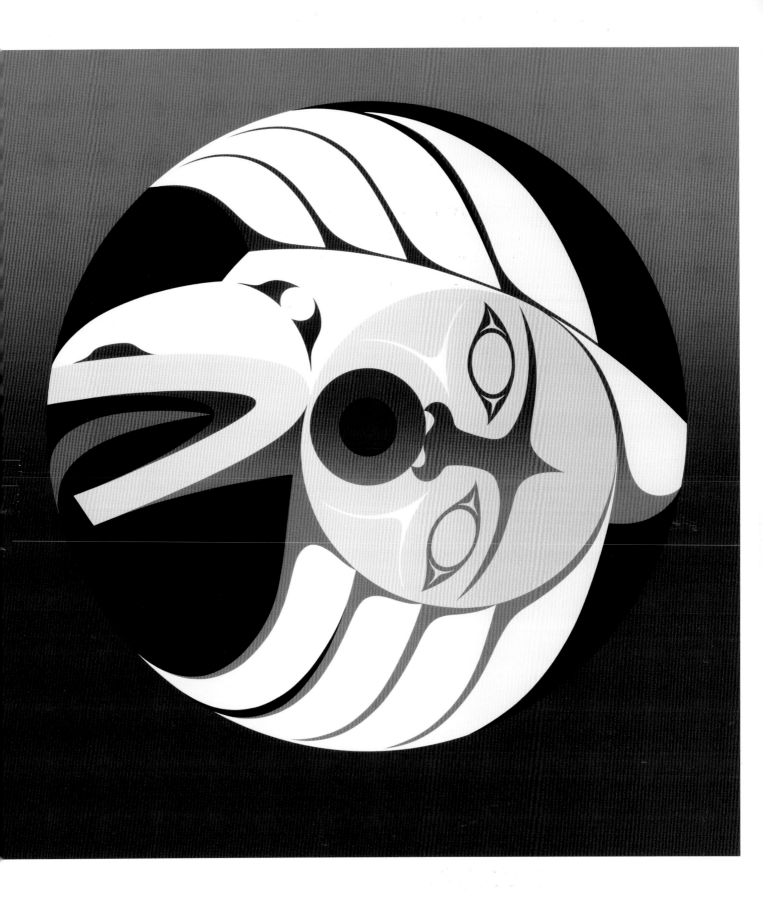

Good Luck
November 2000 · Edition size: 30
Reduction woodblock print
30 × 30 inches

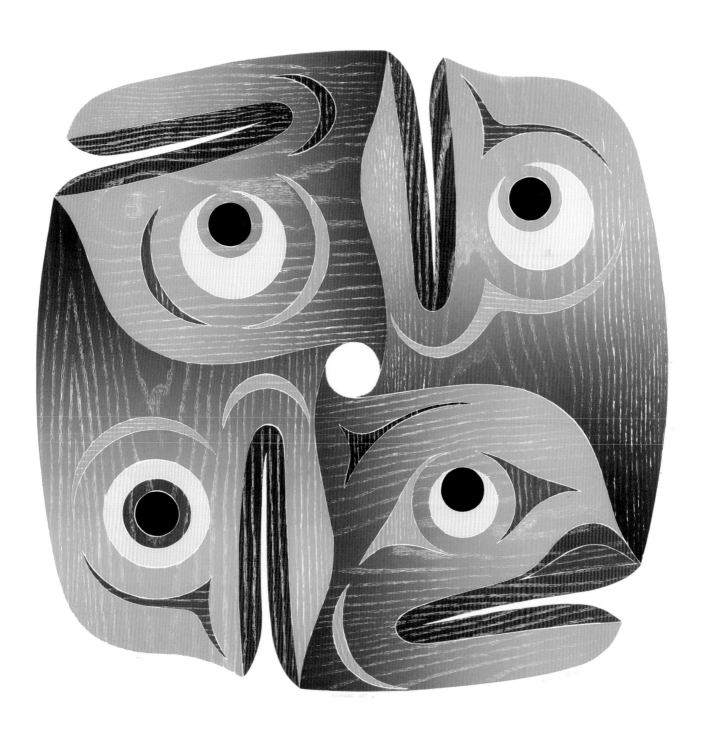

Nowhere Left
November 2000 · Edition size: 44
Puzzle woodblock print
30 × 30 inches

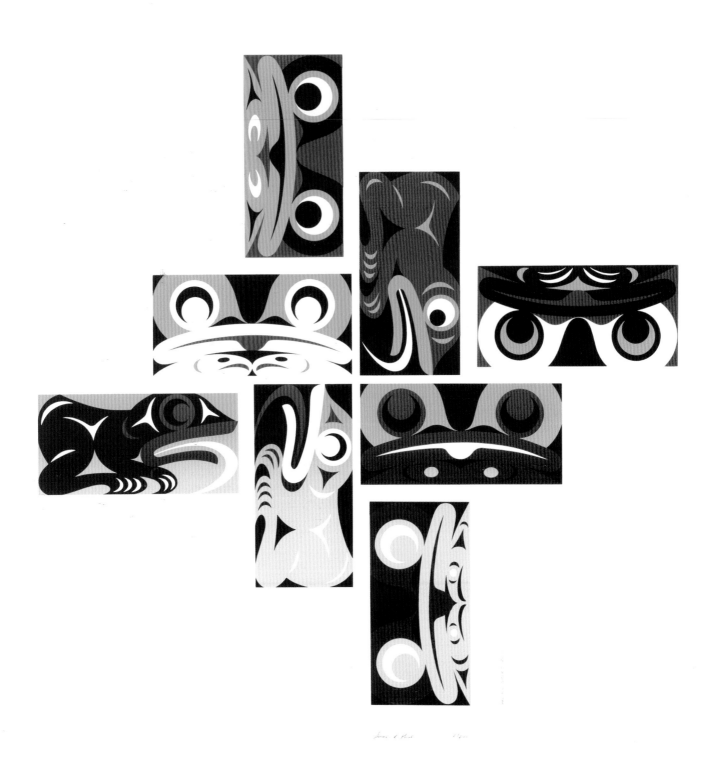

Pacific Spirit 2000
August 2000 · Edition size: 200
Serigraph · 37⅜ × 36⅝ inches

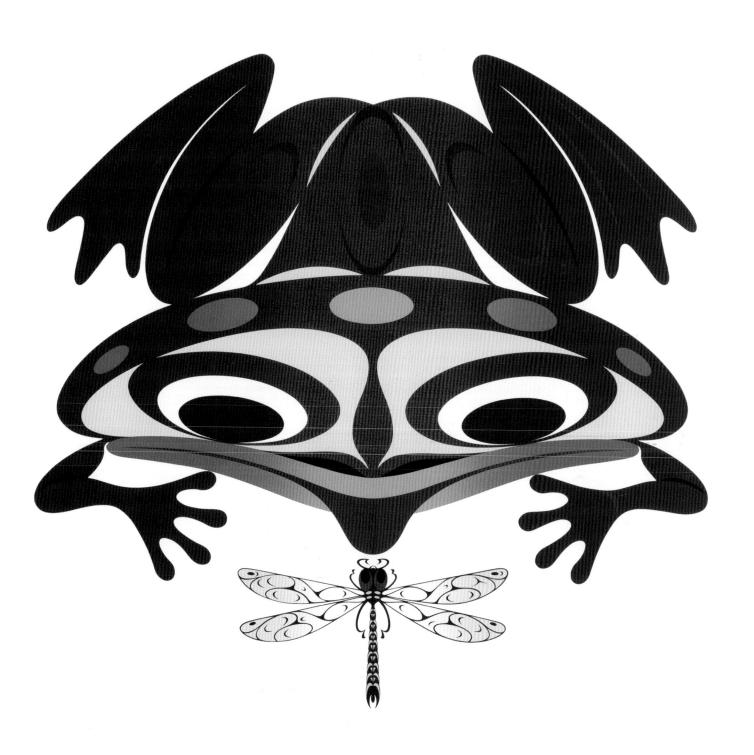

Face to Face
May 2001 · Edition size: 126
Serigraph · 30½ × 30 inches

SHARING THE JOURNEY, our path is often transformed by circumstance and friendships. Sometimes we are aware when it is happening and know that it is a good thing. Some friends can affect us profoundly. They have a power, a gift, which can positively change us. I have been lucky enough to have had a couple of good friends with this gift. I know they inspired me to attempt to be better, through their love and their direction. When I think of our experiences together, I am reminded to share the constant encouragement they gave me. This image tries to reflect their enduring spiritual presence.

SUSAN POINT

FACING
In the Shadow of an Eagle
January 2000 · Edition size: 55
Serigraph · 30 × 30 inches

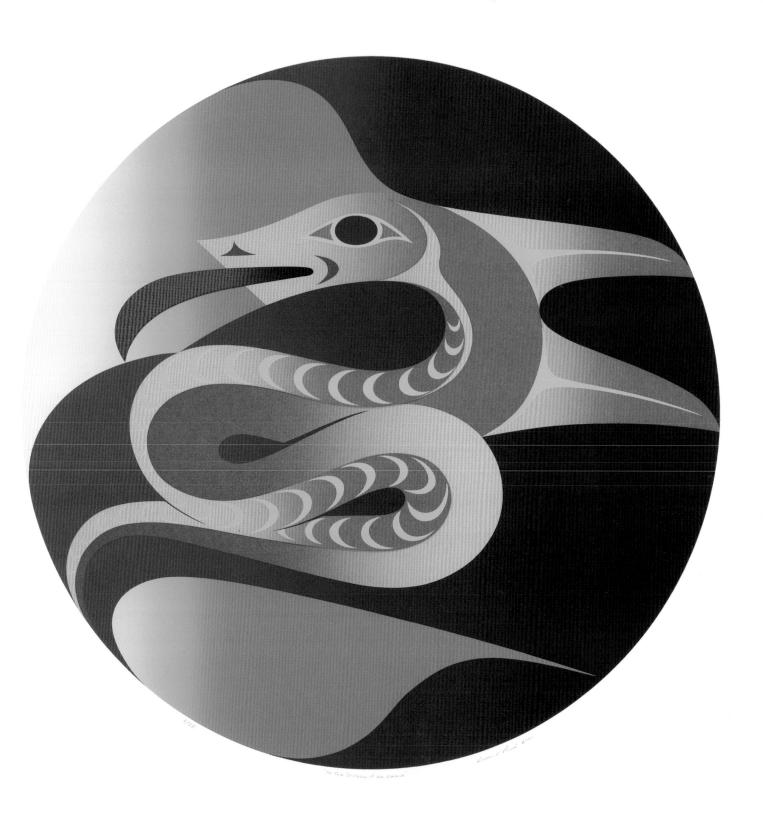

'IN THE SHADOW OF AN EAGLE'

127

Inspiration Weaving Pattern

November 2000 · Edition size: 35

Intaglio and photo intaglio

27¾ × 42 inches

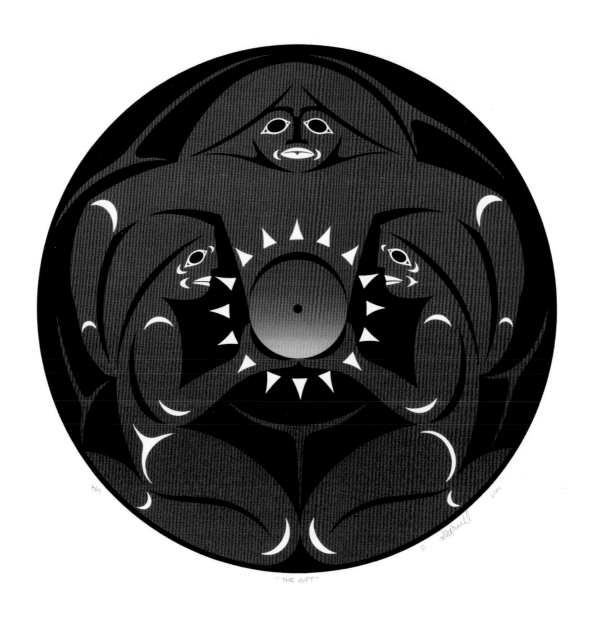

"THE GIFT"

The Gift
with Kelly Cannell
May 2001 · Edition size: 99
Serigraph · 22 × 22 inches

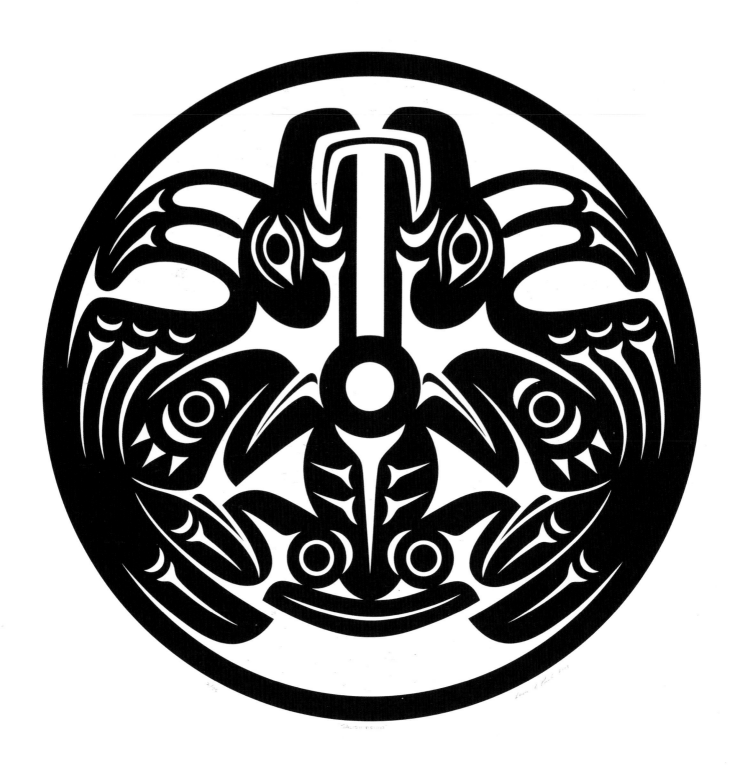

Salish Vision Thunderbird I

November 2001 · Edition size: 75

Serigraph · 26½ × 26½ inches

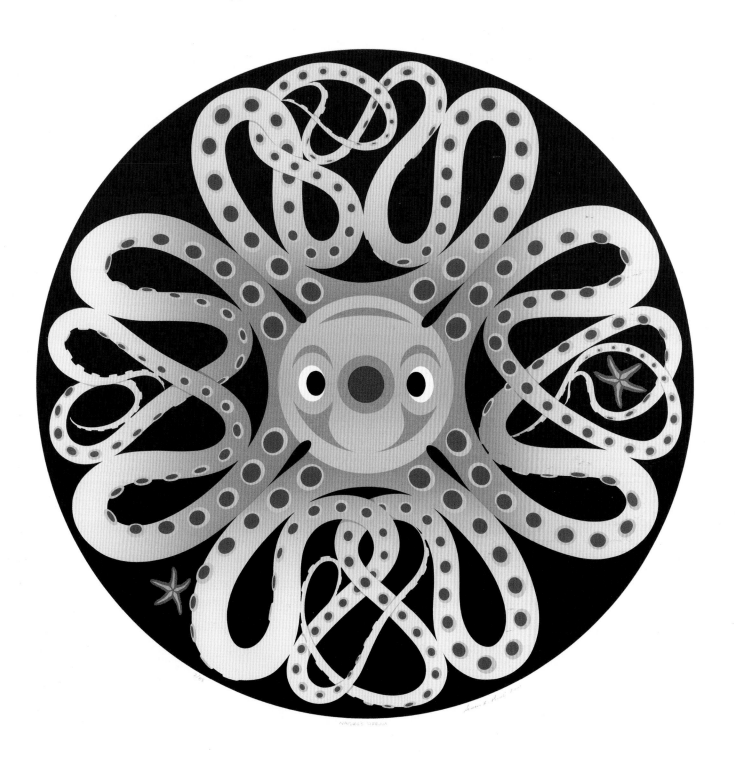

Nature's Dream
April 2001 · Edition size: 88
Serigraph · 26½ × 26½ inches

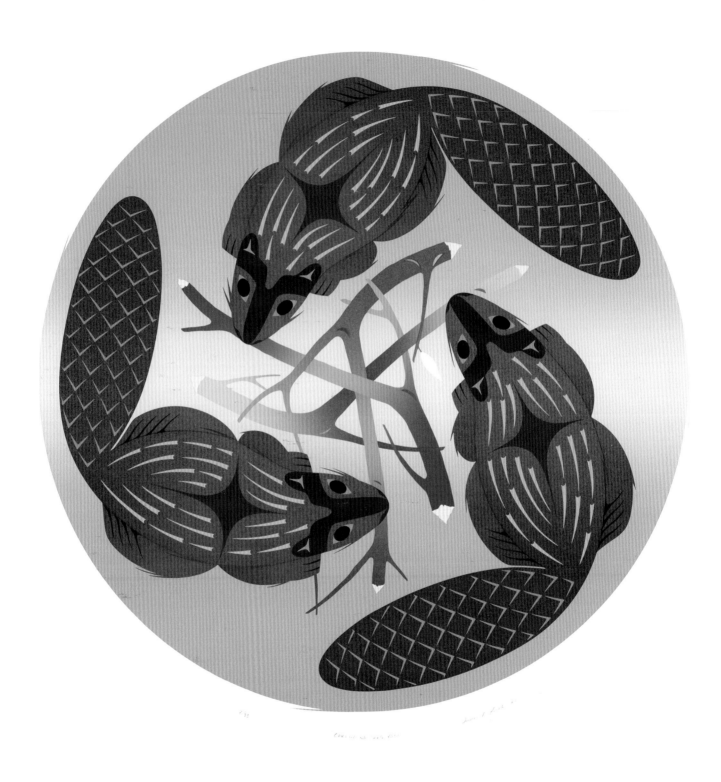

Carving Nature's Path

August 2001 · Edition size: 33

Serigraph · 26⅛ × 26 inches

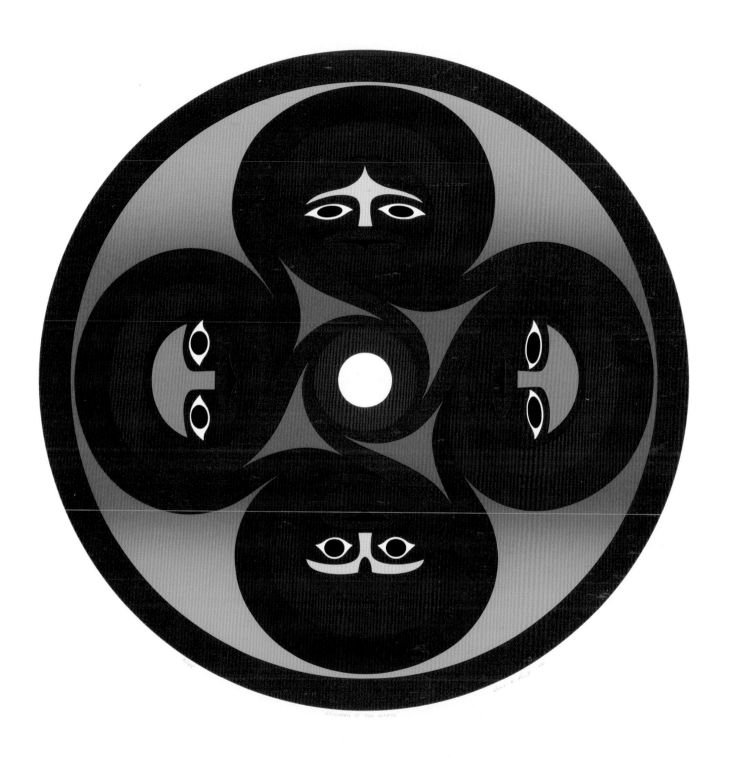

Children of the Earth

June 2002 · Edition size: 85
Serigraph · 30½ × 30 inches

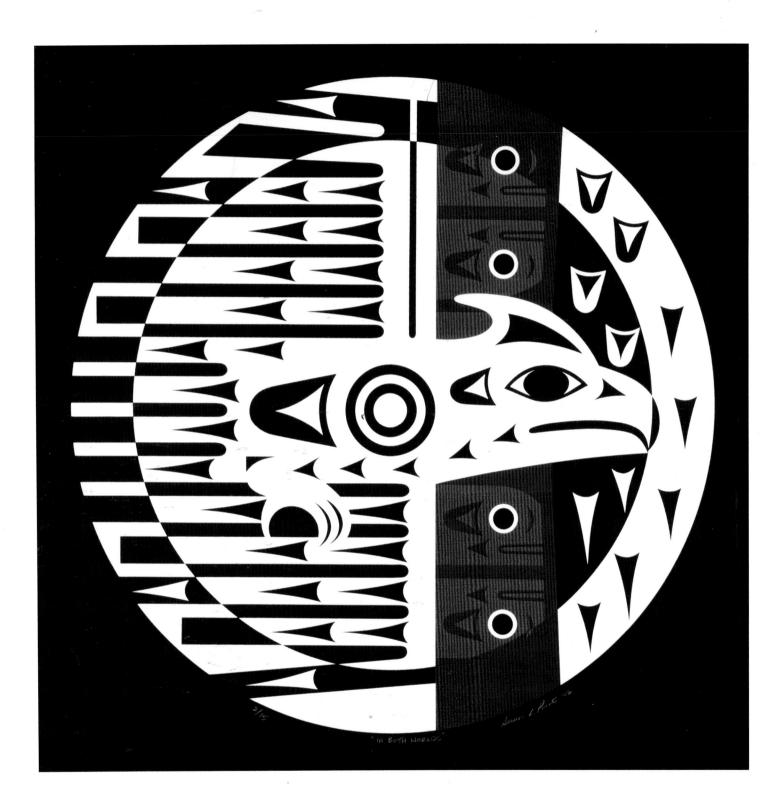

In Both Worlds Thunderbird IV

November 2002 · Edition size: 75

Serigraph · 25 × 25 inches

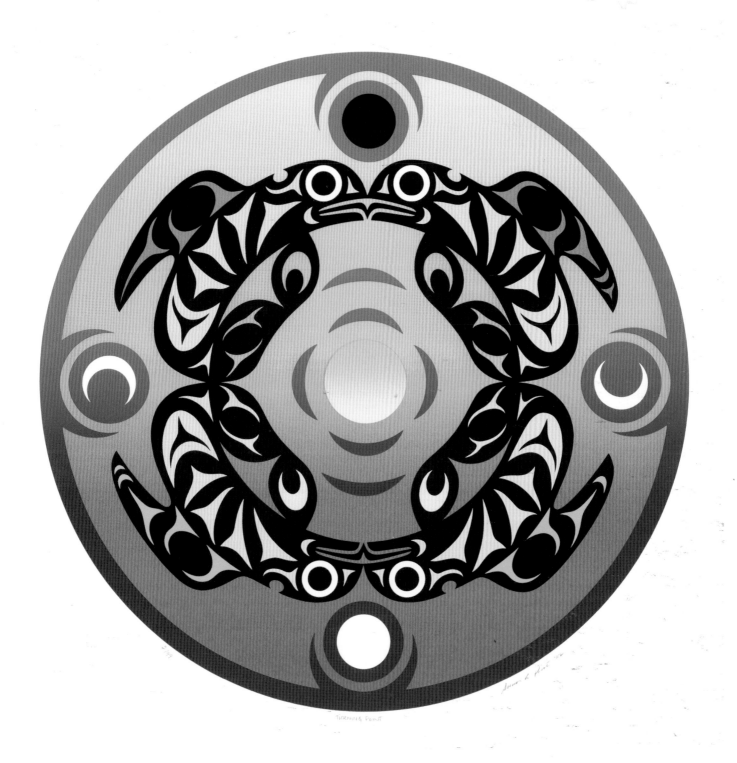

Turning Point

July 2002 · Edition size: 99
Serigraph · 22 × 22 inches

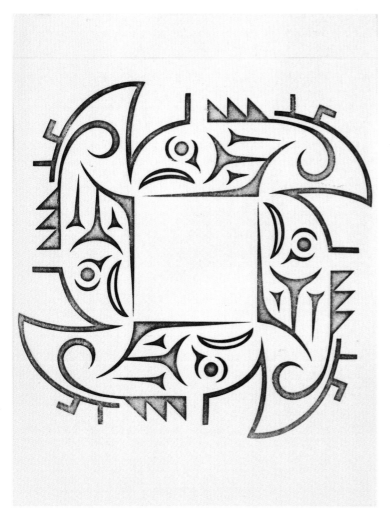

ABOVE LEFT
Bridging Time
Printed at Pilchuck Glass School
July 2002 · Edition size: 8
V/E glass plate print · 22½ × 15 inches

ABOVE RIGHT
A Mark of the Salish
Printed at Pilchuck Glass School
July 2002 · Edition size: 8
V/E glass plate print · 30 × 22 inches

FACING TOP
Flounders Down Below
Printed at Pilchuck Glass School
August 2002 · Edition size: 7
V/E glass plate print · 22 × 30 inches

FACING BOTTOM
A Bay of Spirits
Printed at Pilchuck Glass School
August 2002 · Edition size: 8
V/E glass plate print · 22 × 30 inches

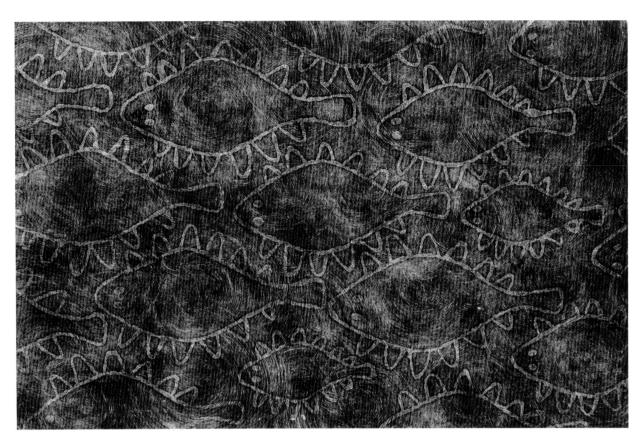

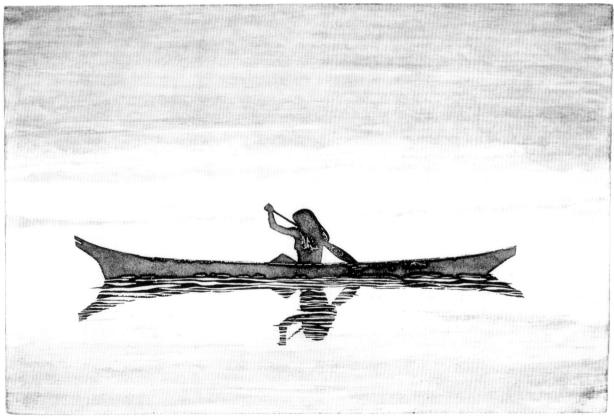

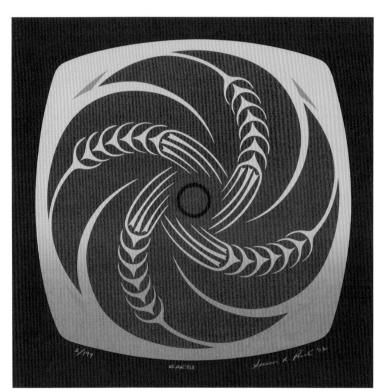

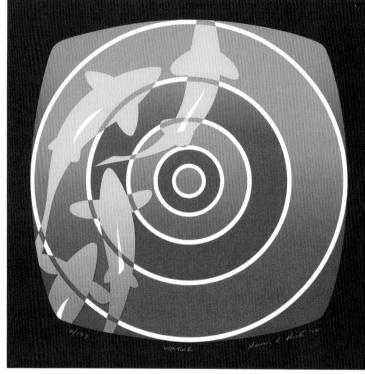

Four elements: Earth

November 2002

Edition size: 199

Serigraphs · 12¼ × 12¼ inches each

Four elements: Water

November 2002

Edition size: 199

Serigraphs · 12¼ × 12¼ inches each

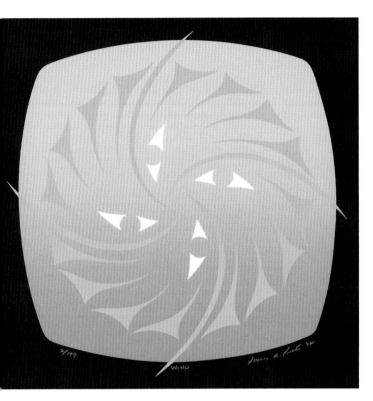

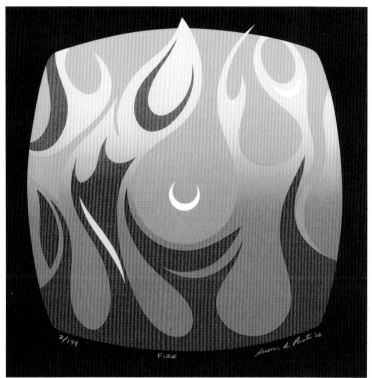

Four elements: Wind

November 2002

Edition size: 199

Serigraphs · 12¼ × 12¼ inches each

Four elements: Fire

November 2002

Edition size: 199

Serigraphs · 12¼ × 12¼ inches each

THIS IS A very personal image, inspired by the many rafting trips that I have made to the Taku River with my family. Teeming with life, the Taku River flows from Alaska through to northern British Columbia.

I have had many spiritual experiences on the Taku, including an exceptionally close encounter with a grizzly bear and a chance to see what I call The Spirit of the Taku, a completely white bald eagle. The image draws on a traditional Salish weaving design, echoing the constant movement of the river. The design flows through the form of the eagle itself, drawing attention to the connections between the eagle and his environment. Within the wings of the eagle there are two salmon heads (traditionally often depicted in pairs for good luck). This image reminds us that we are all linked, both to our environment— and to all the living creatures that share it.

SUSAN POINT

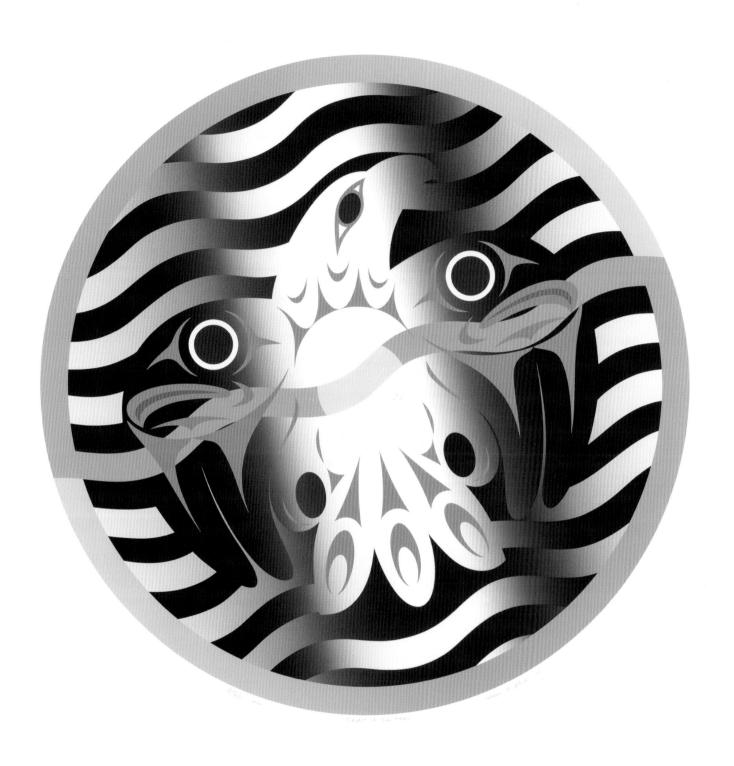

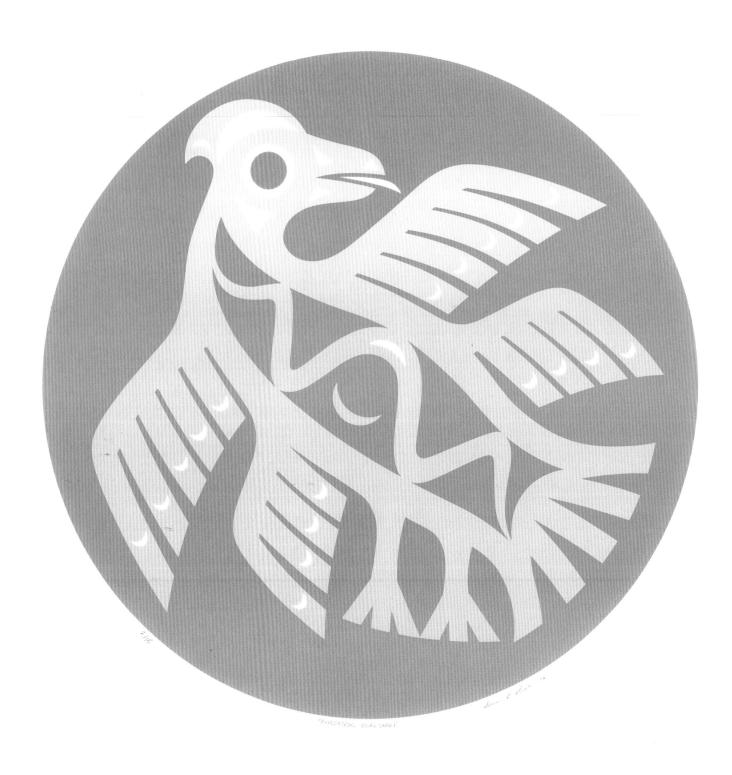

Ancestral Guardian
Thunderbird III

September 2002 Edition size: 75
Serigraph · 26½ × 26 inches

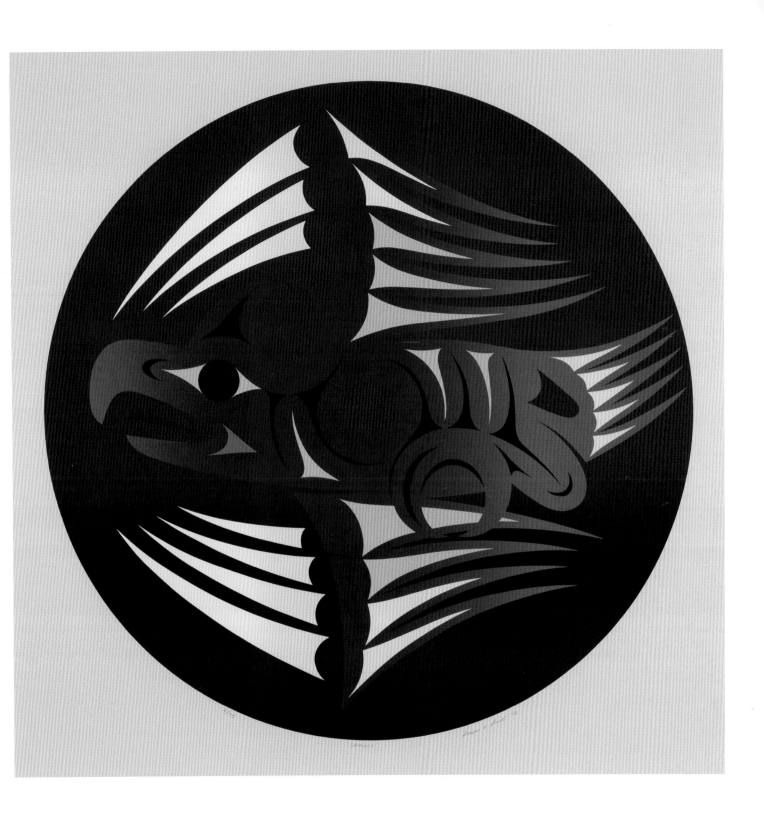

Legacy
Thunderbird v

November 2002 · Edition size: 75
Serigraph · 25 × 25 inches

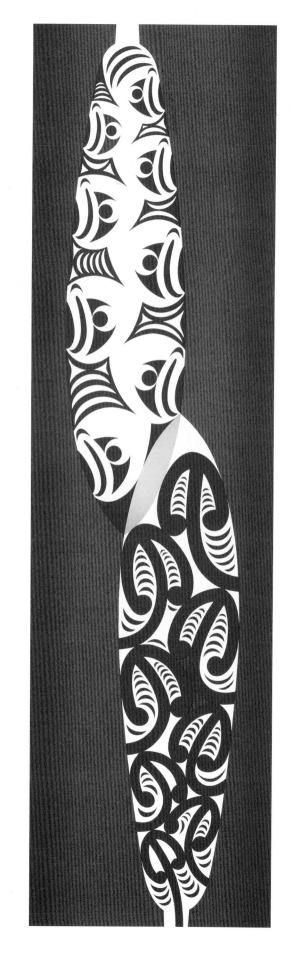

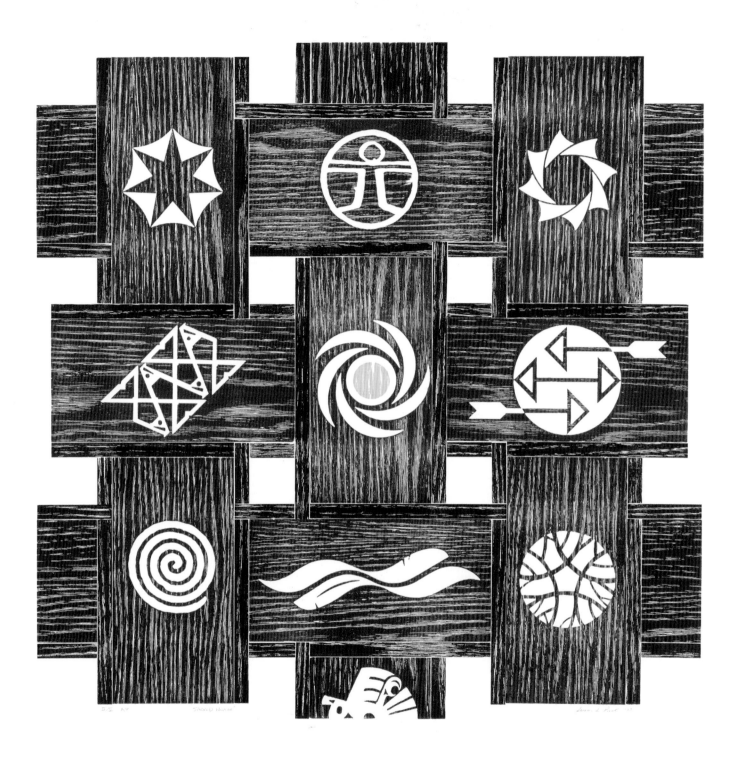

**Mirror Images Salish
and Maori Paddles**

July 2003 · Edition size: 99
Serigraph · 39 × 13½ inches

Sacred Weave

July 2003 · Edition size: 50
Puzzle woodblock · 27½ × 27 inches

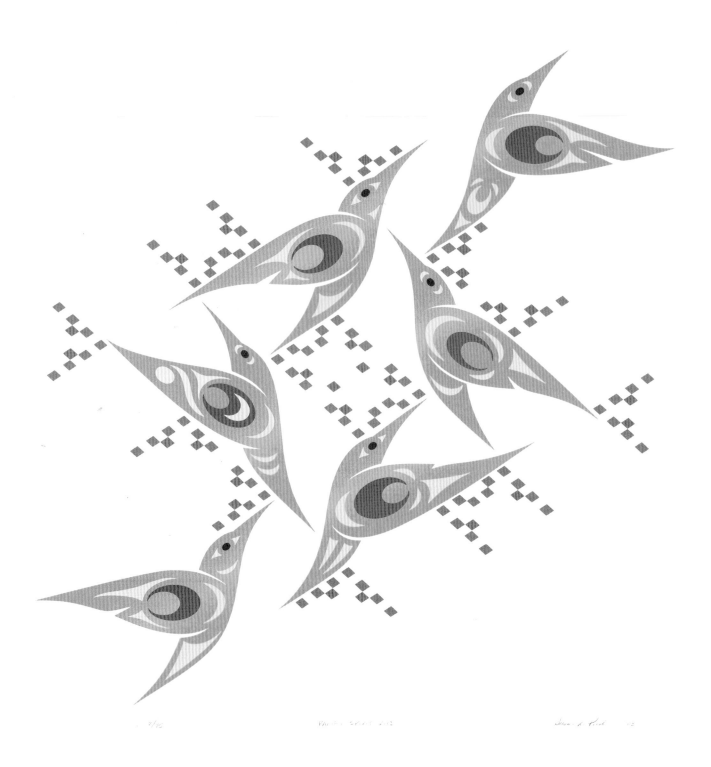

Pacific Spirit 2003

July 2003 · Edition size: 75

Serigraph · 18 × 17 inches

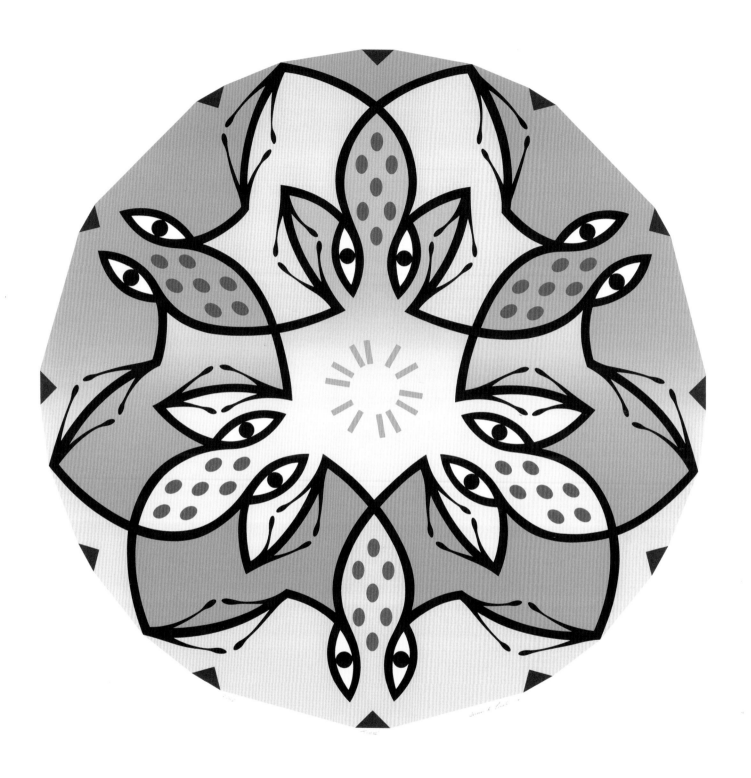

Time

November 2004 · Edition size: 52
Serigraph · 30 × 29½ inches

147

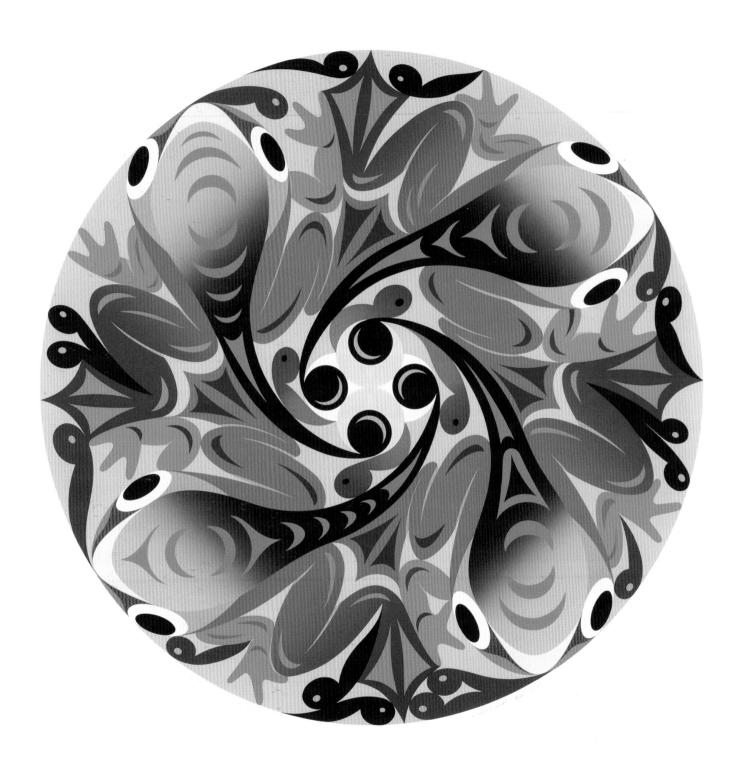

Memory
with Kelly Cannell
March 2005 · Edition size: 77
Serigraph · 30 × 30 inches

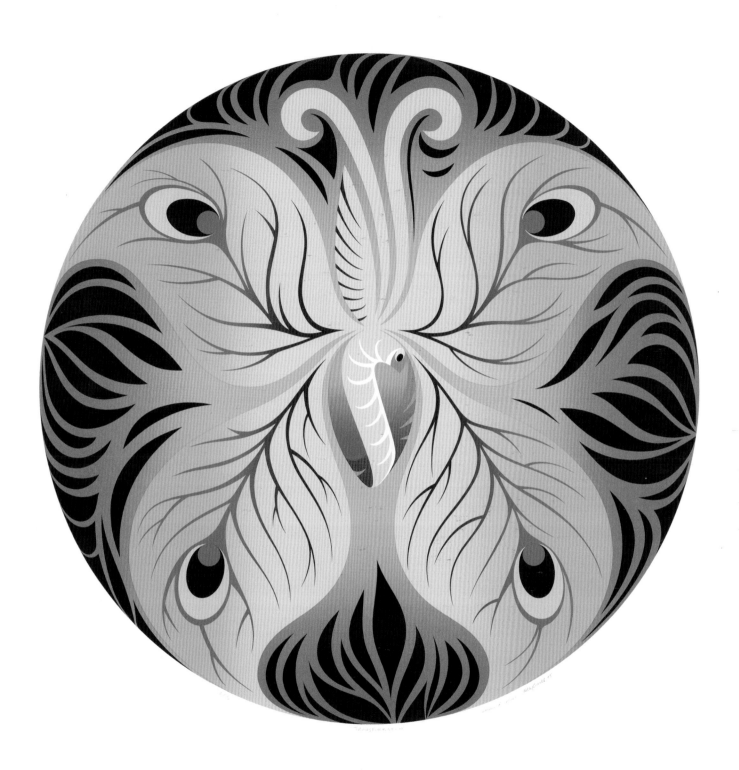

Transformation

with Kelly Cannell

March 2005 · Edition size: 82

Serigraph · 30 × 30 inches

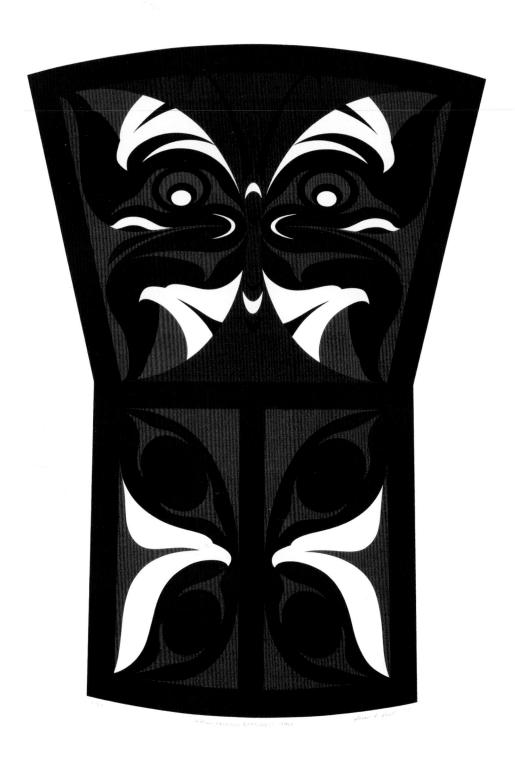

**Eagle, Frog and
Butterfly Copper**
May 2005 · Edition size: 59
Serigraph · 25½ × 19½ inches

150

FACING
Discovery
October 2005 · Edition size: 82
Serigraph · 38 × 26 inches

SP

From the collection
"Connections," box set of 12 prints
October 2005 · Edition size: 15
Photo-etching/chine-collé
9 × 10 inches

Female Figure

From the collection
"Connections," box set of 12 prints
October 2005 · Edition size: 15
Photo-etching/chine-collé
12¼ × 10¼ inches

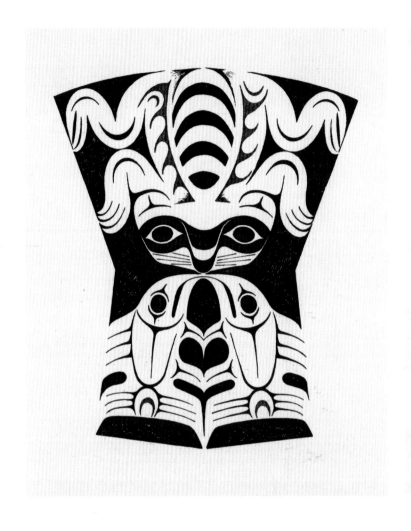

Lizard Copper

From the collection
"Connections," box set of 12 prints
October 2005 · Edition size: 15
Photo-etching/chine-collé
13 × 9½ inches

Racoon Copper

From the collection
"Connections," box set of 12 prints
October 2005 · Edition size: 15
Photo-etching/chine-collé
12¼ × 10¼ inches

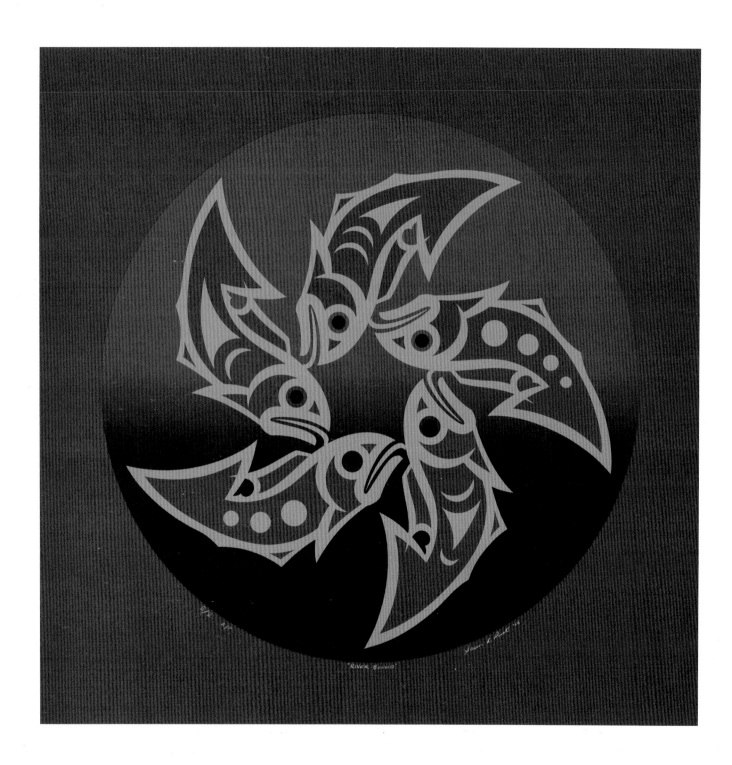

River Bound

September 2006 · Edition size: 20

Serigraph · 26 × 26 inches

FACING

Symphony of Butterflies

April 2006 · Edition size: 104

Serigraph · 37 × 30 inches

THE PHENOMENON OF life exists within nature's splendour. As the land draws its breath from the winds above, so too does it exhale with the receding tides of the ocean. This interpretation of land, sea and air is likened to the majestic bird, the Hokioi (native Eagle, Roi Toia), who traverses the realms of the over worlds, the Thunder Lizard (Susan Point) who protects the "life principle" of the land and the Whai (Stingray, Todd Couper) who patrols the domain of the underworlds. The centre arrangement depicts the essence of life and the evolution of death symbolized by two spirals opposing each other.

Our connection grew following visits in New Zealand and Vancouver. I felt a tremendous kinship with all the Maori artists I met, and was overwhelmed by their generosity and hospitality during my trip to New Zealand. At the time of the *Kiwa* exhibition, we began this collaboration celebrating the artistic and spiritual ties between our cultures.

SUSAN POINT

FACING
Manawanui
with Roi Toia and Todd Couper
February 2006 · Edition size: 99
Serigraph · 30½ × 30½ inches

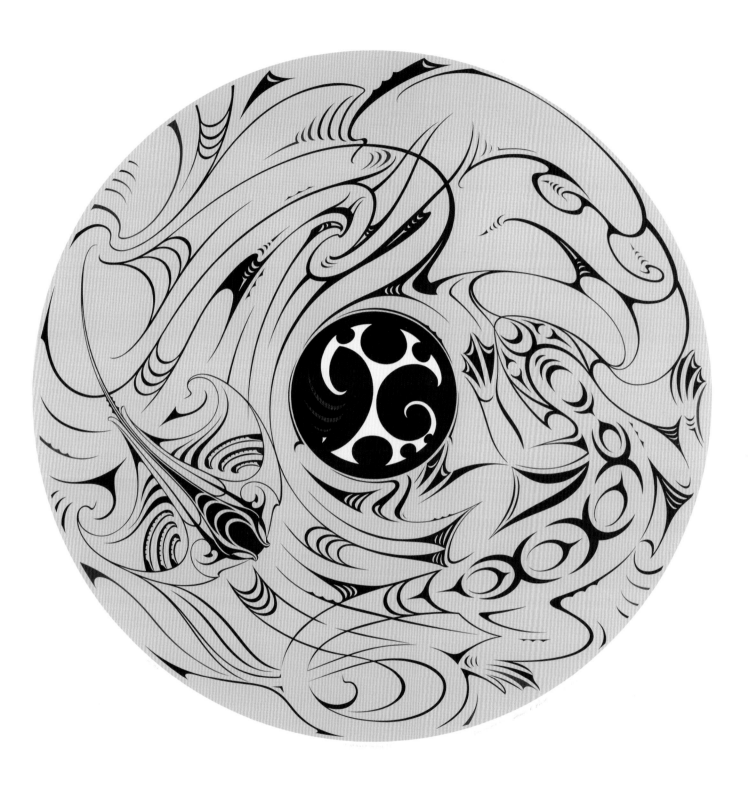

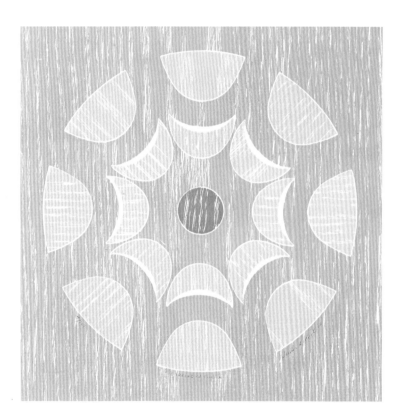

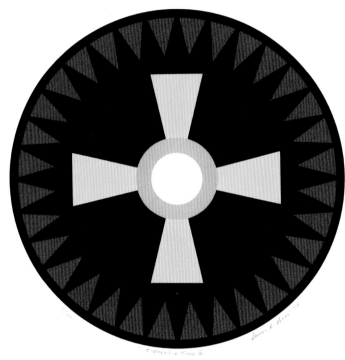

Circles in Time v

September 2008 · Edition size: 101

Serigraph · 8½ × 8½ inches

Circles in Time vi

September 2008 · Edition size: 101

Serigraph · 8½ × 8½ inches

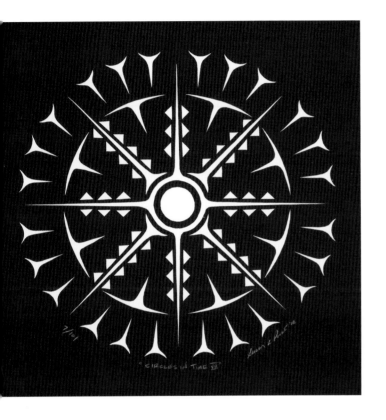

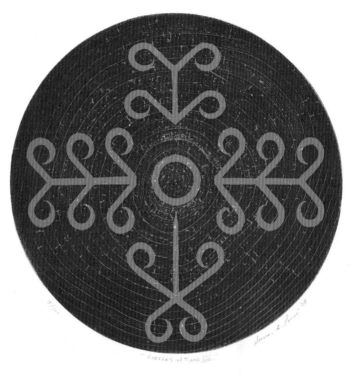

Circles in Time VII

September 2008 · Edition size: 101
Serigraph · 8½ × 8½ inches

Circles in Time VIII

September 2008 · Edition size: 101
Serigraph · 8½ × 8½ inches

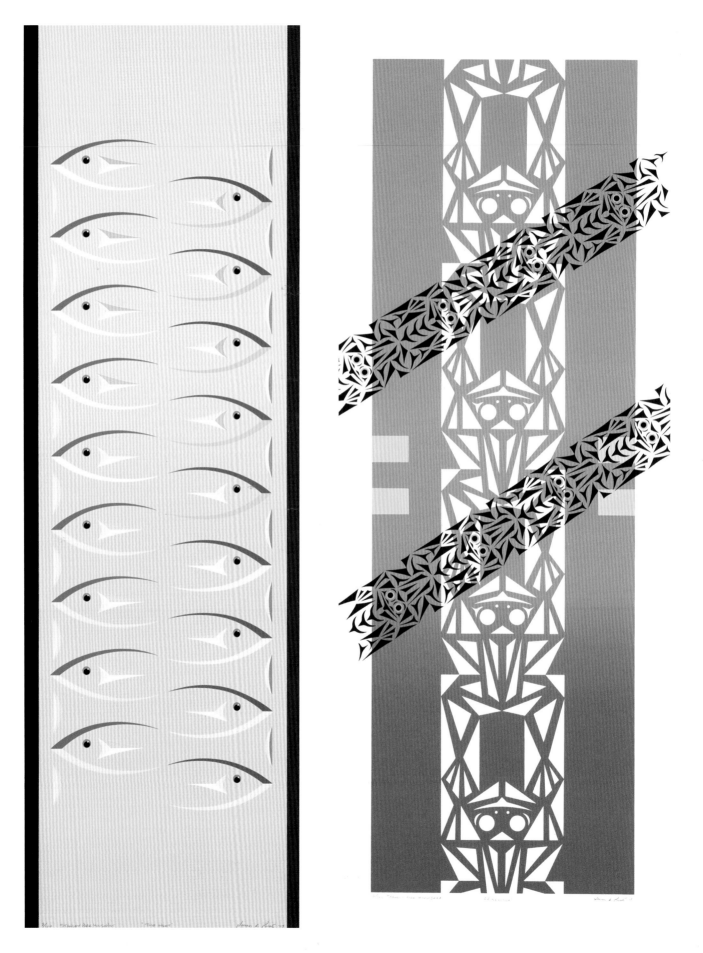

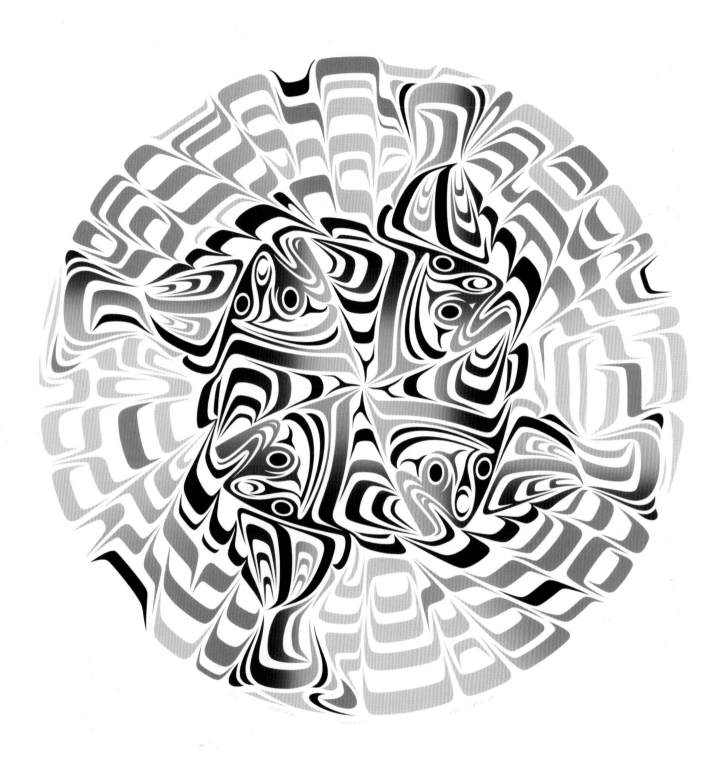

FACING LEFT
The Inlet
1 of 2 Stanley Park houseposts
April 2007 · Edition size: 100
Serigraph · 35 × 13½ inches

FACING RIGHT
Crosswalk
1 of 2 Stanley Park houseposts
April 2007 · Edition size: 100
Serigraph · 35 × 13½ inches

Halibut State I of II
January 2007 · Edition size: 100
Serigraph · 30 × 30 inches

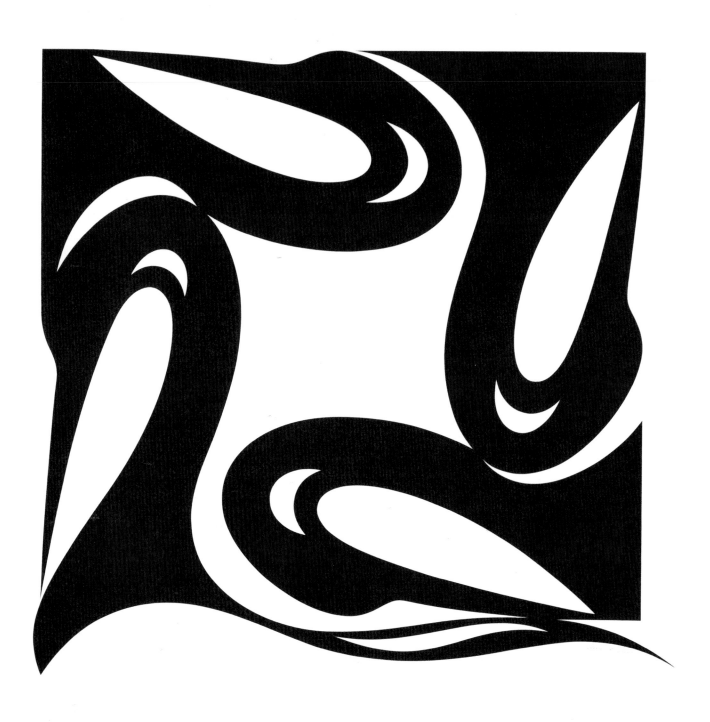

Impressions
October 2008 · Edition size: 82
Serigraph · 22 × 22 inches

FACING
Broken Circle
September 2007 · Edition size: 52
Serigraph · 24½ × 18 inches

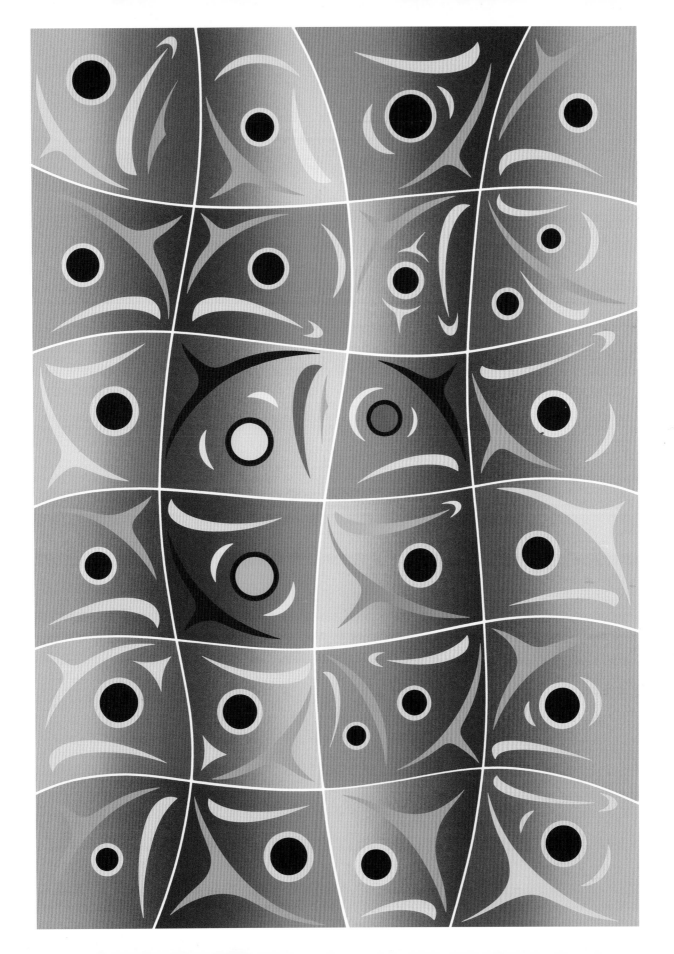

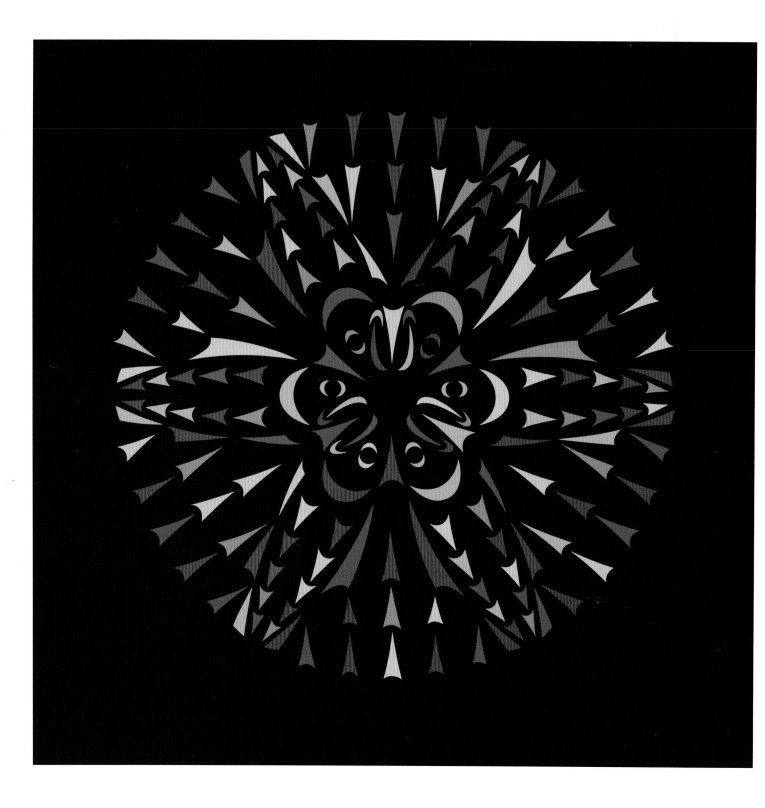

Northern Lights

October 2008 · Edition size: 94

Serigraph · 21¾ × 21¾ inches

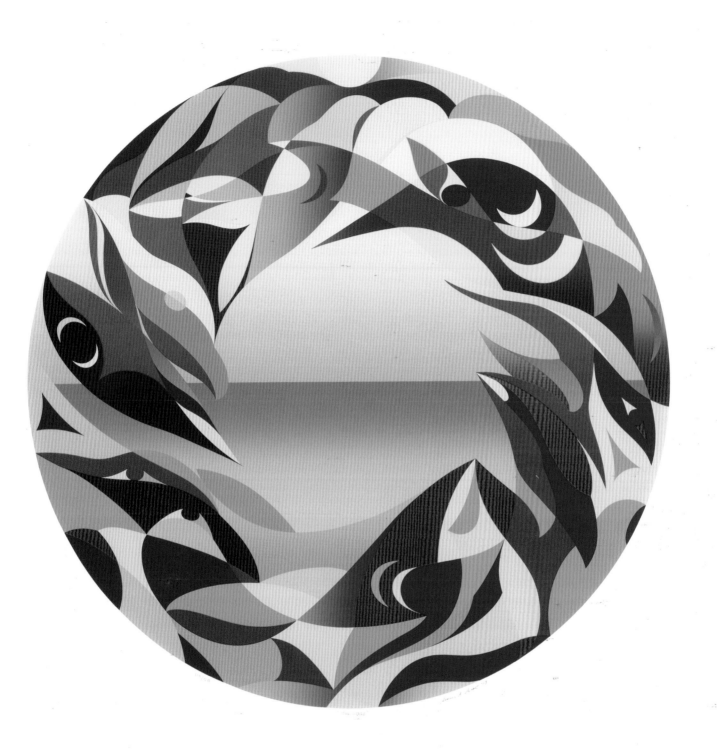

The Edge

October 2009 · Edition size: 120

Serigraph · 27¾ × 27¾ inches

165

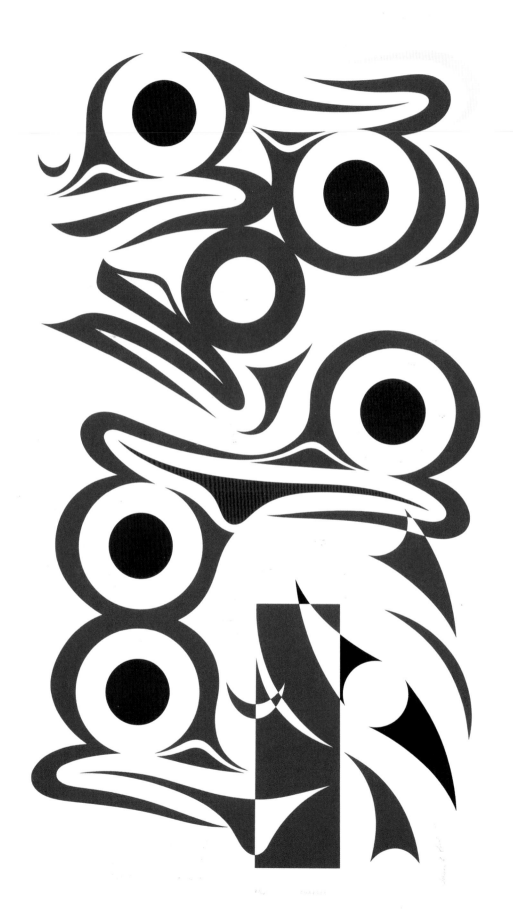

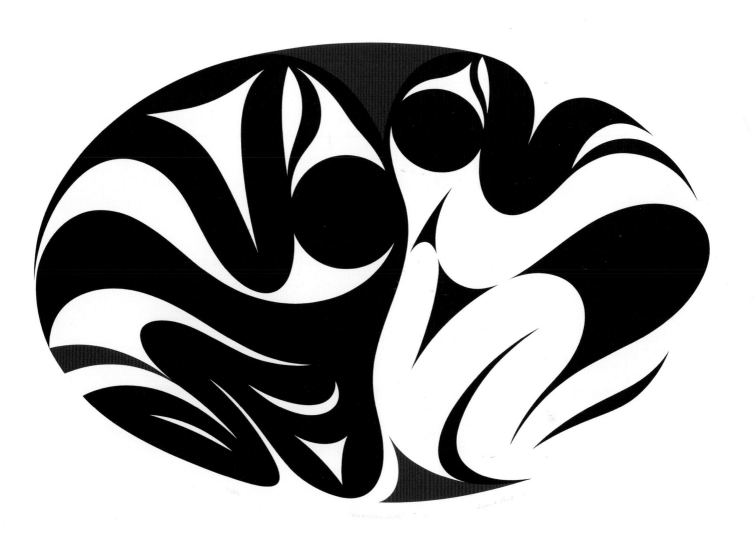

Changes
September 2004 · Edition size: 52
Serigraph · 33 × 20 inches

Reawakening
March 2011 · Edition size: 25
Serigraph · 21 × 28½ inches

167

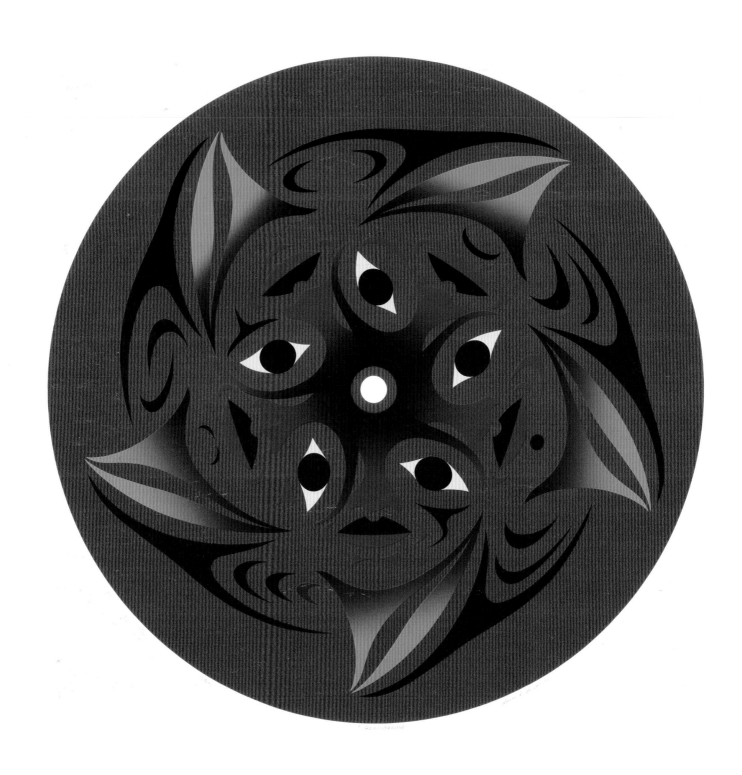

Remembrance

November 2010 · Edition size: 85

Serigraph · 30 × 30 inches

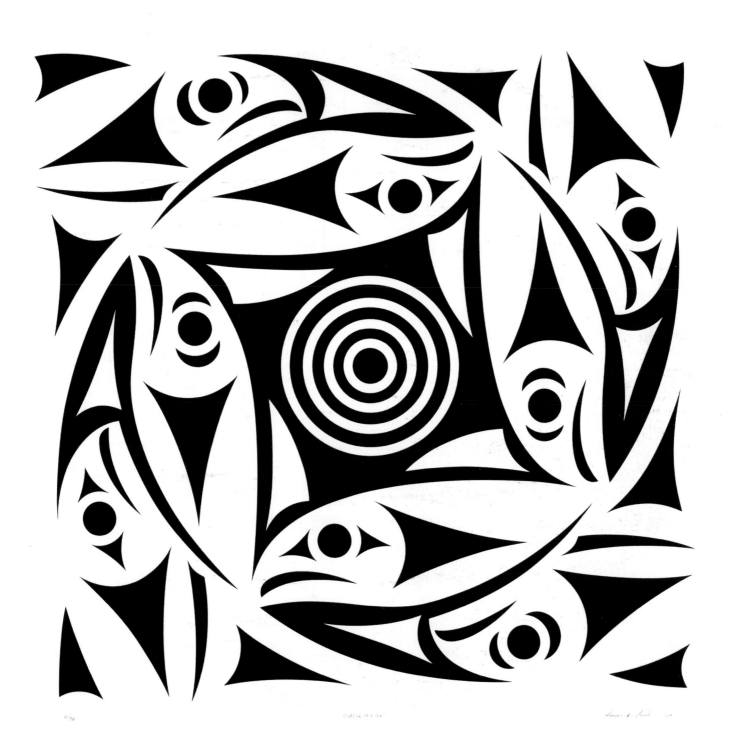

Circle of Life

February 2007 · Edition size: 72
Serigraph · 22¼ × 22 inches

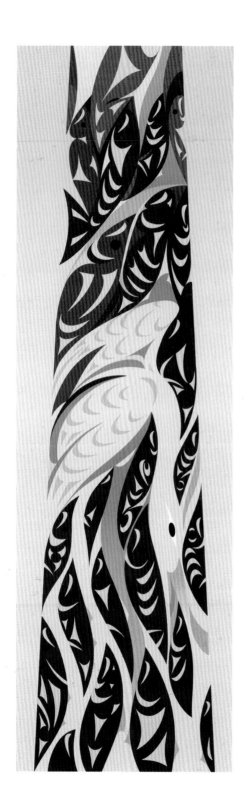

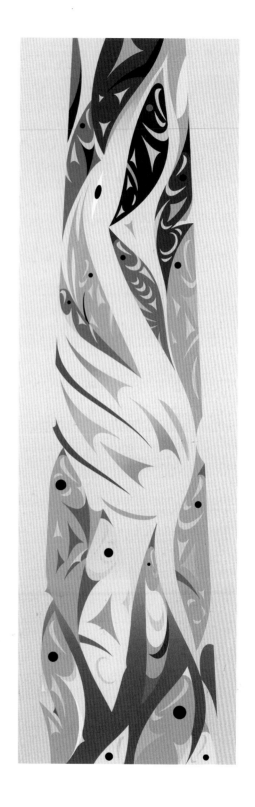

North Arm

September 2011 · Edition size: 100

Serigraph · 31⅞ × 12½ inches

Canoe Pass

October 2011 · Edition size: 100

Serigraph · 31⅞ × 12½ inches

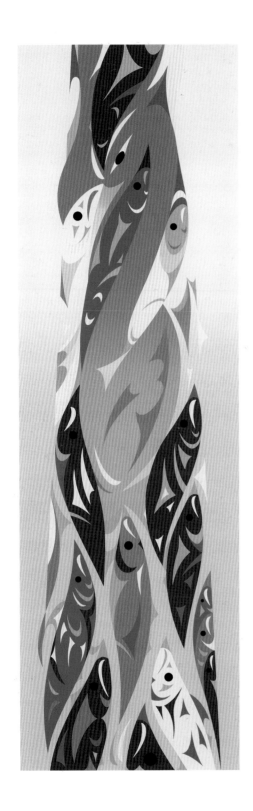

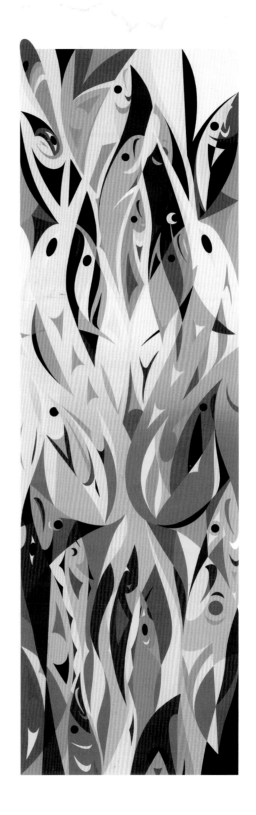

Iona Beach

September 2012 · Edition size: 100

Serigraph · 31⅞ × 12½ inches

Musqueam Foreshore

November 2012 · Edition size: 100

Serigraph · 31⅞ × 12½ inches

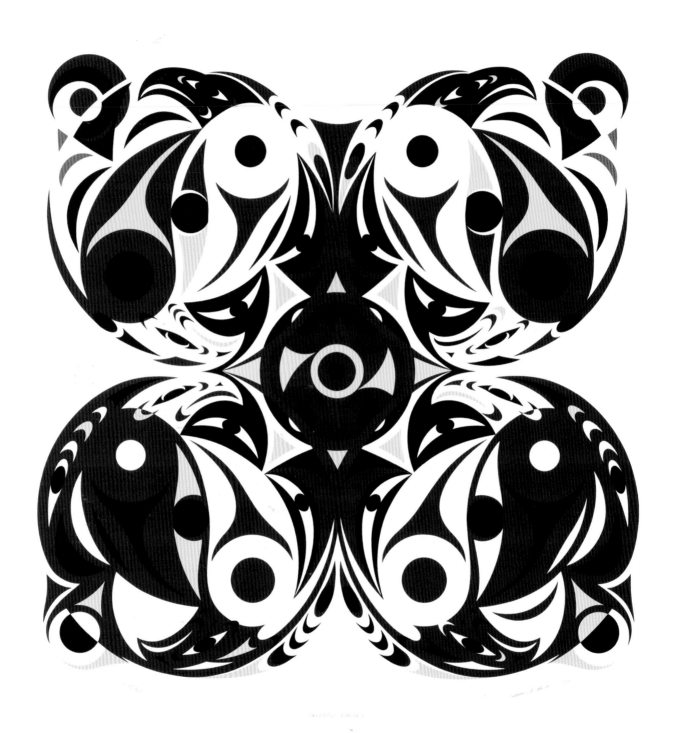

Celestial Circles

December 2010 · Edition size: 150

Serigraph · 26½ × 26 inches

FACING

Salish Path

February 2010 · Edition size: 111

Serigraph · 38 × 28½ inches

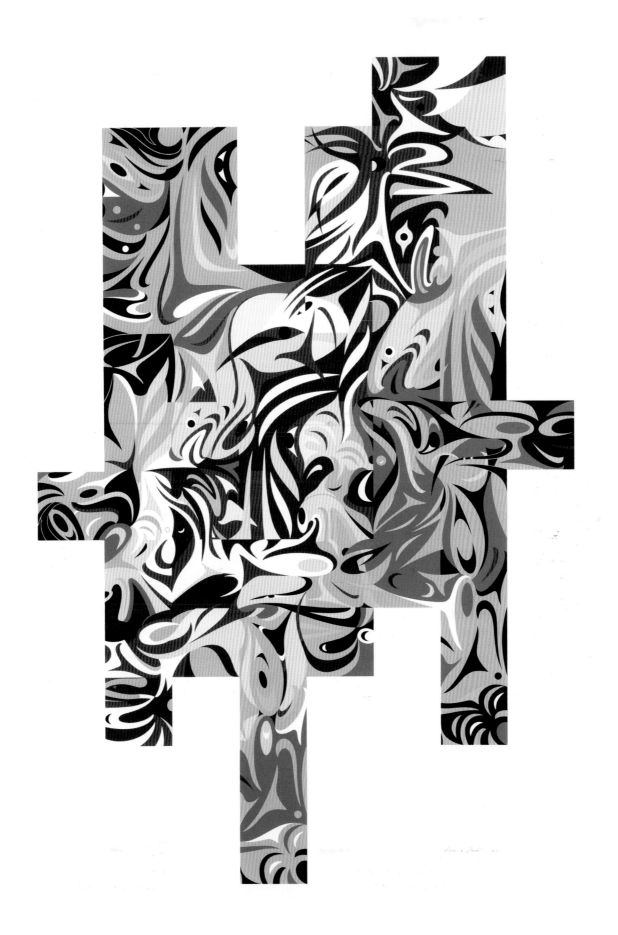

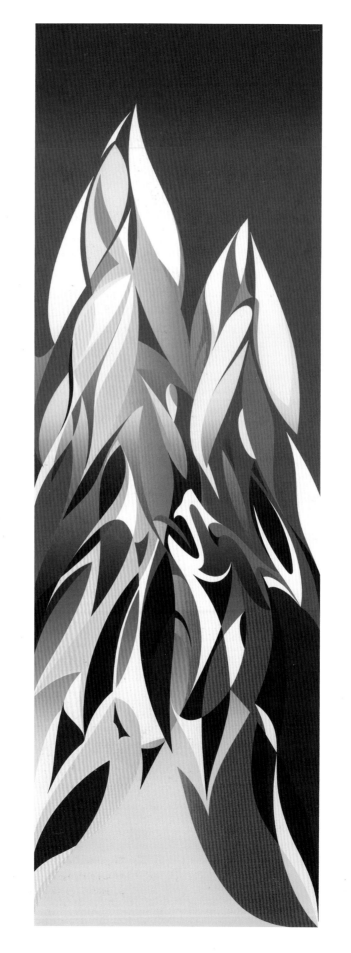

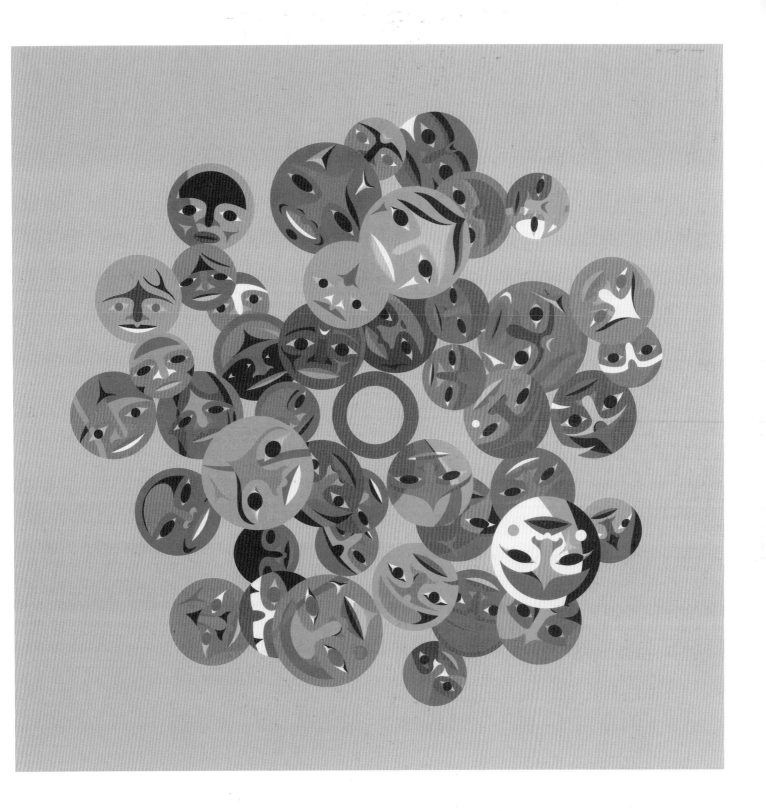

FACING
Whistler
April 2009 · Edition size: 86
Serigraph · 36½ × 14½ inches

Timeless Circle
November 2013 · Edition size: 100
Serigraph · 32 × 32 inches

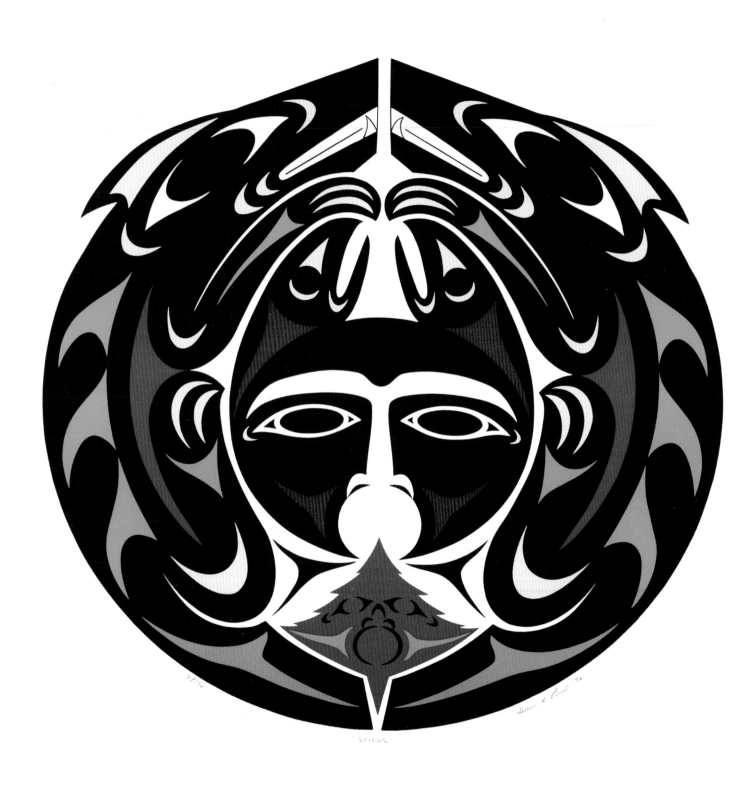

Voices

July 1992 · Edition size: 130

Serigraph · 20¼ × 20 inches

Selected Major Exhibitions and Commissions

1981 Commission: *Grizzly Bear and Sockeye Salmon* design commissioned by the Municipality of North Vancouver for incorporation into their coat of arms.

1982 Exhibition: *Art of the Northwest Coast*, London Regional Art Gallery, London, Ontario.

1985 Exhibition: *The Northwest Coast Native Print*, Art Gallery of Victoria, Victoria, British Columbia, catalogued exhibition.

1986 Commission: *Red Oak* design commissioned by the Municipality of Metropolitan Seattle, cast for tree crates for various locations in the Seattle, Washington area.

1986 Exhibition: *New Visions: Serigraphs by Susan Point, Coast Salish Artist*, University of British Columbia Museum of Anthropology, travelling exhibition; *New Visions*, Museum Note No. 15 by Karen Duffek, published as reference to the exhibition.

1986 Exhibition: Sacred Circle Gallery of American Indian Art, Seattle, Washington.

1989 Exhibition and publication: *Susan A. Point, Joe David, Lawrence Paul: Native Artists from the Northwest Coast*, Ethnological Museum of the University of Zurich, Zurich, Switzerland, catalogued exhibition, text by Peter R. Gerber and Vanina Katz-Lahaigue.

1989 Exhibition: *Beyond Revival: Contemporary Northwest Native Art*, Charles H. Scott Gallery, Emily Carr College of Art and Design, Vancouver, British Columbia.

1990 Commission: Two original *Salmon* designs commissioned by the Dominion Company for the Sechelt Band, a government-sponsored project for use on concrete buildings, Vancouver, British Columbia.

1990 Commission: Pacific Spirit '91 logo design commissioned by the University of British Columbia Hospital Foundation for the Pacific Spirit Park Run, Vancouver, British Columbia.

1990 Exhibition: Solo exhibition, The Art Space Gallery, Philadelphia, Pennsylvania.

1991 Commission: *The Seal and the Raven*, 8′ × 15′ × 2″ carved and painted panel commissioned by the Sechelt Indian Band for their theatre, Sechelt, British Columbia.

1992 Exhibition: *Here Today*, Open Space Gallery, Victoria, British Columbia.

1992 Exhibition: Museu Da Gravura Cidade De Curitiba, Curitiba, Brazil.

1992 Commission: Painted drum commissioned by the Voices of the Earth Foundation, North Vancouver, British Columbia, for presentation to Prince Philip, Duke of Edinburgh.

1992 Commission: Stainless steel and coloured glass mural, 32″ × 53′, commissioned by the Washington State Arts Commission for the Natural Resources Building, Olympia, Washington.

1993 Exhibition: *Wear It!: Northwest Coast Designs in Contemporary Clothing and Jewelry*, The Legacy Ltd., Seattle, Washington.

1993 Commission: Design motifs to be integrated into the overall design of the West Seattle Pump Station commissioned by the Municipality of Metropolitan Seattle, Seattle, Washington.

1994 Exhibition: *Bit Im Presseclub, Zeitgenossische Kunst Der Indianer Der Nordwestkuste Kanada*, Bonn, Germany.

1994 Commission: *Flight*, 17-foot carved red cedar spindle whorl commissioned by the Vancouver International Airport Authority for the new International Terminal Building, Vancouver, British Columbia.

1995 Exhibition: *The 6th Native American Fine Arts Invitational Exhibition*, The Heard Museum, Phoenix, Arizona.

1996 Commission: Logo design and 15 (14 silver and 1 gold-plated) 3-inch medal-lions and an 18-inch carved glass plate of the same design produced in an unlimited edition, commissioned by the National Aboriginal Achievement Awards Foundation, Toronto, Ontario.

1996 Commission: *Salish Woman*, 17′ × 4′ carved red cedar Coast Salish housepost commissioned by the Vancouver International Airport Authority for the new International Terminal Building, Richmond, British Columbia.

1996 Commission: *Salmon Homecoming*, original artwork for limited-edition litho-graphed print of 549, commissioned by the Seattle Aquarium for their fourth annual Salmon Homecoming celebrations, Seattle, Washington.

1996–97 Commission: One carved and painted 22′ × 4′ red cedar with inlaid copper domes welcome figure and two 14′ × 4′ carved and painted red cedar house-posts, commissioned by the Royal Bank of Canada for the University of British Columbia Museum of Anthropology, Vancouver, British Columbia.

1997 Commission: Two carved and kiln-cast glass architectural panels, each panel 4′ × 6′, and a 7′ × 30″ carved and kiln-cast glass totem pole commissioned for the Sprint Canada Building, Toronto, Ontario.

1997 Commission: *Four Corners,* welcoming wall mural cast in pigmented Forton from original carved red cedar patterns, 20′ × 20,′ for the North Seattle Community College Vocational Education Building, commissioned by the Washington State Arts Commission, Olympia, Washington.

1997 Exhibition: *River Deep–Mountain High*, St. Fergus Gallery, Wick, Scotland, travel-ling exhibition that also included Swanson Gallery, Iona Gallery and Inverness Museum of Natural History, all in Scotland.

1998 Exhibition: *Walk with Beauty: Contemporary and Traditional Art*, various locations in downtown Portland, Oregon, one of twelve artists.

1999 Exhibition: Solo exhibition, Motherland Gallery, Fukuoka, Japan.

1999 Commission: *Written into the Earth*, three tree grates carved in yellow cedar and cast in iron and four original medallion designs carved in yellow cedar and cast in bronze, commissioned by First and Goal Incorporated for the Washington State Football/Soccer Stadium and Exhibition Center, Seattle, Washington.

2000 Exhibition: *Susan Point: Coast Salish Artist*, exhibition at the Spirit Wrestler Gallery, Vancouver, British Columbia, in partnership with the Waterfront Hotel, accompanied by book of same name published by Douglas and McIntyre and the University of Washington Press.

2002 Artist in Residence: Pilchuck Glass School, Stanwood, Washington.

2004 Commission: *The Beaver and the Mink*, commissioned by the Government of Canada as a gift to celebrate the opening of the National Museum of the American Indian at the Smithsonian Institution in Washington, D.C.

2006 Exhibition: *Manawa: Pacific Heartbeat*, Spirit Wrestler Gallery, Vancouver British Columbia, catalogued exhibition.

2006 Commission: *Golden Salmon* wall mural, kiln-cast gold fused glass, 45' x 15", commissioned by UBC Rowing Club for new facilities, Fraser River, Richmond, British Columbia.

2006 Commission: *Herons* (Richmond Runnels) artwork engineered into the Richmond Olympic Skating Oval north buttresses, commissioned by the City of Richmond and built for the 2010 Olympic Winter Games, Richmond, British Columbia.

2008 Public art commission: *People Amongst the People*, three carved red cedar Coast Salish gateways, created in collaboration with Coast Salish Arts; Vancouver Storyscapes; the Musqueam, Squamish and Tsleil-Watuth First Nations; and the Vancouver Park Board, and erected at Brockton Point in Stanley Park, Vancouver, British Columbia.

2009 Commission: *The Tree of Life*, series of five stained-glass windows, 29' × 20', installed at Christ Church Cathedral, Vancouver, British Columbia.

2009 Commission: *The Human Spirit,* a 90-foot-long artwork of patinated copper human figures including gold leaf and carved and painted red cedar, along the east and west conecting corridor of the Vancouver Convention Centre, Vancouver, British Columbia.

2009 Commission: *Moon Journey,* a considerable granite floor installed at the Vancouver Convention Centre, east side, Vancouver, British Columbia.

2009 Commission: *Cedar Connection,* a carved and painted red cedar owl taking flight, 20′ × 15′, commissioned by the Vancouver International Airport Authority and installed at the YVR Station along the Canada Line, Vancouver International Airport, Richmond, British Columbia.

2009 Commission: *Salish Path,* an assortment of polished and flamed stones installed as a mosaic in the entranceway to the Museum of Anthropology at the University of British Columbia, Vancouver, British Columbia.

2010 Commission: *Woven to Place,* woven canvas and cedar, hand painted, commissioned by the Washington State Arts Commission for Green River Community College, Auburn, Washington.

2010 Commission: *Rebirth—Salish Housepost,* carved cedar housepost installed in the atrium of the Vancouver Art Gallery for the duration of the 2010 Vancouver Winter Olympic and Paralympic Games, Vancouver, British Columbia.

2010 Exhibition: Solo exhibition, *Salmon People, Coast Salish Fishing on the Fraser River,* Gulf of Georgia Cannery, Steveston, British Columbia.

2011 Public art commission: *Timeless Circle,* a substantial permanent bronze sculptured commissioned by the Municipality of Whistler for the 2010 Olympic Park Legacy, Whistler, British Columbia.

2012 Commission: *Tin-Can-Creek, Spawning Salmon,* carved and painted red cedar whorl commissioned by the MINT Museum, Charlotte, North Carolina.

2013 Commission: *Salish Fish Trap,* collaboration with Thomas Cannell, coated aluminium contemporary fish trap commissioned by Hillsboro Investments and installed in a water feature at River Green, Richmond, British Columbia.

Selected Publications

1986 *New Visions: Serigraphs by Susan A. Point, Coast Salish Artist*, Museum Note No.15, Karen Duffek, Museum of Anthropology, University of British Columbia Press.

1988 *Zeitgenossische Kunst Der Indianer Und Eskimos in Kanada*, Gerhard Hoffman, published in Germany in conjunction with the exhibition *In the Shadow of the Sun*.

1989 *Beyond Revival: Contemporary North West Native Art*, Barbara DeMott, Maureen Milburn, exhibition catalogue, Charles H. Scott Gallery, Emily Carr College of Art and Design, Vancouver, British Columbia.

1994 *Life of the Copper: A Commonwealth of Tribal Nations*, Elaine Monds, exhibition catalogue, Alcheringa Gallery, Victoria, British Columbia.

1996 *Topographies: Aspects of Recent British Columbia*, Grant Arnold, Monika Kin Gagnon, Doreen Jensen, exhibition catalogue, Vancouver Art Gallery, published by the Vancouver Art Gallery with Douglas and McIntyre.

1998 *Native Visions: Evolution of Northwest Coast Art from the Eighteenth through the Twentieth Century*, Steven Brown, exhibition catalogue, Seattle Art Museum, published in the United States by the Seattle Art Museum and in Canada by Douglas and McIntyre.

1998 *Premonitions: Artists Exploring the Possibilities*, Gary Wyatt, exhibition catalogue, Spirit Wrestler Gallery, Vancouver, British Columbia.

1999 *Objects and Expressions: Celebrating the Collections of the Museum of Anthro-pology at the University of British Columbia*, guest curators writing on pieces in the museum's collection, published by the University of British Columbia Museum of Anthropology.

1999 *Fusion: Tradition and Discovery*, Derek Norton, exhibition catalogue, Spirit Wrestler Gallery, Vancouver British Columbia.

2000 *Susan Point: Coast Salish Artist*, Michael Kew, Peter McNair, William McLennan, Vesta Giles and Gary Wyatt, exhibition catalogue, published in Canada by Douglas and McIntyre and in the United States by the University of Washington Press. Book documents her career to date as well as forty-one pieces from the exhibition hosted by the Spirit Wrestler Gallery and the Waterfront Hotel.

2000 "Vancouver Project," *World Sculpture News*, article documenting the art installations at the Vancouver International Airport, page 48.

2003 *Land Sea Sky: Art at YVR*, Ilona Beiks, Leslie Wootton, Marguerite Chiarenza, book documenting the art installations and collection of the Vancouver International Airport, published by YVR Art Foundation, Richmond, British Columbia.

2003 *Kiwa: Pacific Connections*, Nigel Reading, Gary Wyatt and June Northcroft Grant, exhibition catalogue, Spirit Wrestler Gallery, Vancouver, British Columbia,.

2005 *Manawa: Pacific Heartbeat*, Nigel Reading, Gary Wyatt and Darcy Nicholas, exhibition catalogue, Spirit Wrestler Gallery, Vancouver, British Columbia, published in Canada by Douglas and McIntyre and in the United States by the University of Washington Press.

2009 *O Siyam: Aboriginal Art Inspired by the 2010 Winter Olympic and Paralympic Games*, VANOC, exhibition catalogue, published by John Wiley & Sons.

2012 *Record, (Re)create: Contemporary Coast Salish Art from the Salish Weave Collection*, Toby Lawrence, exhibition catalogue, Art Gallery of Greater Victoria, Victoria, British Columbia.

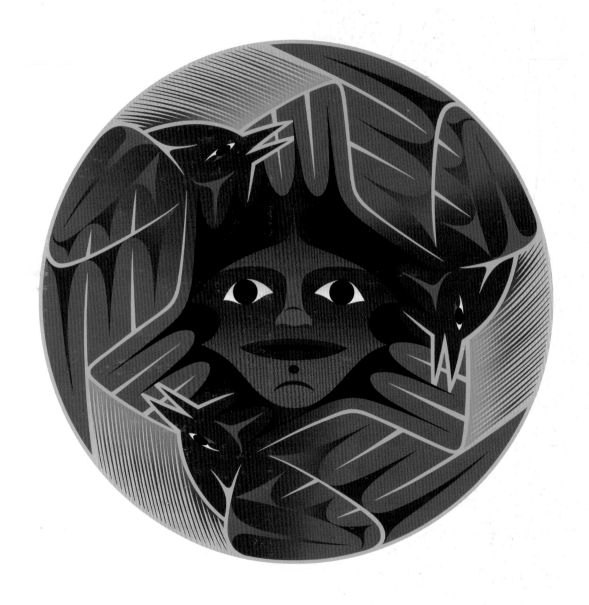

Belonging

June 2001 · Edition size: 150
Serigraph · 22 × 22 inches